MARVEL

BLACK PANTHER

SCRIPT TO PAGE

MARVEL'S BLACK PANTHER: SCRIPT TO PAGE

Black Panther created by Stan Lee and
Jack Kirby

Angélique Roché interview by Andrew Sumner

MARVEL PUBLISHING

Jeff Youngquist, VP Production & Special
Projects

Brian Overton, Manager, Special Projects

Sarah Singer, Associate Editor, Special
Projects

Sven Larsen, Vice President, Licensed
Publishing

Jeremy West, Manager, Licensed Publishing

David Gabriel, SVP Print, Sales & Marketing

C.B. Cebulski, Editor in Chief

ISBN: 9781789098846

Ebook ISBN: 9781803360843

Published by

Titan Books
A division of Titan Publishing Group Ltd
144 Southwark St
London
SE1 0UP

www.titanbooks.com

First edition: November 2022
10 9 8 7 6 5 4 3 2 1

To receive advance information, news,
competitions, and exclusive offers online,
please sign up for the Titan newsletter on our
website: www.titanbooks.com

Did you enjoy this book? We love to hear
from our readers. Please e-mail us at:
readerfeedback@titanemail.com or write to
Reader Feedback at the above address.

A CIP catalogue record for this title is available
from the British Library.

Printed and bound in the UK.

MARVEL

BLACK PANTHER

SCRIPT TO PAGE

SCRIPTS BY

Reginald Hudlin

Ta-Nehisi Coates

Roxane Gay

Bryan Hill

Nnedi Okorafor

TITAN BOOKS

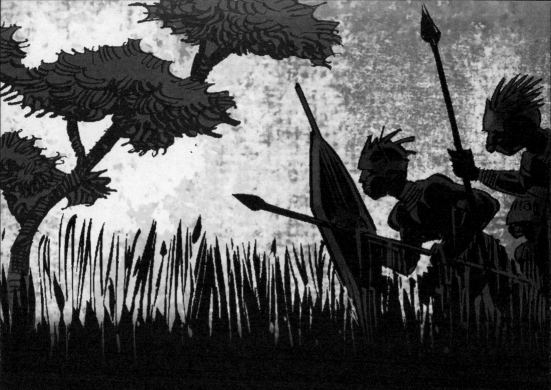

CONTENTS

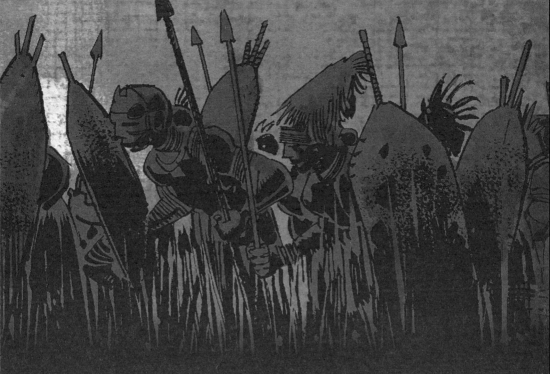

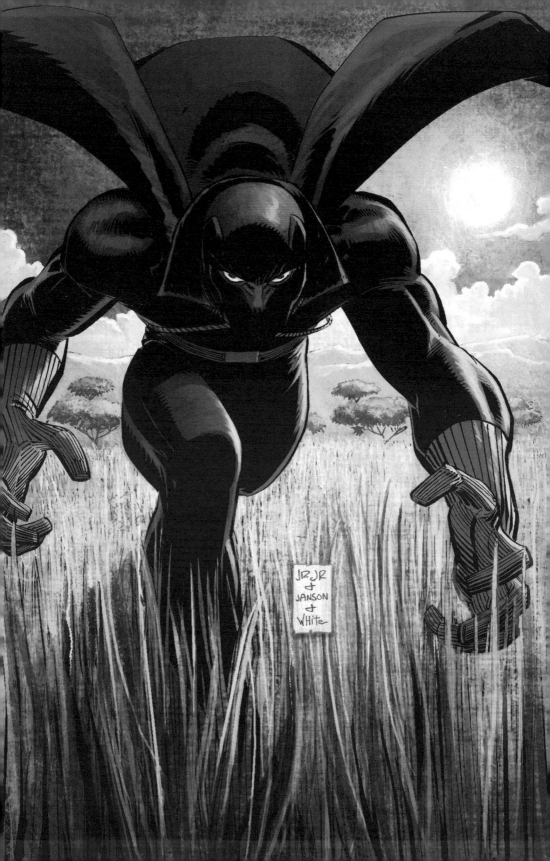

BLACK PANTHER (2005) BY REGINALD HUDLIN

AN INTRODUCTION BY **ANGÉLIQUE ROCHÉ**
IN CONVERSATION WITH **ANDREW SUMNER**

In 2005, movie writer/director Reginald Hudlin (*House Party, Boomerang, Django Unchained*) received a long-awaited chance to write his version of Black Panther. And for a lot of folks who had not seen T'Challa in a while, this was a unique opportunity to present this character to a broader, more contemporary audience. Reggie had enjoyed a lot of success in movies, so this was also his opportunity to bring a new style, a new sense of pace, and a new contemporary flavor to *Black Panther*. Hudlin brings his insight as a filmmaker into the visual shots described in his scripts, from the camera-style angles to his precise framing of scenes. There's a conciseness to his dialogue, to the whole narrative, that reflects his years of working in the movie industry.

Reginald Hudlin is a true comic book fan. He has loved comics for a very long time, and with this 2005 update of T'Challa, he's literally a kid in a candy store writing *Black Panther*. What he does is this: he takes the character, all that great work by Don McGregor in the 1970s and by Christopher Priest in the 1990s (the Priest run really supercharged Black Panther, established T'Challa as a diplomat, and introduced Everett Ross), and he updates it for a contemporary African-American audience. Reggie's T'Challa becomes the leader of a nation who talks in a certain persuasive manner, who is very stately and diplomatic.

Before Hudlin, most *Black Panther* comic books were written for comic book fans, but Reggie's T'Challa is written for African-Americans, and contains a lot of references to African-American culture. As his storyline develops, he really explores the power—and empowerment—of Wakanda being an African nation that has never been conquered. He digs into that very quickly, and explores the fear that instills in the rest of the world, because they are Africans who are not conquered. What does that mean? What is this fear of the unknown? Right away, in his first couple of panel descriptions, he uses T'Challa's arch-nemesis, the person who

killed his father, as an exploration of the overall concept of fear. Hudlin immediately establishes that he is not going to take for granted that the reader knows anything about the Black Panther. He approaches his story from the outset in a very interesting way: from the perspective of the world outside looking into Wakanda. It's a very international introduction and an international viewpoint.

One of the interesting things about Reginald Hudlin in 2005 is that, by this point, he's a well-known director who has scripted/directed some of the most iconic American movies of the nineties. He's got this extremely fast, cinematic pace to his writing, and the pacing of his dialogue is very specifically rooted in movies and TV. There's an immediate sense of irony in Hudlin's dialogue; he's brought all these aspects of his movie technique, all these pieces of himself, into what he's making.

The filmmaker's perspective is interesting because comic books are a team sport, just like movies. Every single writer of comic books has a personally specific way in which they approach the genre, in which they write their scripts for their collaborators. There is always an underlying formula to it, a math and a science to it—but each writer is unique. And Reginald's scripts are full of camera directions. You can see from the scripts presented here that Reggie is always visualizing a shot: he sees the shot that he wants to create for the reader, and he cinematically visualizes what the shot says, alongside writing his dialogue.

There are occasions on which his dialogue almost feels secondary to the image he's projecting, as in his presentation of the fight between Captain America and Black Panther—it's layered in his script as if you are watching a movie or a television series. The action has pace and firmness, and it's laid out scene by scene. He does a couple of time jumps here and there in his scriptwriting, but his scenes are neat and clean when he's transitioning, and that's very much a television/movie script style. It really works because he has to cover so much ground so quickly—particularly for folks back in 2005 who may just be getting introduced to Black Panther.

It really works to the benefit of the story, particularly in these first two issues.

Hudlin also really knows his comics lore. There's a wonderful note in issue one about T'Challa's fight with Captain America, where Reggie is using his deep love for (and knowledge of) Marvel history to explain why T'Challa is beating Captain America. There's this delightful note referencing specific Marvel history, but it's also referencing American hubris. This is the American government: how dare you say Captain America can't beat someone! He's the best of the best because Captain America reflects us, the American people!

Reggie's examining the homogeneity of what a super hero meant at the time when Captain America was created, what a super hero was designed to be (generally speaking, a white, cisgender, heterosexual male). Captain America was the apex of the American hero, particularly to the people that are being depicted in this scene. But in his script, Reggie is being very specific for those who haven't followed the hodgepodge of Black Panther's history at Marvel. I'm sure the series artist, the very talented John Romita Jr., laughed his ass off when he read this, because his dad [legendary Marvel art director and Spider-Man artist John Romita] would have said, "Yeah, yeah, this is correct!"

This note reminds me of two kids arguing in the playground. "No, Captain America is bigger than Black Panther, Black Panther can't beat Captain America!" And Reginald is literally responding as if his twelve-year-old self was holding the issue in his hand. "Nah, dude—the task force got their butts beat right off the bat, and I'm going to show you the flashback scene where it actually happens!" It shows the impact T'Challa, his favorite comic book character, had on a young Reginald Hudlin. You can see the love, care, and respect that Reggie has for Black Panther—a love, care, and respect that's on every page of these two scripts.

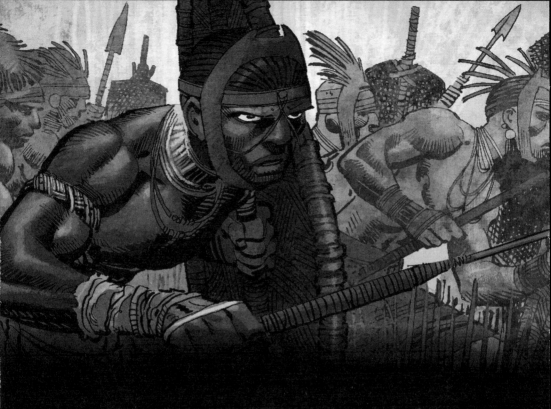

BLACK PANTHER

BLACK PANTHER
ISSUE #1
2005

"Who is the Black Panther? -- Part One"

By Reginald Hudlin

Art by John Romita Jr., Klaus Janson,
and Dean White

PAGE ONE

1.

At the top of the page, there is an elaborate woodcut, flanked by carved silhouettes of the African continent.

WOODCUT WAKANDA 5TH CENTURY AD.

2.

Very wide shot (think David Lean) of the veldt. There is a group of men arcing across the waist-high grass.

3.

Moving closer, we see they are a group of INVADERS from a nearby tribe. They are heavily armed and look dangerous.

> **INVADER #1:** Stay focused. I've heard that the Wakandans are fierce.

4.

Tighter shot. We see these are very big and scary looking guys.

> **INVADER #2:** _Fierce_? Isn't that what you said about the _last_ tribe?

> **INVADER #3:** Yeah, and the one _before_ that!

> **INVADER #1:** Actually, no. I only said that about the Wakandans.

PAGE TWO

1.

Closer on Invader #2 as he speaks. We see he has body parts as mementos from previous battles.

> **INVADER #2:** Well, it doesn't matter. I _hope_ they can fight. Because I'm getting bored--

2.

Close-up of his foot buried in the grass. He doesn't see the mechanical device he's about to step on.

3.

Medium shot of the guy as a man-sized TRAP springs.
Razor-sharp teeth close on him, driving into his back and chest.

4.

He's pinned, almost severed in two. Everyone else is freaked out.
Invader #1 is a bit cooler than the rest.

> **INVADER #3:** What is _that_?!!

> **INVADER #1:** The _Panther's_ _Teeth_. Now
> get focused.

5.

Wide shot. They pull their weapons and comb the ground carefully,
looking in all directions for more traps and approaching troops.

PAGE THREE

1.

Close-up of nervous soldier.

2.

Close-up of a spear combing through the grass.

3.

Wide overhead. Long moments pass as they step carefully.

4.

Med. close-up the next victim when a trap springs. Another man
caught in its jaws.

5.

The men panic. Some start running away.

> **INVADER #1:** _Hold_ your ground! Running
> will only make it worse!

6.

One man looks up.

> **INVADER #3:** Oh, it's getting worse...

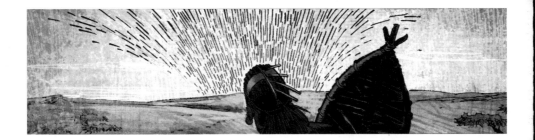

PAGE FOUR

1.

Narrow frame. They all look up. From a distance, it looks like a swarm of bees in the sky.

2.

Tight shot. The "swarm" is hundreds of SPEARS and they are headed right for them.

3.

Now everyone loses it. Running like hell. Some cower in a ball, as if the spears won't see them kneeling in the grass.

4.

While running, a few more guys get caught in the "Panther's Teeth."

5.

A few men do make it to the tree line, where they take cover.

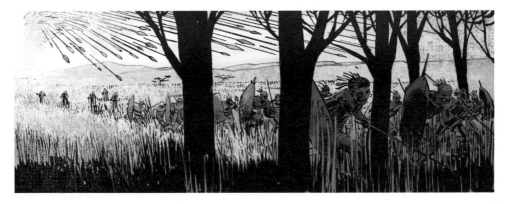

PAGE FIVE

1.

Whatever these guys do, it doesn't make a difference. It's the 5th Century equivalent of "Shock and Awe." They don't stand a chance. Men are nailed to the ground, run through while running away.

2.

Spears even drive through and split trees to kill the man hiding on the other side.

3.

Wide shot. Another volley of spears is headed their way.

4.

Overhead looking down. The leader of the invaders stands defiant.

> **INVADER #1:** Kiss my butt, Wakan--

5.

Side Angle. He is run through.

6.

Wide shot. All is silent.

PAGE SIX

1.

The lone survivor pulls his head out of his ass and looks around at the devastation.

2.

Everyone is dead--and they never even saw their opponent. Some of the men avoided the spears but were hit by falling trees split by the spears.

3.

He looks toward Wakanda. A voice is heard from the jungle.

> **VOICE (O.S.):** Tell your tribe.

4.

He slowly backs away.

> **VOICE (O.S.):** Tell everyone.

5.

Turning home, he runs like hell.

PAGE SEVEN

1.

Cut. Now we're in a dank old stone prison. But there's a cell within a cell. Suspended from the ceiling is a modern Plexiglas chamber that holds a middle aged, paunchy white guy (we'll call him PRISONER). He doesn't look that tough, given the precautions. He's talking to a person who's inside the cell but outside of his box. That man's back is to us so we can't see his face (we'll call him UNSEEN MAN).

> **PRISONER:** The Wakandans had giant crossbows? That's amazing ... I'm not sure the English had such technology at the time...
>
> **UNSEEN MAN:** Not until the 10th Century. Wakanda was already ahead of the rest of the world.

2.

Focus on Prisoner.

> **PRISONER:** Clever little buggers. And tough, too.

3.

Focus on Unseen Man. (Maybe we see just a corner of his mouth, curling into a smile?)

> **UNSEEN MAN:** Oh, you haven't heard anything yet...

PAGE EIGHT

1.

Cut! Full frame of a bronze plaque.

BRONZE PLAQUE WAKANDA 19TH CENTURY.

2.

Very wide shot as a battalion of BOER SOLDIERS arc across the veldt.

3.

Wide shot of A PRIVATE (overweight and wheezing) as he huffs his way up front to speak with his COMMANDING OFFICER.

> **PRIVATE:** <u>Sir</u>! The natives refuse to go any farther, sir!
>
> **C.O.:** Flog them.

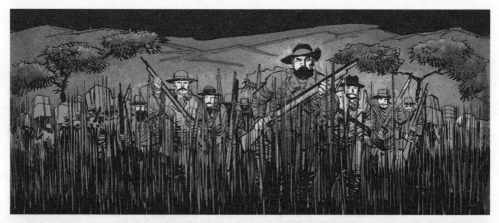

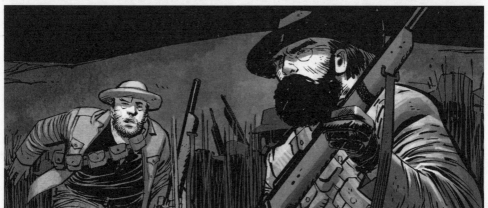

4.

Closer shot of the private and the Commander.

 PRIVATE: Uh, we <u>have</u>, Sir. They still won't budge.

 C.O.: Have these people no sense of industry?

 PRIVATE: They say it's the <u>Wakandans</u>. Bad juju, that sort of thing.

PAGE NINE

1.

A lieutenant sniggers.

 LIEUT: Labor problems in Africa-- <u>that's</u> a new one!

2.

The commanding officer gets in the Lt.'s face.

 C.O.: Do you think this is <u>funny</u>? Do you?

3.

The Lt. is shut up. The Commander heads to the back of the line.

 C.O.: I don't have time for this superstitious nonsense. How the hell are we supposed to get that blasted Gatling gun in position?

 PRIVATE: These are some of the same boys we had during the <u>South African</u> campaign. They did a bang-up job there. Don't know what's gotten <u>into</u> them.

4.

The Commander pulls his pistol, cocks it.

 C.O.: If they don't get off their black asses, it'll be hot lead--

 PRIVATE #2: They're <u>running</u> for it!

5.

Shot of the bearers running away. The Commander is furious.

 C.O.: Treasonous bastards! <u>Fire</u> <u>at</u> <u>will</u>!

PAGE TEN

1.

The commanding officer and other troops shoot at the escaping Africans.

2.

Most escape, but a few are shot in the back.

3.

The Commander has a sick smile. Private looks a bit wan.

 C.O.: <u>That'll</u> show 'em.

 PRIVATE: Oh no!

 C.O.: What...

4.

They look around at all their equipment on the ground.

 PRIVATE: <u>Who's</u> going to <u>carry</u>
all this?

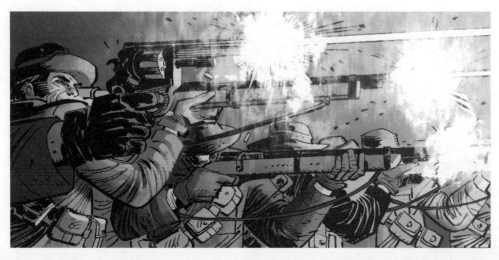

PAGE ELEVEN

1.

Cut! Now all the Boers are carrying their own ▌▌▌▌ up a steep ass hill, and they are not happy about it. Even the Commander is busting his ass.

> **LIEUT:** Perhaps, given our circumstances, we could leave the fine china behind?

> **C.O.:** <u>No</u>! We will <u>not</u> lose our grip on civilization because of those monkeys. We will not be dragged down to their level...

2.

A group of enlisted men are trying to push a heavy cannon up the hill.

> **SGT.:** Don't faint on me now, Jensen...

3.

The weight gets the better of them and it rolls backwards. One man is crushed underneath.

> **PRIVATE:** <u>Aaarrrgh</u>!

4.

Private #2, seeing the morale of the men plummet, has a moment with the Commander.

> **PRIVATE #2:** Sir ... perhaps an inspiring word?

5.

Silent beat as Commander gives him a sideways look.

6.

The Commander begins his speech. The men look up.

> **C.O.:** I <u>swear</u> on my child's life, when we get back to our hard-won base camp in Pretoria, every porch monkey on our land will pay five times over for this betrayal!

> **C.O.:** I will teach these Wakandans the true meaning of <u>fear</u>!

PAGE TWELVE

1.

Ext. Wakandan border--dusk. A spyglass POV of Wakanda is seen. It looks "futuristic" for its time, which is still retro for us, but still impressive looking.

There is a tower with a bust of a black panther in the center of the city that, if you're in the mindset, is sort of a "middle finger" to the world. [Important to note that Wakanda is "eco-friendly" in design, so it's not simply some sprawling metropolis.]

 OFF (C.O.): WAKANDA...

PAGE THIRTEEN

1.

The Commander views Wakanda with his spyglass.

 C.O.: ...It's <u>everything</u> the legends say
 it is. Weird-looking buildings, though.
 But I can see gold trinkets from here.

2.

His POV through the spyglass of a shapely native girl as she walks.

 C.O.: The boys will get their fair share
 of <u>booty</u> tonight, for sure.

3.

Suddenly, a figure in the distance rises into his view, blocking his sight lines.

4.

Suddenly, the Commander is looking at THE BLACK PANTHER! (The Panther's attire makes that clear, even though it's not the exact same outfit T'Challa wears. It's also "period.")

PAGE FOURTEEN

1.

The Commander is so startled he drops the spyglass.

<u>2.</u>

The Panther is still there, in the distance, staring right at them.
Even alone, he's an intimidating sight.

<u>3.</u>

The Commander has been waiting for this moment.

 C.O.: They're <u>onto</u> us! Prepare for <u>battle</u>!

<u>4.</u>

All the men quickly load and unshoulder their rifles.

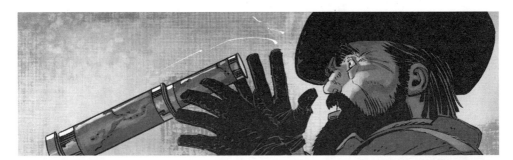

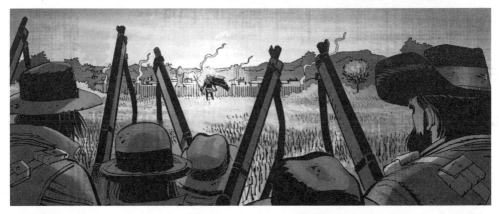

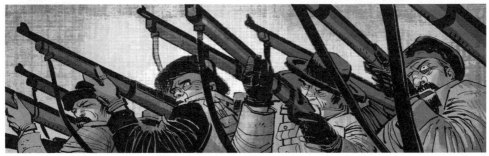

PAGE FIFTEEN

1.

The Panther doesn't move an inch.

2.

A large device rises behind him. It looks like a cross between an African totem and a Jack Kirby "special."

> **PANTHER:** Leave now and I will let you live.

> **PANTHER:** Attack and only one of you will be left standing.

3.

The Boers look at one another like, "is he kidding?"

> **C.O.:** Right...

4.

Triggers are pulled.

> **C.O.:** Fire at will!

5.

The Panther is cool as a fan. He is framed by the device behind him.

6.

Instead of releasing a hail of bullets, the chambers of the rifles and pistols EXPLODE, maiming the soldiers' hands and faces with shrapnel and burns.

PAGE SIXTEEN

1.

The Commander is stunned at the devastation.

> **C.O.:** What ... just ... happened?

2.

The Panther still hasn't moved.

> **PANTHER:** Last chance to leave with your wounded.

3.

The Commander turns to the Gatling gun operators.

> **C.O.:** Shoot that bastard!!!

> **SOLDIER:** But, Sir, what if we misfire, too? It couldn't all be an accident. He's doing something...

4.

The Commander shoves the soldier aside.

> **C.O.:** Remind me to shoot you later, coward.

5.

The Commander aims the Gatling gun at the Panther.

PAGE SEVENTEEN

1.

The Commander looks at the trigger. He's scared.

2.

He looks to his troops. They back away from him. Which scares the Commander more? Dying or backing down?

3.

He decides to go for it. He pulls the trigger.

> **C.O.:** Die you Black--

4.

It explodes spectacularly.

5.

As the smoke clears, the men look and see the Panther still staring at them. They feel like the defenseless prey they are. One guy starts to plead their case to him.

> **PRIVATE:** Sir, before you slaughter us all, I hope you noticed that he was the <u>only</u> person who continued to fire on you. I hope your offer to allow us to leave is still open...

6.

The Panther says nothing. The troops realize that they are surrounded by Wakandan WARRIORS.

> **PRIVATE:** Please?

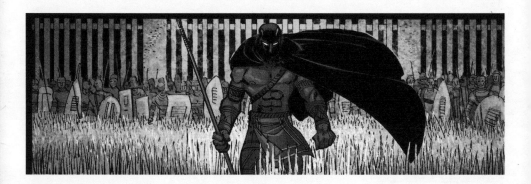

PAGE EIGHTEEN

1.

Cut! Ext. shot of the White House.

> **FROM IN:** They can't <u>do</u> that!

2.

Cut inside. A White House briefing--modern day. A very bellicose GENERAL makes himself heard. The room is filled with high-level government operatives.

> **GENERAL:** We're the #$%^& United States of %^$%#$ America! Where do a bunch of jungle bunnies get off telling us they've got a "no fly" zone over their thatched hut?

3.

Dondi Reese, head of the NSA, glares at him. The room falls silent. Everyone else feels very uncomfortable.

4.

All eyes on the General.

> **GENERAL:** Did I say something wrong?

5.

It occurs to him.

> **GENERAL:** Oh God, Dondi--I'm sorry!
> You know I don't mean <u>you</u> when I say--

6.

Dondi is ice cold.

> **DONDI:** Shut up, Wallace.

> **GENERAL:** --I mean, they're nothing
> like you--

> **DONDI:** Shut. Up.

7.

He shuts up.

PAGE NINETEEN

1.

Dondi takes charge of the meeting.

> **DONDI:** Is there someone here who
> can give us some <u>accurate</u> <u>intel</u> on these
> people?

2.

From a waaaaay back corner of the room, a small man coughs for
attention.

> **EVERETT:** Uh, that would be <u>me</u>,
> Ms. Rice.

> **DONDI:** Mr. Ross. Who the hell <u>are</u>
> these people, Everett?

3.

Everett rises, mans the slide projector.

> **EVERETT:** Wakanda is a small country in Africa notable for never having been conquered in its <u>entire</u> <u>history</u>.

4.

The lights dim, and first slide pops up.

> **EVERETT:** When you consider the history of the region, the fact that the <u>French</u>, the <u>English</u>, the <u>Belgians</u> or any number of <u>Christian</u> or <u>Islamic</u> invaders were never able to defeat them in battle ... well, it's...

5.

Close on Everett, considering his words carefully.

> **EVERETT:** ...unprecedented.

6.

The second slide pops up.

> **EVERETT:** The Wakandans have a warrior spirit that makes the Vietnamese look like, well, the <u>French</u>. They have also maintained a <u>technological</u> <u>superiority</u> that defies explanation.

> **SUIT #1:** Where'd they get their <u>tech</u> from? <u>Soviets</u>?

PAGE TWENTY

1.

The slide show continues.

> **EVERETT:** No Cold War alliances with either side, and no contemporary alliances with the Arab world--including OPEC. Despite geologists' estimates that they have large oil deposits--

>**SUIT #2:** That's what our boys at Halliburton said--
>
>**EVERETT:** --they don't even pump it.

2.

A silent beat.

3.

Now everyone is really paying attention.

>**GUY IN SUIT:** That's crazy.
>
>**EVERETT:** Apparently they don't need it as an energy source _or_ a financial base. They have a variety of eco-friendly alternative power sources like solar and hydrogen--

4.

This causes a lot of murmuring in the room. "Bad example" ... "public opinion" ... "money just lying there" ... "bigger than Nigeria."

5.

The General speaks up again.

>**GENERAL (loud):** What does this have the do with the price of tea in China, gentlemen? Since when has beating the French meant anything? Give me a 12-man black ops squad and I'll--
>
>**EVERETT:** It's been _tried_, General. With the best.
>
>**GENERAL:** "The _Best_." As if you had a day of military training--

6.

Small thin panel of Everett.

>**EVERETT:** The _Best_.

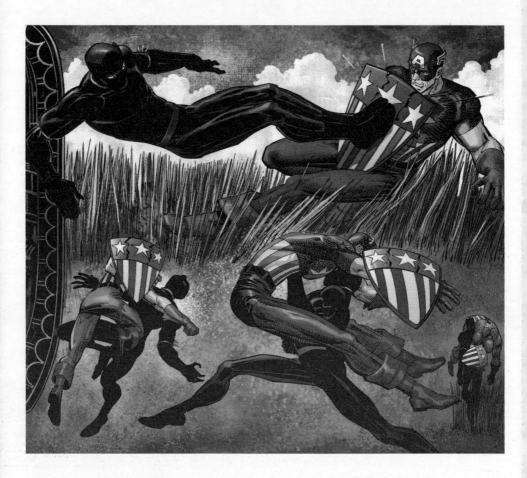

PAGE TWENTY-ONE

1.

Cut to another thin panel, shaped like a plaque, this one made of marble.

MARBLE PLAQUE WAKANDA, 1944.

2.

Back to the veldt. But no wide shot. This time we're plunging right into the action. The BLACK PANTHER and the 1940's CAPTAIN AMERICA (check the shield shape) do battle. The Panther is kicking the shield so hard (with both feet) and even Cap is knocked off his feet.

> **EVERETT (V.O.):** "Captain America
> entered Wakanda during World War Two
> on a search-and-destroy mission.

PAGE TWENTY-TWO

1.

Captain America is going all out against the Panther.

> **EVERETT (V.O.):** "He was hunting Nazis who where also out to exploit Wakandan science.

> **EVERETT (V.O.):** "Cap didn't know the Wakandans had already beheaded the Nazis days ago.

2.3.4.

Zoom in a bit more. Fierce fighting between Cap and the Panther.

> **EVERETT (V.O.):** "He had an extended hand-to-hand battle with the Black Panther."

5.

Cut back to the White House. Close on Everett as a suit asks the obvious question.

> **OFF:** And?

6.

Cut back to flashback: The Panther puts Cap on his back.

> **EVERETT (V.O.):** "He lost."

[Okay. I know. You're saying, "But the Panther can't beat up Captain America!" Actually, Stan and Jack had the Black Panther beat the FF when they first met him AND Cap when they first met, back in TALES OF SUSPENSE. (This scene was retold in a flashback scene in the most recent run of the PANTHER). So, if someone has a problem with it, they are going against YEARS of continuity by THE MASTERS--STAN AND JACK.]

PAGE TWENTY-THREE

1.

Cut back to the General, who is pissed.

> **GENERAL:** Bull!

2.

He goes after Everett. Everett tries to backpedal, but the General grabs him by the tie.

> **EVERETT:** If it makes you feel better, the Panther also beat the Fantastic Four in--

3.

Several aides have to separate them. Dondi gestures to two Secret Service Agents. She's had enough of the General.

> **EVERETT:** Don't shoot the researcher, General.

> **DONDI:** Get him out of here.

4.

Secret Service agents step in to drag the general out.

> **GUY IN SUIT** : If this guy is all that, who <u>can</u> handle him?

PAGE TWENTY-FOUR

1.

Cut! Now we're back in the prison cell with the Prisoner and the Unseen Man.

> **PRISONER:** Obviously a Presidential Pardon is appealing.

> **PRISONER:** Let's say I <u>join</u> your team. If these Wakandans are all you say they are, what are our chances of <u>success</u>?

2.

We finally see the face of the "Unseen Man." He's handsome, except for the scar on one side of his face and the evil glint in his eye. As he raises his hand, it starts to extend metal parts. It's cybernetic.

> **UNSEEN MAN:** Pretty good. I've already killed one Black Panther 15 years ago. I <u>almost</u> killed his son then.

3.

The hand starts to reshape itself like the villain in TERMINATOR 3, but cooler.

> **UNSEEN MAN:** He hurt me, but he made the <u>mistake</u> of not killing me.

> **UNSEEN MAN:** With your help and my little "<u>enhancements</u>," there's no doubt in my mind that he will die...

4.

Klaw's hand now looks like a very scary looking weapon.

> **UNSEEN MAN:** ...by the hand of <u>KLAW</u>!

CAP: to be continued

BLACK PANTHER

BLACK PANTHER
ISSUE #2
2005

"Who is the Black Panther? -- Part Two"

By Reginald Hudlin

Art by John Romita Jr., Klaus Janson,
and Dean White

PAGE ONE

1.

EVERETT ROSS is addressing a meeting of the NSA, chaired by DONDI REESE, the no-nonsense head of the agency.

> **DONDI:** You've told us a lot about Wakanda, Everett. They've got incredible natural resources, technology on par with the U.S...

> **GUY IN SUIT:** ...and a bad attitude when it comes to international cooperation!

> **DONDI:** What we don't know is: who is the Black Panther?

2.

Focus on Everett.

> **EVERETT:** His name is T'Challa. Son of T'Chaka.

PAGE TWO

1.

Splash page. Close up on a GIANT black onyx sculpture of a black panther. For a visual reference, check out the opening splash page of FANTASTIC FOUR #45...I think that's the one.

Anyway, it's an artistic and engineering feat.

Beneath the head of the giant crouching sculpture is a circle of men stripped down for hand-to-hand combat. A trio of drummers (and other percussionists) are at the head of the circle, setting the tempo for the combat between the men who face off in the circle (ever seen the Afro-Brazilian martial art CAPOEIRA? It's like that).

PAGE THREE

1.

Suddenly the drumming stops. As the fighters clear the ring, a special rhythmic "fanfare" starts.

<u>**2.**</u>

Everyone looks up. In the crowd, a father holds his young son in his arms, as the jaw of the giant sculpture opens.

 FATHER: Look, son...

<u>**3.**</u>

...revealing THE BLACK PANTHER (the man) inside the mouth. The crowd CHEERS at the sight of him.

 FATHER (o.s.): ...it's him...

<u>**4.**</u>

Cut! Everett, talking. Dondi, listening.

 EVERETT: ...the Black Panther is
 the ruler of Wakanda. It's a spiritually
 based warrior cult. Sort of like being
 Pope, President and head of the Joint
 Chiefs of Staff all at once...

<u>**PAGE FOUR**</u>

<u>**1.**</u>

Cut back to The Panther, as he leaps into the air...

<u>**2.**</u>

...does a perfect flip...

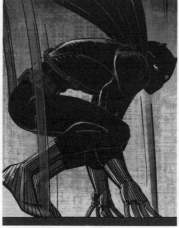

3.

...and lands in the center of the ring.

4.

The Panther starts walking inside the rim of the circle.

5.

As he walks, he stares into the eyes...

6.

...of the very tough looking young men who line the edge of the circle.

> **EVERETT (v.o.):** "...the Panther is a hereditary title, but you still have to earn it."

PAGE FIVE

1.

One man falls in step behind the Panther.

> **EVERETT (v.o.):** "The series of tests that a Panther must pass is so arduous that only candidates who've had special training from childhood can qualify."

2.

The Panther accepts the challenge and starts running faster around the circle.

> **EVERETT (v.o.):** "But just so everyone gets a chance, once a year there's a day when any Wakandan can challenge the king for the throne."

3.

The CHALLENGER quickens his step in pursuit.

> **EVERETT (v.o.):** "So as royal lineages go, it's a lot more of a meritocracy than, say, England."

4.

The crowd watching presses closer.

5.

Suddenly the Panther spins around and launches a fierce attack.

6.

There's a brief exchange of blows.

PAGE SIX

1.

The Panther kicks the guy so hard he flies out the ring. The other challengers don't catch him--they lean out of the way.

2.

The kicked guy ends up landing among the audience.

3.

The crowd pushes him off them, and he puddles on the floor.

4.

The next challenger steps into the arena. He's as big as a house. Shaq-sized. The crowd goes "ooooooooh".

5.

As he passes, two FELLAS from the front of the audience do "play by play" and "color commentary".

> **M'SHULA:** Oooh, that's a big one, K'Tyah.

> **K'TYAH:** Truly, M'Shula. With those muscles he must be a miner.

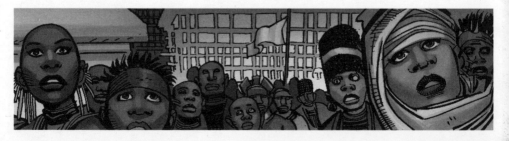

PAGE SEVEN

1.

BIG BOY throws a kick. The Panther ducks it.

> **M'SHULA:** Yikes! That tree trunk almost took his head off!

> **K'TYAH:** But watch this: The Panther will chop him into firewood!

2.

The Panther punches Big Boy in the liver. The fellas are impressed.

> **M'SHULA:** Oh! Liver punch! That'll do him!

3.

But Big Boy only smiles.

> **BIG BOY:** That's it?

4.

The Panther rises up and KICKS Big Boy in the face with a flying kick.

5.

Big Boy gives Panther a bloody smile.

> **BIG BOY:** That was better, but...

6.

Big Boy grabs Panther's leg and slams him back to Earth - face first. The boys are worried.

> **BIG BOY:** A knockout may not be enough to take the crown. I might have to kill you.

> **M'SHULA:** Okay ... even if the Panther loses... there's no way that big bonehead is taking the throne! They have a literacy requirement!

PAGE EIGHT

1.

Cut! Exterior shot of the Royal Palace. Even in a land of spectacular architecture, this place stands out.

> **QUEEN** (from in): Have you heard anything yet?

2.

Inside, The QUEEN MOTHER paces in her chambers. Her HANDMAIDEN sits anxiously, trying to figure out how to calm her Queen.

> **HANDMAIDEN:** No, your highness.

> **QUEEN:** I can't take this stupid ritual every year! It's too nerve wracking.

3.

She tries to focus on the wall screen television, but cannot.

> **QUEEN:** Not going is worse than being there.

> **HANDMAIDEN:** Perhaps you should visit the Princess. I'm sure she's depressed since you locked her in her room to stop her from attending the tournament.

4.

The Queen Mother heads down the hall.

> **QUEEN:** Good idea!

PAGE NINE

1.

Cut! We see two guards snap to a defensive position as someone approaches. Princess Shuri.

> **GUARD #1:** Princess Shuri!

> **GUARD #2:** The Queen has strict orders that you cannot enter!

2.

First she seems like she's going to cooperate.

> **PRINCESS SHURI:** Well, I hate to get you in trouble...

3.

Big Panel as she LEAPS OVER THEM...

> **PRINCESS SHURI:** But I got to go!

4.

...and climbs up the wall to a window to enter.

5.

From inside, we see Shuri climb though the window to see what's going on. No one notices her enter - the crowd is too focused on the fight inside.

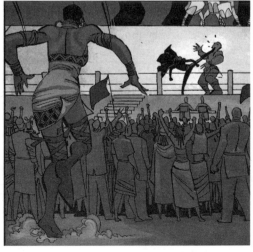

PAGE TEN

1.

From Shuri's high POV, we see the crowd cheer as the Panther is up and beating the hell out of the Big Boy. The fellas are so hyped.

> **M'SHULA:** I <u>told</u> you he would come through!

> **K'TYAH:** No, I told you!

2.

As Shuri reaches the floor of the arena, she sees the first opponent that the Panther knocked out. He's on a stretcher at the first aid station.

> **PRINCESS SHURI:** T'Shan?

3.

Closer. He looks up through swollen eyes.

> **T'SHAN (groggy):** Hey ... cousin...

> **PRINCESS SHURI:** Any tips for me?

> **T'SHAN:** What? You can't be serious... about fighting...

> **PRINCESS SHURI:** Oh yes I am!

4.

She heads toward the circle, T'Shan calling after her.

> **T'SHAN:** You haven't even finished your training...

5.

Too exhausted to pursue her, he falls back on the cot.

> **MEDIC:** Just rest. We'll be back to bandage her up later.

PAGE ELEVEN

1.

Shuri squeezes between our two favorite ringside commentators, M'Shula and K'Tyah. But their eyes are too focused on what's in front of them. Specifically, on the giant who is now falling their way, like a redwood in the forest.

> **PRINCESS SHURI:** Excuse me! Contestant coming through!

2.

Our guys clear out, but Shuri doesn't look up until it's too late. A shadow falls over her face.

> **PRINCESS SHURI:** You didn't have to leave, I was just trying to get to the--

3.

She's pinned underneath a mountain of unconscious flesh.

> **PRINCESS SHURI:** Get off me!

4.

Another contestant enters. He's dressed in a simple loincloth like the others, but has a mask over his face.

> **PRINCESS SHURI:** Hey, I'M supposed to go next!

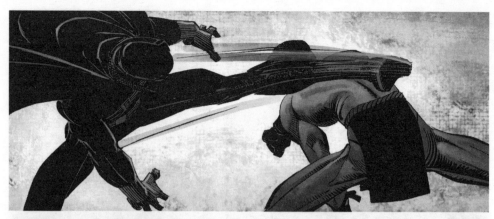

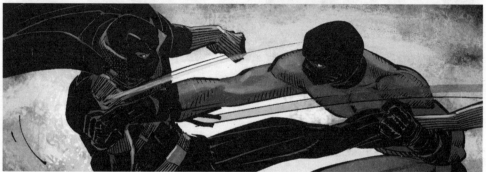

PAGE TWELVE

1.

The Panther assumes a defensive stance, but the masked challenger makes an "after you" gesture.

2.

The Panther walks the circle. The masked man follows. It's a relaxed pace.

3.

The fellas return, now using Big Boy's body like a bench.

> **M'SHULA:** Hmm! The mystery man sure is cocky! I wouldn't give the Panther a chance to recover after that last guy.

> **K'TYAH:** I guess he doesn't want anyone to question his victory--

> **BOTH:** --yeah right! As if!

4.

They laugh. But Shuri is even more pissed.

> **PRINCESS SHURI:** Hey! Get up! I'm UNDER here!

PAGE THIRTEEN

1.

The Panther, now with his wind back, turns and faces his opponent.

2.

The Panther attacks. The opponent matches his moves perfectly. It's clearly the best fight of the day.

3.

The medical team is now trying to remove Big Boy. He's so heavy they are having a hard time lifting him onto the stretcher. The fellas move to accommodate first aid workers, but never take their eyes off the fight.

> **M'SHULA:** Now THIS is a fight!

> K'TYAH: Who IS that masked man?

4.

Now unpinned, Shuri pops up and joins the commentators.

> PRINCESS SHURI: Aw man! I was gonna
> do that move!

5.

M'Shula and K'Tyah notice Shuri for the first time.

> M'SHULA: Princess!

> K'TYAH: When did YOU get here?

PAGE FOURTEEN

1–4.

A series of panels as The Panther and the Masked Man are going at it. It's a Jackie Chan meets Jet Li-level battle. Lots of great aerial work. Each move is topped by the next man's counter. Perhaps this forms the top tier.

5.

The Masked Man gets a solid blow in. The Panther is stunned. The crowd goes "oooooh".

6.

The Panther counters. But it isn't enough.

7.

The Masked Man KNOCKS THE PANTHER OUT.

PAGE FIFTEEN

1.

Big wide shot. The arena falls silent.

2.

The Princess has a huge tear falling out of her left eye.

<u>3.</u>

The Panther tries to pull himself up ... but can't.

<u>4.</u>

He collapses into the dirt.

<u>PAGE SIXTEEN</u>

<u>1.</u>

The Masked Man shoots out his arms in victory. A TRIBAL ELDER steps into the ring, addressing the crowd and the masked man.

> **ELDER:** The MATCH is OVER!
>
> **ELDER:** Please remove your mask.

2.

He removes it. His back is to us, so we don't see his face.

3.

There is a collective GASP from the Elder and the entire audience.

4.

We see the handsome face of the masked man for the first time.

> **ELDER:** The new Black Panther is...
> T'CHALLA! SON OF T'CHAKA!

5.

The room EXPLODES with joy! The fellas are beside themselves. Shuri is not so happy.

> **M'SHULA:** I <u>knew</u> it! Who else could fight that well but royalty?
>
> **K'TYAH:** You knew no such thing.
>
> **PRINCESS SHURI:** I was robbed! By my own BROTHER!

PAGE SEVENTEEN

1.

T'Challa leans down to comfort the outgoing Panther. They clasp arms in a "soulful" way, and T'Challa helps lift him up. He removes the ceremonial mask.

> **T'CHALLA:** Are you okay, Uncle?
>
> **UNCLE S'YAN:** Fine--now that I know it was you!

2.

Now standing, Uncle P removes the ceremonial mask and lifts his nephew's arm in triumph.

3.

The crowd loves it. Except for one. In the back of the room, T'Shan struggles up from the stretcher he was on, disgusted.

T'SHAN: Look at my "father"... So happy that it isn't me. He made sure of that.

ROYAL PHYSICIAN: It was a fair fight. Both his ... and yours.

T'SHAN: What do YOU know?

4.

He storms out. Except for the doctor, no one notices. Everyone is cheering T'Challa, who's being lifted out of the arena on the shoulders of the crowd.

5.

Cut! The Handmaiden runs into the Queen's quarters.

HANDMAIDEN: Did you hear? Your son--

QUEEN MOTHER: --won. Yes, I know. It was inevitable.

6.

She sits heavily.

HANDMAIDEN: But ... why are you sad? He has ascended to his father's throne!

QUEEN MOTHER: Making him a better target.

PAGE EIGHTEEN

1.

Cut! Back at the NSA, where Dondi is taking this all in.

> **DONDI:** ...So what we've got here is a highly militaristic culture with no ties to the United States...

2.

Two-shot of Guy in Suit and Everett.

> **GUY IN SUIT:** They're a rogue state!

> **EVERETT:** Before you go adding them to the "Axis of Evil," I should point out that they have never invaded anyone. The only time they've taken hostile action is defending their own borders.

3.

Angle in Dondi.

> **DONDI:** But a REGIME CHANGE could bring about a change in that policy. Look, I don't want to jump the gun here, but it's standard operating procedure to have a military option in place for any potential threat to the United States.

4.

Angle on Everett.

> **EVERETT:** I certainly don't want to speak in the place of the recently departed general, but with our military forces stretched all over the Middle East, do we even have the resources--?

5.

Dondi pointedly cuts him off.

> **DONDI:** You're right Mr. Ross, that is NOT your area of expertise. You just keep providing accurate information.

DONDI: Besides, this conflict would not be appropriate for conventional forces. This is a job for Special Forces.

6.

Zoom in close on her.

DONDI: VERY Special Forces...

PAGE NINETEEN

1.

Cut! Wide shot of two men at the front door of a very nice brownstone. We see them from behind.

VOICE (DOOR): Who is it?

2.

Through the fish-eye lens peephole, we see the faces of Klaw and the man he got out of prison last issue.

KLAW: Klaw...

KLAW: ...and a very special friend.

3.

Klaw and the man from issue #1 (The Prisoner) step inside a lavish brothel, escorted by the elegant Madam. There is a parade of beautiful women in lingerie to choose from (artist: be discreet).

MADAM: Take your pick, gentlemen.

KLAW: None for me, thanks. But my friend here has been away for a while, so I'm treating him.

4.

The Man from jail is guided to a bedroom by one of the women.

KLAW: Good choice. When should I come back?

5.

Angle on the Man, smiling.

MAN: Oh, I'd say an hour. At least.

PAGE TWENTY

1.

Cut. In a bedroom, the man leans in for a kiss. Woman refuses.

WOMAN: Sorry, we don't kiss. It's
too ... personal.

2.

He throws a wad of money on the table.

MAN: I understand. Does this
make it worth your while?

3.

Close on Woman.

WOMAN: No, I'm sorry--

4.

More money on the table. Hundreds.

MAN: How about now? It's just
one kiss.

5.

Close on Woman.

WOMAN: Okay ... just one.

6.

Close on their mouths, just about touching.

7.

Angle up to show her eyes starting to bug out.

8.

Her eyes go dead. He sucked the life out of her.

PAGE TWENTY-ONE

1.

Cut to the waiting room in the brothel, where the Madam and a few girls sit around.

2.

Suddenly, the woman who we just saw dead walks into the room, heading for the front door.

> **MADAM:** Where are you going? Your shift's not done yet!
>
> **WOMAN:** I quit.

3.

Woman is gone. Madam and girls all look at one another with a "what the ███?" expression.

4.

Madam knocks on the door to one of the rooms.

> **MADAM:** Excuse me--sir? Are you still here?

5.

Madam cracks the door open and steps inside...

6.

...and finds the dead body of the john (Klaw's buddy). Big panel.

> **MADAM:** Oh no! Call clean-up!

PAGE TWENTY-TWO

1.

Cut outside. Over the woman's shoulder, we see that she is being greeted by Klaw, who is picking her up in his car.

> **KLAW:** Need a lift?

2.

Woman sits down in passenger seat, Klaw marvels at the change.

> **KLAW:** It's just amazing. You look like her, sounds like her.

> **WOMAN:** I AM her. I even have her memories.

3.

As they drive off, Klaw grins.

> **KLAW:** You really are a Cannibal.

> **CANNIBAL:** I prefer the term--

> **KLAW:** WHATEVER. So now you're a woman. How does it feel?

4.

Close on Cannibal, smiling an evil smile.

> **CANNIBAL:** I've always wanted to be with a woman like this. Now I AM a woman like this.

5.

KLAW's hand starts to "weaponize" in excitement.

KLAW: And I thought my hand was dangerous.

KLAW: Between the two of us, The Black Panther doesn't stand a chance!

CAP: *TO BE CONTINUED*

BLACK PANTHER (2016) BY TA-NEHISI COATES

AN INTRODUCTION BY **ANGÉLIQUE ROCHÉ**
IN CONVERSATION WITH **ANDREW SUMNER**

The Ta-Nehisi Coates run on *Black Panther* brings in his love of literature and his love of poetry—he really brings all of his personal creative hallmarks. He also brings in his love of comic books, and with these two scripts you can see his desire to have this really strong, cooperative relationship with his artist (the great Brian Stelfreeze). What we aren't seeing in the pages of the script here are the no doubt dozens of emails/calls back and forth, fleshing out the details of the Coates/Stelfreeze run. What Ta-Nehisi is focusing on here, on the page, is the emotions that are leaping from his words. His scripts are linear, but they are also very fluid—he's bringing the reader along on a journey and, like Hudlin before him, he's telling multiple storylines. But with Ta-Nehisi Coates, his primary script focus is on "this is what I want the panel to feel like."

These Ta-Nehisi scripts were far more concise than I expected. They really feel like reading poetry to me because his words are very sparse and succinct. When you see the beauty of what Ta-Nehisi and Brian achieved together in the published comics and you then read them in script form, you really see the importance of Brian's contribution—their success has a lot to do with Brian's work, how Brian interprets Ta-Nehisi's scripts and approaches his art.

The interesting thing is, Coates takes us from this outside view of "what does the world think of Wakanda?" to "what does Wakanda think of Wakanda?" And it's very interesting because Ta-Nehisi Coates is a writer's writer—whether it's prose, fiction, or non-fiction, he's really written across the board. These days, of course, he's doing more work in the entertainment industry, and in movies and television, but he comes from a pure literary background, and this was his first comic book script.

One of the things you have to think about here is that before he started on *Black Panther*, Ta-Nehisi had written literary works that were

world bestsellers (like *Between the World and Me*). Across the board, his literary work was being lauded—he hit President Obama's book lists—and he comes from a very rich history, attending Howard University and being personally brought up in the HBCU tradition. There's this very proud blackness that comes with Coates that's apparent with his writing. And that's what he brings to the world of Wakanda with these scripts.

From a technical perspective, when you look at Ta-Nehisi's scripts, there is much more of an economy and a much heavier lean on the artist to bring forth their vision. Comic book writing is, of course, about teamwork, and Marvel paired Ta-Nehisi Coates with Brian Stelfreeze—two wonderful wordsmiths and storytellers, who matched each other perfectly.

Stelfreeze accepted this assignment because the story that Ta-Nehisi was trying to tell spoke to him. Brian will tell you, "I don't do interiors unless the story is worth it. And when I saw this story, it was a story that I wanted to tell." Stelfreeze has this great ability to focus illustration, which stops the brain in a way: you look at one of his panels and it can stop you in your tracks—you want to savor it as a pure piece of artwork, you want to savor the lines and the details. Brian really wanted to work with Ta-Nehisi on this book, to really build out Wakanda. So, as he writes these scripts, Coates is really writing for Brian Stelfreeze's skills as a visual storyteller, allowing Stelfreeze to add visual nuance. You see a lot fewer 'camera angles' in Ta-Nehisi's scripts because you're not dealing with someone whose background is directing a cinematographer and composing multiple camera angles and getting multiple shots on a daily basis. You're dealing instead with Ta-Nehisi Coates, a prose writer who wants to paint an emotional picture for the reader. You're dealing with a poet; you're dealing with someone who prides himself in the craft of the words. And so, Ta-Nehisi's dialogue stretches even further. You sit longer in the scenes; his flow is very linear, and he wants to build out his characters.

Whereas in Reggie Hudlin's scripts he's very much focused on Black Panther, the history, the tradition, how he got there, how he moves through the international community, in Ta-Nehisi's scripts, even from the very beginning, he spends very little time saying, "this is who I am,

this is this is where I am, this is my conflict." He gets through that in a matter of panels, and then we're straight into "It's the people revolting." And suddenly you see where the people of Wakanda are. And that's the story you get brought into, literally by page two of his first script.

There's so much trust in the artist in these scripts. Coates lays out what the key players are supposed to be doing, how they're supposed to be involved, but there are way more emotional descriptors than we've seen previously. There's a lot more talking about how people feel, what their understanding of their situation is, their fear of consequences. It's key to Coates' narrative that "this is a journey that I am taking you on. This is for the people and of the people."

Where he begins emotionally at the opening of the story is extremely important to where the story goes, even in the choice of a villain who is exacerbating already-existing feelings. In my personal opinion, at this point Coates is reflecting back to what Don McGregor was trying to achieve in the 1970s, where there's a vacuum created because the people had lost faith in their king. The fact that their king isn't coming for them is reflected in the idea that all these traumas have happened to Wakanda. The nation has almost lost its faith, and a militant group has been created because the people are not satisfied with where their country is. And who T'Challa actually is sets the stage for revolution, for change—as depicted in the scene where Black Panther beats up the militant guys and says to the people, "I'm here to take care of you," and they say back, "The militants were taking care of us. You're just an omnipotent regal presence." Coates' question is: if the people have lost faith, if the Dora Milaje have lost faith and there are atrocities happening underneath your nose, where do you go from there?

This is what Coates brings to *Black Panther*: pure poetry, and an investigation of the layers of complexity that exist within an intellectual, advanced society whose citizens' ideas of liberation may not always sit on the same page.

BLACK PANTHER

BLACK PANTHER
ISSUE #1
2016

"A Nation Under Our Feet -- Part One"

By Ta-Nehisi Coates

Art by Brian Stelfreeze
and Laura Martin

PAGE 1

PANEL 1

We are just outside the mines of the Great Mound. Close shot of
T'CHALLA kneeling. He is in his Black Panther uniform with the face
drawn back. A stream of blood is coming out of the right side of
his mouth, as though he's just been sucker punched. He is tired. He
is not afraid. He is not angry. He is just tired.

LOCATION CAPTION: THE GREAT MOUND

> **CAPTION**
> I am the orphan-king.

PANEL 2

T'CHALLA pleading with his ancestors. His father--T'CHAKA--and
Panther ancestors turning, abandoning him, and walking away. See
New Avengers #21

> **CAPTION**
> Who defied the blood...

> **T'CHAKA**
> You have no people. You are no longer my son.

PANEL 3

Flashback to T'CHALLA and NAMOR from the epilogue of Infinity.

> **CAPTION**
> Who defied his country...

> **NAMOR**
> You spent your life building a perfect
> kingdom, and now you have been cast out.

PANEL 4

Two Dora Milaje standing before an angry T'CHALLA, breaking their
spears. See Infinity #22

> **CAPTION**
> And was divided from you.

> **DORA MILAJE**
> You have lost your way, my king.

PAGE 2

PANEL 1

Big splash page. Zoom out and see several members of the Wakandan army firing wildly into a crowd of charging miners. T'CHALLA kneels, wounded, amidst the chaos. The sense should be that the soldiers have lost control of themselves. We want to allude to the Boston Massacre. This is the onset of a revolution--soldiers firing into a peaceful crowd.

V/O CAPTION
"You have lost your soul."

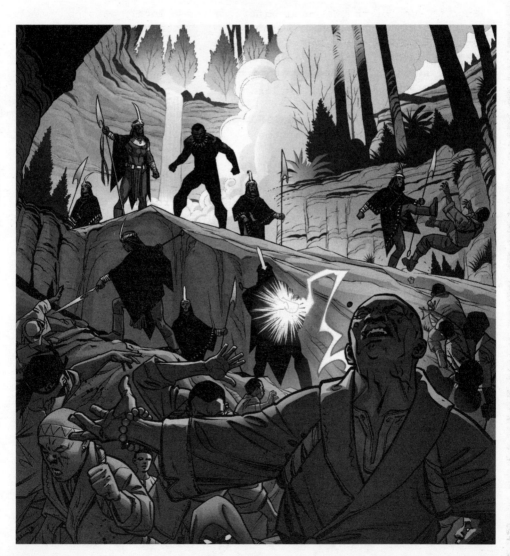

PAGE 3

PANEL 1

Shot of T'CHALLA standing up amidst the chaos.

> **CAPTION**
> I came to praise the heart of my country,
> the miners of the Great Mound. For I am
> their king and I love them as the father
> loves the child.

PANEL 2

Shot of some of the Wakandan miners at waist level, raising shovels and picks in a threatening manner. Their faces are angry. Their eyes are wild. They should look like they're under the effects of ZENZI.

> **CAPTION**
> But among my children, all I found
> was hate.

PANEL 3

Shot of WAKANDAN SOLDIER #1 firing at an angry miner. Brian, I don't know how you are imagining ZENZI manifesting her power, but we should sense that the soldier is not firing purely of his own volition. I imagined a small bright star encircling his left eye, but it doesn't have to be that. Maybe their eyes are white. I have no idea. But there should be some obvious connections between the two.

> **CAPTION**
> The hate spread.

> **WAKANDAN SOLDIER #1**
> Back, you filthy dogs! On your knees
> before your king!

PANEL 4

T'CHALLA standing fully erect now. His Black Panther mask comes over his face. This effect should be automated--it shouldn't be T'CHALLA physically pulling it over his head. Check out New Avengers #1 to see the effect I'm thinking about. Any way we can picture him glancing toward ZENZI? If we can hint at her presence that would be great.

> **CAPTION**
> And so there is war.

PAGE 4

PANEL 1

A woman stands off to the side. This is ZENZI. We should see her manifesting her power. There should be some obvious connection between her and the soldiers she's manipulating. Maybe she has the same star around her eye, if you go with that. Regardless, she should somehow look calmer than everyone else. She should almost have a look on her face of bemused mischief.

> **CAPTION**
> The hate did not rise alone.

PANEL 2

T'CHALLA leaps toward ZENZI.

> **CAPTION**
> Deceivers are loose in my kingdom.

PANEL 3

T'CHALLA tackled by two raging miners as he's trying to get to ZENZI.

> **CAPTION**
> And so the hate spreads.

> **MINER #1**
> Death to tyrants!

> **MINER #2**
> A throne for the People!

PANEL 4

More miners leap onto T'CHALLA.

> **CAPTION**
> Consuming the body of the nation.
> Dividing me from my very blood.

PANEL 5

Now T'CHALLA seems overwhelmed, buried by miners attacking him.

> **CAPTION**
> Now they call me Haramu-Fal--the orphan-king.

PAGE 5

PANEL 1

Miners go flying into the air--evidently tossed off by T'CHALLA.

CAPTION
But I have not forgotten my name.

PANEL 2

More miners flying as T'CHALLA emerges from the pile, his fist raised.

CAPTION
Damisa-Sarki--the Panther.

PANEL 3

T'CHALLA searching for ZENZI amidst the chaos. There's a melee all around him but he is seeking her out. Brian, lets try to show T'CHALLA using his supernatural senses here. I've always admired how Claremont was able to depict WOLVERINE using his heightened senses. He made it look like a real power, and I think we have a chance to do the same here.

I suggest we have T'CHALLA use his advanced senses to track something more than the physical. Every life-form has a "soul signature," which T'CHALLA can track. We want to visualize him doing this in some really cool way. T'CHALLA's "Soul-Stalker" power is the union of all his heightened senses--hearing, smell, and sight joined together into one sense that defies natural law. I think this could look really cool visualized.

CAPTION
My name is my nature. I can track a man
through wind and rain, for I stalk not
the man, but the soul itself.

PANEL 4

One of T'CHALLA's lieutenants stands behind him. This is SHAGARI, a member of T'CHALLA's inner circle. T'CHALLA is searching for ZENZI. But SHAGARI is trying to get him to pull back.

CAPTION
But the deceiver's scent is stale.

SHAGARI
My king, we must go!

PANEL 5

T'CHALLA is still looking. SHAGARI's face is adamant. He is worried about the consequences of Wakandan royalty slaughtering their own people. We see Wakandan soldiers are still firing and fighting.

CAPTION
Her power fades.

SHAGARI
Call the soldiers back, my king! We must not massacre our own people!

PAGE 6

PANEL 1

T'CHALLA waving and telling his forces to fall back. SHAGARI in the background, doing the same. Wakandans slowly recovering from ZENZI's manipulation.

CAPTION
And I must now reckon with what is loose in my country.

PANEL 2

T'CHALLA troops, all with looks of horror on their faces, having recovered from ZENZI's control.

CAPTION
The hate fades.

PANEL 3

Shot of the dead and wounded miners. Large view of the carnage. Should show the effects of massacre. Widespread carnage.

CAPTION
And we must reckon with what we have done to our own blood.

PAGE 7

PANEL 1

We cut to a shot with exteriors of the Golden City.

LOCATION CAPTION:
THE GOLDEN CITY

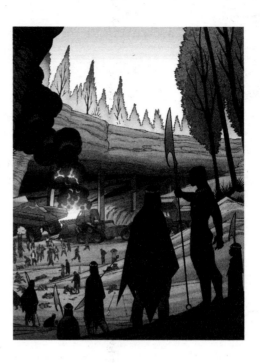

V/O CAPTION
There are no assassins among
the Dora Milaje, Mother. The
Dora Milaje are the nation.

PANEL 2

Open up to see AYO and RAMONDA.
We are in a tribunal/courtroom
of some sort. AYO is appealing
and RAMONDA is judging.

AYO
Our forces are drawn from all
the tribes, and forged into a
singular emblem of the country.
We are the blood alloy of
Wakanda itself.

PANEL 3

Pull out on the shot. Now we see ANEKA chained and RAMONDA's
face. AYO should be drawn in the same fashion as the other Dora
Milaje. She should be recognized as part of the same order that
told T'CHALLA, "You have lost your way. You have lost your soul."
ANEKA's head is shaved. She is a prisoner and bears none of
the traditional tribal paint of the Dora Milaje. RAMONDA looks
resplendent and grand--like a wise grandmother. Her face is long
and aged. She wears her long gray dreadlocks pulled back.

AYO
None know this more than Aneka, our
captain. She would die for the future of
Wakanda. She would die for our king. She
would die for you.

PANEL 4

On AYO still.

AYO
But Wakanda is in chaos, Mother. The
roads are infested with robbers. Farmers
are cut down in their own fields.
Villainy rules. Justice is a slave.

PANEL 5

On AYO. Her face intensifying. We want something reflecting her militancy. Perhaps her hand is on her spear. Perhaps she is clenching her fist.

> **AYO**
> Your daughter, our queen, has vanished.
> Our king rules from a shaky throne. No
> one is coming to save us. And so we must
> save ourselves.

PAGE 8

PANEL 1

Flashback to a greedy chief laughing at a poor family shrinking before his wrath.

> **AYO**
> The chieftain's outrages upon the girls
> of his village were known. Yet his
> lechery was unopposed.

PANEL 2

Flashback shot of ANEKA confronting the chieftain. Him laughing at her.

> **V/O CAPTION**
> Aneka spoke to him as fathers and
> brothers should have spoken long before.

PANEL 3

ANEKA hurling her spear, evidently at the chieftain, who is off panel.

> **V/O CAPTION**
> And when she was not heeded, she did
> as the honor of Wakandan fathers and
> brothers has always demanded.

PANEL 4

On ANEKA, chained.

V/O CAPTION

Aneka stood against the jackals of our
country. And for this she is branded a
murderer who must give her life.

PANEL 5

Back to a determined AYO.

AYO

Spare her, Mother. Spare her the
bastard sanction of men whose honor is
ostentation, whose justice is deceit.

PAGE 9

PANEL 1

Now on RAMONDA. Her face is stern. She betrays no emotion whatsoever.

NO DIALOGUE

PANEL 2

Same shot.

RAMONDA

No.

PANEL 3

AYO and RAMONDA in the same shot. AYO is stunned. RAMONDA is cold
as ice.

RAMONDA

You are Dora Milaje, champion of our
nation, celebrated in fables and songs.
But now you stand before me--a shield-
maiden in peasant's clothes--pleading for
some other standard.

PANEL 4

RAMONDA still.

RAMONDA

You have said it yourself--villainy
overwhelms us. And your answer to this
villainy is to turn the upholders of
Wakandan law into its flouters.

PANEL 5

Ramonda still.

RAMONDA

No. You are exemplars of our nation. And if
you will not serve in life, you will serve
in death. I take no joy in doing my duty.
But I will do it, even as others falter.

PAGE 10

PANEL 1

Cut to an establishing shot of Wakandan aircraft landing. T'CHALLA
on board, coming home. Perhaps some sort of skyline? Really, Brian,
anything you think might work.

CAPTION

For the life of her son, my mother gave
her own.

PANEL 2

T'CHALLA's men, clearly shaken, coming off the plane.

CAPTION
For the life of his nation, my father did
the same.

PANEL 3

Shot of RAMONDA worried as T'CHALLA emerges with his mask off.

CAPTION
Ramonda, my father's second wife and
widow, is as much my mother as the mother
who died for me.

PANEL 4

RAMONDA and T'CHALLA seated across from each other in a conference
room. There is a tablet in front of T'CHALLA, like an iPad or
something. This tablet is a riff on the Kimoyo Card T'CHALLA used
during Priest's run. When T'CHALLA touches it with his hand,
it projects a 3-D image of a person based on data gleaned from
T'CHALLA's Soul-Stalker power.

RAMONDA
What happened, my son?

T'CHALLA
I appealed to them to return to work. I
told them that in these times we needed
them more than ever.

PAGE 11

PANEL 1

Shot of Ramonda's face.

RAMONDA
And did they hear you?

PANEL 2

T'CHALLA using his Tech Bracelet. We should be able to see the
screen, which should say something like "Soul-Stalker Interface
Initiated." T'CHALLA is listening to RAMONDA, but he's trying to
track ZENZI by inputting data he took.

CAPTION

No.

PANEL 3

We see T'CHALLA looking at a projection coming up from the beads. The projection is of a 3-D humanoid figure. There should be some amount of data around the figure. The readable data shows the following:

CLASSIFICATION – METAHUMAN

DISCIPLINE – MENTIS DOMINUS

AURA – CHAOS

APPELLATION – UNKNOWN

CAPTION

They were listening to someone else.

PANEL 4

Back to T'CHALLA and RAMONDA both. T'CHALLA angry.

T'CHALLA

I saw her, Mother. The one who drew out this hate. She turned us against our own people. For fear of more lives lost, I let her go. But I will find her. And I will kill her for this.

RAMONDA

More death, T'Challa?

PANEL 5

On RAMONDA. No longer ice-cold. Her face has softened and is mournful.

RAMONDA

Today I upheld an execution for one of our own Adored Ones. T'Challa, it was my duty, and I would do it again. But I am not blind to what this means.

PAGE 12

PANEL 1

RAMONDA and T'CHALLA together talking.

RAMONDA
Wakanda is in strife--invasion, flood,
infiltration...

PANEL 2

RAMONDA bowing her had in sadness, or some other way to convey that
the death of her daughter, SHURI, is personal to her.

RAMONDA
Regicide.

PANEL 3

To RAMONDA and T'CHALLA now.

T'CHALLA
One cataclysm at a time, Mother.

RAMONDA
No. Focus, my son. Do you not see some
larger work in our troubles? We have had
so much of them of late. Is the smoke not
blinding us to the fire?

T'CHALLA
I saw the fire right there, in her eyes,
right when she turned innocent men
against their country.

PANEL 4

RAMONDA's face, solo.

RAMONDA
Then do what you must, T'Challa. But
don't lose yourself. You are a not a
soldier. You are a king.

PANEL 5

T'CHALLA's face, solo, perhaps eyes narrowing as her point sinks in.

OFF (RAMONDA)
And it is not enough to be the sword. You
must be the intelligence behind it.

PAGE 13

PANEL 1

Projection of the Massacre at the Mound from the Tech Bracelet.
Scene is just before the fight breaks out.

V/O CAPTION
I saw an agony in them so complete that
it eclipsed everything...

PANEL 2

Image of miners tackling T'Challa.

V/O CAPTION
Duty to country, king, even each other.
Agony over all.

PANEL 3

Soldiers and miners fighting.

V/O CAPTION
Humiliation, sadness, all agony. And then
under the agony, I saw something else...

PANEL 4

Now we see it's ZENZI narrating the events and projecting from her
bracelet.

ZENZI
Rage.

PAGE 14

PANEL 1

Now zoom out and we see ZENZI and TETU. She is briefing him.

> **TETU**
> And you encouraged that rage?

> **ZENZI**
> No. I revealed to them, in all their
> agony, their deeper, truer selves.

PANEL 2

Close in on ZENZI's face.

> **ZENZI**
> I gave them a gift. I encouraged nothing,
> for I come to Wakanda not as an exhorter,
> but as a liberator.

PANEL 3

Now TETU and ZENZI together. They are standing and beginning to
walk somewhere.

> **TETU**
> Do they still fear Haramu-Fal?

> **ZENZI**
> They have learned that there are greater
> agonies than the wrath of kings.

PANEL 4

TETU and ZENZI together, pausing.

> **TETU**
> Do the people now hate him?

> **ZENZI**
> Haven't you been listening? The Golden
> City was breached. Their children were
> drowned and burned. And Haramu-Fal did
> nothing. The people don't hate their
> king, Tetu. They are ashamed of him.

PAGE 15

PANEL 1

Now walking through a door into a hallway.

> **TETU**
> Have the auras passed?

> **ZENZI**
> The auras never truly pass. The agony was
> in me. I felt it all.

PANEL 2

Now onto a balcony.

> **TETU**
> It was the agony of labor, Zenzi. It had
> to be done. It was the agony of birthing
> our new nation.

PANEL 3

Now a shot of TETU's soldiers--the Sun Touchers--below the balcony, with TETU and ZENZI looking on.

> **TETU**
> For out of the rage shall come another
> Wakanda, and a better and brighter world.

PAGE 16

PANEL 1

We see ANEKA alone in her cell, looking despondent.

LOCATION CAPTION: THE GOLDEN CITY

PANEL 2

An explosion.

> **(BOOM! or some such)**
> **NO DIALOGUE**

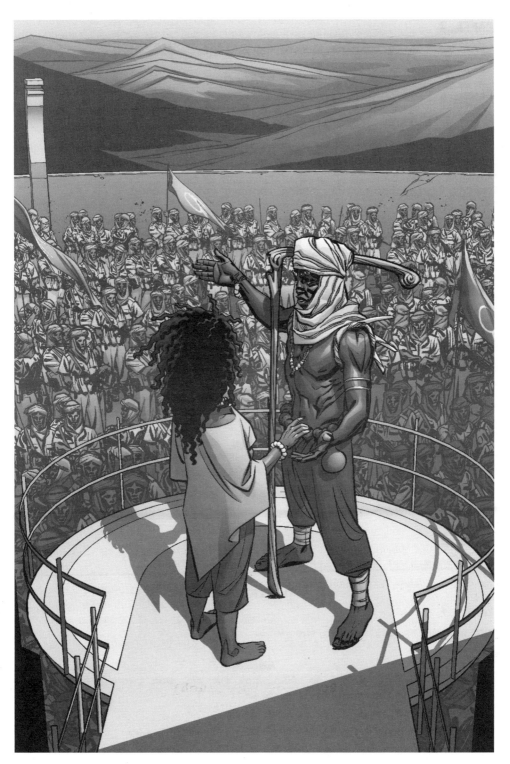

PANEL 3

Wakandan guards running toward explosions.

NO DIALOGUE

PANEL 4

ANEKA looking up, curious.

NO DIALOGUE

PANEL 5

Guards flying backwards. ANEKA looking out, shocked.

NO DIALOGUE

PAGE 17

PANEL 1

AYO, in the Midnight Angel armor, rushes forward. Big panel.

PANEL 2

AYO aiming a cannon at the door. ANEKA protesting.

> **AYO**
> Back away.

> **ANEKA**
> Ayo, no. Don't do it.

> **AYO**
> Back away.

PANEL 3

ANEKA shielding herself as the door explodes.

NO DIALOGUE

PANEL 4

AYO and ANEKA talking in the cell.

> **ANEKA**
> Ayo, don't do this. Not for me. Don't
> throw it away, Beloved.

PANEL 5

AYO looking longingly at ANEKA. Maybe touching her face or clasping her hand?

NO DIALOGUE

PANEL 6

Shots from behind them. ANEKA shoving AYO out of the way.

ANEKA

Ayo, down!

PAGE 18

PANEL 1

Hole blown through the prison wall. AYO standing and returning fire.

NO DIALOGUE

PANEL 2

AYO looking down, horrified. ANEKA unconscious.

NO DIALOGUE

PANEL 3

AYO, looking pissed, now attacks the remaining guards.

NO DIALOGUE

PANEL 4

AYO tossing one guard with one hand and smashing another into a wall.

NO DIALOGUE

PANEL 5

AYO thrashing another guard.

NO DIALOGUE

PANEL 6

AYO, with ANEKA in her arms,
flying off.

NO DIALOGUE

PAGE 19

PANEL 1

Cut to: a camp scene in the
wilderness. ANEKA is sleeping
on a pallet. AYO is looking out.
The Midnight Angel armor is to
the side.

NO DIALOGUE

PANEL 2

AYO looking down at ANEKA.
Love and concern should be
conveyed here.

NO DIALOGUE

PANEL 3

ANEKA wakes up. AYO is smiling, happy to see this.

NO DIALOGUE

PANEL 4

ANEKA sits up a little.

ANEKA
I knew it was you. It only could have
been you.

AYO
I tried their way, Beloved.

PANEL 5

On AYO and ANEKA now.

ANEKA

I know. And now they are going to kill us both.

AYO

They were going to kill us both anyway. When they condemned you, dear heart, they condemned me.

PAGE 20

PANEL 1

AYO maybe looking off. Something to convey thoughtfulness.

AYO

A part of me is already dead.

ANEKA

And what part is that?

AYO

The part of me that was Dora Milaje. The part of me that once lived for our king. Wakanda is falling, Beloved. Not even Damisa-Sarki can save us.

PANEL 2

ANEKA and AYO, clasping hands.

AYO

Does he even care, Aneka? Did he ever care?

ANEKA

Does it matter? Has it ever mattered?

PANEL 3

The two kiss here. Should be tender and human.

NO DIALOGUE

PANEL 4

Now ANEKA standing, looking resolved.

ANEKA
Ayo, they are going to kill us, so I
shall speak as my dead self, which is my
best self. I am tired of living and dying
on the blood-right of one man.

AYO
No one man should have that much power.

PANEL 5

AYO loading herself into the Midnight Angel armor. ANEKA with a
spear, ready for battle.

ANEKA
I knew it was you, Beloved. Only you
would be so mad as to steal the Midnight
Angel prototype.

AYO
Both prototypes.

ANEKA
Yes ... Both prototypes ... Well then ...
Ring the alarm. Come ruin and wrack...

PANEL 6

Both AYO and ANEKA now armed and ready to go.

ANEKA
At least we'll die with harnesses on our back.

PAGE 21

PANEL 1

Cut to: Exterior shot of the City of the Dead.

LOCATION CAPTION: THE CITY OF THE DEAD

NO DIALOGUE

PANEL 2

T'CHALLA, mask off, descending into the City of the Dead.

CAPTION
How long must I be divided from my own people?

PANEL 3

Shot of Wakandans viewing footage of the Massacre at the Mound on their smartphones.

CAPTION
From my country...

PANEL 4

Flashback of T'CHALLA leaving SHURI behind and the Black Order closing in.

CAPTION
From my own blood...

PANEL 5

T'CHALLA at a computer, working. There is a screen in front of him showing the physiology of a female. In red there we see the following words: RESUSCITATION FAILURE. T'CHALLA looking pained.

PAGE 22

PANEL 1

Big splash panel here of SHURI in the Living Death. She is petrified--literally--and chained. She looks defiant and ready to fight.

CAPTION
How long must I be parted from you?

END.

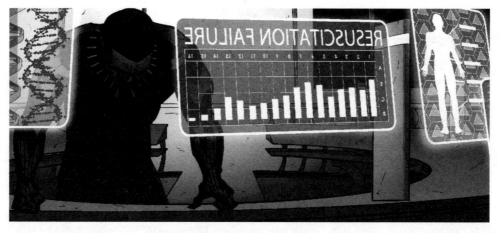

BLACK PANTHER

BLACK PANTHER
ISSUE #2
2016

"A Nation Under Our Feet -- Part Two"

By Ta-Nehisi Coates

Art by Brian Stelfreeze
and Laura Martin

PAGE 1

PANEL 1

We open with a projection from a Wakandan Tech Bracelet into the air. We can see T'CHALLA's council around him. On the projection we see ERIK KILLMONGER addressing a group of Nigandans. HODARI, who is now T'CHALLA's intelligence chief, is giving the briefing. We can see RAMONDA, SHAGARI, and AKILI, who leads the Hatut Zeraze, along with a few others seated around the table.

LOCATION CAPTION: THE GOLDEN CITY

HODARI
It began with Killmonger's final act of treachery. The Nigandans were the key.

PANEL 2

We focus in on the projection and see several Nigandans chained to tables in a lab being exposed to KILLMONGER's attempt to manufacture meta-humans. Their faces are pained.

HODARI
Power was what Killmonger promised them. Power to crush Wakanda and bring all of Africa to its knees.

PANEL 3

We see KILLMONGER's troops executing the Nigandans. Brian, if we don't want to use guns, I'm fine with that. Though we might consider guns to draw a distinction between KILLMONGER's people and T'CHALLA's.

V/O CAPTION
And when it seemed Killmonger's genius had failed him, he blamed these same Nigandans.

PANEL 4

Just as ZENZI is about to be killed, her power manifests.

V/O CAPTION
In fact it was not Killmonger's genius that failed him.

PANEL 5

We see several of KILLMONGER's soldiers start going mad and shooting each other, as ZENZI manipulates them.

V/O CAPTION
It was his patience.

PAGE 2

Brian, there are a lot of panels on this page, I know. I think it's important to show the factions among T'CHALLA"s counsel, while at not getting bogged down here. I want to get to the action as quickly as possible. It's okay to use a number of panels for conversation, while using fewer panels on the action pages to let them breathe.

PANEL 1

HODARI finishing.

HODARI
Killmonger is dead. Still, his creation haunts Wakanda. It was this creation that twisted our men, and angled them toward massacre.

PANEL 2

T'CHALLA now projecting a map of Wakanda with the approximate location of ZENZI marked off. RAMONDA objecting.

T'CHALLA
I have tracked her to the frontier, at the edges of the Wakandan border. I will go alone.

RAMONDA
No, T'Challa. You are king. If you fall ... Should anything happen to you, Wakanda will rupture.

PANEL 3

AKILI and SHAGARI.

AKILI
Our queen mother is right, my king. The Hatut Zeraze cannot allow it. Had we been at the Mound...

T'CHALLA
Akili, I was there. This is not a fight that can be settled by mere arms. It was by our very arms that we fell upon our own people.

PANEL 4

RAMONDA looking concerned. T'CHALLA dead serious.

RAMONDA
And why will you, alone, fare any better?

T'CHALLA
Because I've fought those who would control the mind before. I am prepared. Our soldiers are not.

PANEL 5

Same headshot but with the Black Panther mask coming over T'CHALLA.

T'CHALLA
The blood of my people is on my hands. I shall bring this woman to heel. And no psychic trick will save her.

PAGE 3

PANEL 1

CUT TO: Exterior night scene of a compound somewhere in Wakanda.

LOCATION CAPTION: COMPOUND OF WAKANDAN SEX TRAFFICKERS

V/O CAPTION
Thandiwe, when they come for you, do not scream.

PANEL 2

We focus in tight on the frightened faces of two women peering through the bars of a cage. THANDIWE is a young girl of about sixteen. MBALI is an older woman. She could be THANDIWE's grandmother. We can see other caged women in the shadows.

> **MBALI**
> Do not plead. Do not cry, for your cries are but song to them.

> **THANDIWE**
> Yes, Nana.

PANEL 3

Traffickers approaching the cage from a distance. We can still see the cages and the shadows of the women.

> **MBALI**
> Be strong, Daughter. We must live, Thandiwe. You must live.

> **THANDIWE**
> Nana, I...

PANEL 4

Zero in on TRAFFICKER #1 grabbing THANDIWE by the neck. WOMAN #2 looks terrified.

> **THANDIWE**
> Nana! Help me! Save me from them!...

> **TRAFFICKER #1**
> Don't worry, girl. I will save you. And I promise plenty of "saving" for your Nana, too.

PAGE 4

PANEL 1

AYO, in armor, crouching on top of the cage. She is holding her staff horizontally in both hands.

> **AYO**
> And how will you save them, Mjinga...

PANEL 2

AYO leaps into the fray, striking TRAFFICKER #1 with her club.

AYO
...when you cannot even save yourself?

TRAFFICKER #1
Uhhkk!

PANEL 3

AYO dispatching TRAFFICKER #2 while dodging a blow from TRAFFICKER #3.

AYO
Vermin and vultures!

PANEL 4

TRAFFICKER #4 opens fire with a machine gun on AYO from behind. Bullets bounce off her.

AYO
Feeding amidst the decay of your own country!

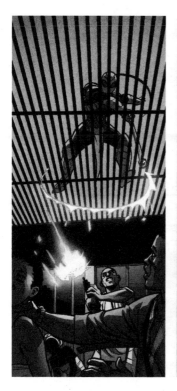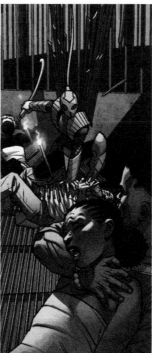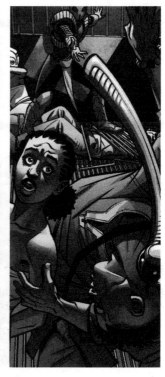

PAGE 5

PANEL 1

AYO grabs TRAFFICKER #4 by the neck. TRAFFICKERs #5, #6, #7, and #8 are rushing in.

> **AYO**
> But though the Golden City cowers at your approach...

PANEL 2

AYO tosses TRAFFICKER #5 into #6 and #7.

> **AYO**
> By the Orishas, I swear it...

PANEL 3

AYO delivers a vicious head-butt to TRAFFICKER #8.

> **AYO**
> Wakanda has not yet died!

PANEL 4

AYO looking at TRAFFICKER #9. TRAFFICKER #9 looking back.

> **NO DIALOGUE.**

PANEL 5

TRAFFICKER #9 runs.

> **NO DIALOGUE.**

PAGE 6

PANEL 1

AYO looks toward the woods.

> **AYO**
> Too easy, Beloved.

PANEL 2

ANEKA walks out holding her spear.

> **ANEKA**
> Perhaps.

PANEL 3

ANEKA now next to AYO, looking off into the distance.

> **ANEKA**
> And perhaps not.

PANEL 4

Traffickers gathering around them.

> **AYO**
> Do you suppose they can be reasoned
> with, Beloved?

> **ANEKA**
> I think not, Beloved.

PANEL 5

Shot of AYO readying her club.

> **AYO**
> Good.

PAGE 7

PANEL 1

CUT TO: MBALI kneeling before AYO and ANEKA. Head bowed in thanks.
Other women standing around. Cages broken.

MBALI
Praise the Goddess. You have delivered us.
Praise you. Our Daughters of the Dark.

ANEKA
This is but the first trial, Mother.
Death's shadow still hangs over us all.

PANEL 2

THANDIWE is angry. Her face is a mixture of tears and rage.

THANDIWE
I don't care if we die. Make them pay!
Make all the jambazi pay for what they
have done to us!

PANEL 3

ANEKA, AYO, and THANDIWE in the shot. ANEKA is touching the
girl's cheek.

ANEKA
You deserved so much more, Little Flower.
You deserved a Wakanda that cherished you.

AYO
But this is the Wakanda we have. And
while the Midnight Angels breathe, I
swear to you...

PANEL 4

Now onto a pile of the bodies of the traffickers whom AYO and
ANEKA have killed. We see scrawled along the wall of the largest
hut in the compound "NO ONE MAN." Check out Jason Aaron's story
"See Wakanda and Die." Think of the last panel: "This is what you
get when you invade Wakanda." That's what we're going for. Should
almost be a tribute.

V/O CAPTION
They shall all pay.

PAGE 8

PANEL 1

CUT TO: AYO and ANEKA in the wilderness at the campsite. Embracing
affectionately on a pallet. AYO looks distracted.

> **AYO**
> It is a big country, Beloved. A big,
> unruly country filled with jambazi
> and corrupt chieftains, many of them
> operating right under the royal eye.

> **ANEKA**
> When you stole the armor and freed me, I
> assumed you had a plan.

PANEL 2

AYO stands, dressing. ANEKA still on the pallet.

> **AYO**
> Yes, a plan...

> **ANEKA**
> You did not think past the prison, did you?

PANEL 3

ANEKA sitting. AYO kneeling next to her.

> **AYO**
> I thought past the prison, but only of you.

PANEL 4

ANEKA stands, dressing.

> **ANEKA**
> Your sweet words can't save you now,
> Beloved. We'll need something more.

PANEL 5

ANEKA and AYO in the shot. ANEKA using a Wakandan Tech Bracelet. The two of them look at a projected map of Wakanda with targets marked. Most of the targets are obscured. Here are the ones we can see:

N'Cada Sarki, Order of the Knife

Amal Sharrief, the Ninth Jihad

Mobutu, the Lord's Conquering Lions

M'Baku, the White Gorilla Army

 AYO
 What is this?

 ANEKA
 This, Beloved, is a plan.

PAGE 9

PANEL 1

Exterior shot establishing a base for the Sun Touchers at the
northwestern edge of the country.

 CAPTION
 When I was boy, my Uncle S'Yan ruled in
 my stead.

PANEL 2

Two of the People's guards on patrol. T'CHALLA lands behind them in
the shadows, crouching.

 CAPTION
 And when I was of age, he stood aside
 as I was crowned. He did this happily.
 Too happily.

PANEL 3

T'CHALLA takes out one guard with a leg-sweep.

 CAPTION
 I believed his happiness a mask for
 intrigue and scheme. Only with the crown
 upon my head did I come to understand.

PANEL 4

T'CHALLA takes out the other.

 CAPTION
 The proverb does no justice to the weight
 of the nation, of its peoples, its
 history, its traditions.

PAGE 10

PANEL 1

Now other guards see T'CHALLA and attack.

> **CAPTION**
> The day after I became king, S'Yan
> offered a single piece of wisdom.

PANEL 2

T'CHALLA dodges their fire and engages them in hand-to-hand combat.

> **CAPTION**
> Power lies not in what a king does, but
> in what his subjects believe he might do.

PANEL 3

T'CHALLA fighting the guards while they hang on to him. One guard
is around his neck.

> **CAPTION**
> This was profound.

PANEL 4

T'CHALLA now using one arm to throw one guard off and his elbow to
crack another.

> **CAPTION**
> For it meant that the majesty of kings
> lay in their mystique...

PANEL 5

Finishes them off and finds himself facing a big, muscular dude.

> **CAPTION**
> Not in their might.

PAGE 11

PANEL 1

T'CHALLA tries to rush this guy.

CAPTION

Every act of might diminished the king,
for it diminished his mystique.

PANEL 2

The guy grabs him.

CAPTION

Might exposed the king's powers and thus
his limits. Might made the king human.

PANEL 3

He starts pounding the hell out of T'CHALLA.

CAPTION

Breakable.

PANEL 4

More pounding. But T'CHALLA looks like he's "powering up."

CAPTION

And so some amount of my might I have
kept from the world, allowing legend and
myth to fill in the gap.

PAGE 12

PANEL 1

T'CHALLA releases an incredible kinetic charge!

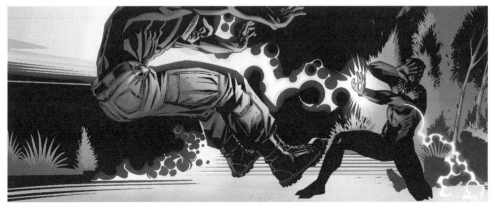

CAPTION
For what the people know not is the true
power of kings.

PANEL 2

Guy goes flying through the camp and through a large building in
the center.

CAPTION
My uncle S'Yan is dead now. Murdered by
another king.

PANEL 3

T'CHALLA following the guy.

CAPTION
I loved him. But I wish he'd told me not
just of the power of kings, but of the
might of the people.

PANEL 4

T'CHALLA finds him in a room full of children and the elderly.

CAPTION
I wish he'd warned me that they, too,
have secrets.

PAGE 13

PANEL 1

T'CHALLA's Soul-Stalker power now kicks in. And he sees ZENZI, who
is hooded, with her back turned to him.

CAPTION
They, too, hold mysteries.

PANEL 2

T'CHALLA approaches gingerly. Her head is turned.

CAPTION
They, too, possess a power all their own.

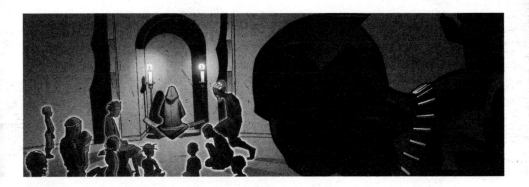

PANEL 3

T'CHALLA still walking, getting closer. ZENZI's back is still turned.

<div align="center">

T'CHALLA
Do not try to get in my head, witch.

</div>

PANEL 4

Closer now. ZENZI removing her hood.

<div align="center">

ZENZI
But why trifle with your head, my king...

</div>

PANEL 5

ZENZI turns toward T'CHALLA. Her eyes are on fire.

<div align="center">

ZENZI
When I can so easily devour your heart?

</div>

PAGE 14

PANEL 1

Exterior shot of Azzaria. This is the town where Wakanda's best university--Hekima Shule--is located. Largely because of the university, Azzaria has a vibrant cultural life and is a breeding ground for the sages and wise men of Wakanda. It is also a breeding ground for democratic dissent. The town is named for the Black Panther's grandfather, AZZARI THE WISE. Perhaps we should have some sort of statue of him?

> **OFF (CHANGAMIRE)**
> "The injury and the crime is equal, whether committed by the wearer of a crown, or some petty villain..."

PANEL 2

Now into a classroom. We see CHANGAMIRE reading from a text, walking amongst his seated students.

> **CHANGAMIRE**
> "Great robbers punish the little ones to keep them in their obedience, but the great ones are rewarded with laurels and triumphs..."

PANEL 3

CHANGAMIRE still walking among students.

CHANGAMIRE

"Because they are too big for the weak hands of justice in this world, and have the power in their possession, which should punish offenders..."

PANEL 4

CHANGAMIRE closes the book and looks up at the class.

CHANGAMIRE

"What is my remedy against the robber, who so broke into my house?"

PANEL 5

Students now gathering their things to leave.

SOUND EFFECT

(Some sort of bell here signaling the end of class)

CHANGAMIRE

Think about Locke for tomorrow, students. How should the weak marshal justice against the powerful?

PANEL 6

CHANGAMIRE gathering his things.

OFF (TETU)

How should one do such a thing, Baba?

PAGE 15

PANEL 1

Again, a lot of panels here, Brian. Sorry about this.

TETU standing at the edge of the class. CHANGAMIRE looking down, still gathering his things.

CHANGAMIRE

When you left the university to join the shaman, Tetu, I did not expect to continue to see so much of you.

PANEL 2

TETU and CHANGAMIRE.

> **TETU**
> Science or mysticism. The search for
> knowledge, Baba, never ends.

> **CHANGAMIRE**
> Is knowledge all you seek?

> **TETU**
> Is that not enough?

PANEL 3

TETU and CHANGAMIRE.

> **CHANGAMIRE**
> Do you believe it is enough? These days
> I hear tales of your associations with
> brutal men sworn to the knife.

> **TETU**
> What I do, I do for a better country.

> **CHANGAMIRE**
> And is that enough? Once, I thought you
> were better than that. Why did you come
> here, Tetu?

PANEL 4

TETU and CHANGAMIRE.

> **TETU**
> I came to talk, Baba.

> **CHANGAMIRE**
> Did you? Or did you come for the
> sanctification of an old man?

> **TETU**
> I have founded an order that fights
> to protect Wakandans, while our king
> slaughters them. Or have you not heard?

> **CHANGAMIRE**
> I have.

PANEL 5

Now TETU standing and walking out.

> ### TETU
> And? Can you answer your own question?
> I need no blessing for what comes next.
> But I thought the sage Changamire might,
> by now, have seen some other answers.
> Instead I only hear more questions.

> ### CHANGAMIRE
> The questions are the point. You never
> understood that. And your answer, what
> you think is an answer, is simply
> another question.

> ### TETU
> Perhaps. But staying here, shut up
> in thought and abstraction--that is
> unconscionable. How do you live here,
> knowing your people are dying? How long
> will they plunder our people while we
> stand aside and look?

PANEL 6

CHANGAMIRE looking intense.

> ### OFF (TETU)
> What is my remedy against the robber, who
> so broke into my house?

PAGE 16

PANEL 1

T'CHALLA, kneeling down. No Panther mask on. Maybe, like, ethereal feet around him. Brian, I talked with Wil about this series of panels and we'd like something in the background to make sure people know that T'CHALLA is not in the real world. Wil suggested a burning, almost hellish backdrop, or even having the ancestors zombified as opposed to healthy. I like the idea of burning, I think. But if you have something else, please feel free to do it. We just need people to know that this isn't the real world, that it's a place of torment for T'CHALLA. Make sense?

> **CAPTION**
> Nothing here is real.

PANEL 2

SHURI in Panther garb, standing over T'CHALLA. Mask on.

> **CAPTION**
> And yet everything here matters.

PANEL 3

SHURI angry, pointing at T'CHALLA. Panther mask off.

> **CAPTION**
> That a thing is unreal does not make
> it untrue.

> **SHURI**
> How could you do it, T'Challa?

PANEL 4

SHURI, in full Panther garb, kicks T'CHALLA.

> **SHURI**
> How could you leave me?!?!

PAGE 17

PANEL 1

SHURI knees T'CHALLA.

CAPTION
This is the truth of what I believe.

SHURI
You are no king!

PANEL 2

T'CHALLA on his knees, looking defeated.

CAPTION
The truth of what I feel, whenever I hear my name.

SHURI
You are a fool, T'Challa!

PANEL 3

T'CHALLA looks out and sees T'CHAKA, SHURI, and ancestors condemning him.

CAPTION
I have lost my way. I have lost my very soul.

PANEL 4

T'CHALLA's Soul-Stalker power reveals an absence of soul-signatures among the ancestors.

CAPTION

To get back, I must see beyond myself, beyond my deepest truths.

PANEL 5

Ancestors now fading before T'CHALLA's Soul-Stalker power. Other soul-signatures appearing before T'CHALLA.

CAPTION

To get back, I must see things not as I feel them to be, but as they are.

PAGE 18

PANEL 1

Back to reality. T'CHALLA being kicked by Sun-Touchers.

CAPTION

I was wrong. My enemy is not a beguiler, but a revealer.

PANEL 2

T'CHALLA rises up, angry.

CAPTION

She brings out of us all the awful feelings that we have hidden away.

PANEL 3

T'CHALLA begins beating on soldiers.

> **CAPTION**
> And makes them manifest.

PANEL 4

T'CHALLA physically beats the rest of them.

> **CAPTION**
> So I know now that this is who I am--
> Might. Shame. Rage.

PAGE 19

PANEL 1

T'CHALLA looks out and notices he's in the same room with the kids and elders.

> **CAPTION**
> And now they know too.

PANEL 2

T'CHALLA pauses among the violence. The mercenaries have all been defeated. Mask comes off. T'Challa wants his people to see him.

> **T'CHALLA**
> Your king will provide for you. These men are responsible for crimes against your country.

PANEL 3

T'CHALLA speaking.

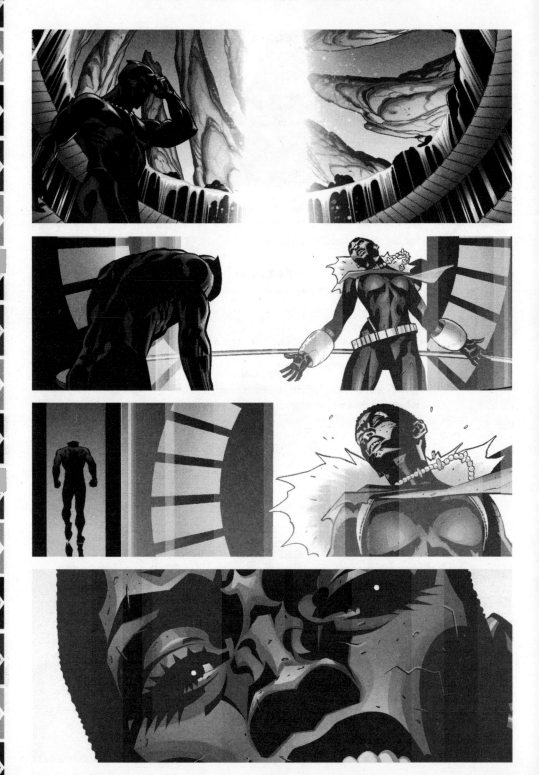

T'CHALLA
These men will be brought to justice. You
will be provided for.

PANEL 4

Shot of the faces of children--fear.

PANEL 5

Shot of the elders--Anger. Focus in on an OLD WOMAN.

OLD WOMAN
These men were providing for us.

PANEL 6

Shot of T'CHALLA's face. What we need to convey here is subtle. He
is disappointed in himself. But he can't show this. Perhaps angst?
Frustration?

NO DIALOGUE

PAGE 20

PANEL 1

Exterior shot establishing the City of the Dead.

NO DIALOGUE

PANEL 2

T'CHALLA looking at SHURI in the Living Death.

NO DIALOGUE

PANEL 3

T'CHALLA walking away.

NO DIALOGUE

PANEL 4

Hard focus on SHURI.

NO DIALOGUE

PANEL 5

Hard focus on her eyes.

NO DIALOGUE

PAGE 21

PANEL 1

Still focus on SHURI's face. But now human, not petrified. Eyes closed. Looks at peace.

NO DIALOGUE

PANEL 2

Open up, reveal SHURI appearing to meditate.

NO DIALOGUE

PANEL 3

SHURI now opens her eyes. Face still at peace.

NO DIALOGUE

PANEL 4

Shot of SHURI with a woman's hand on her shoulder.

> **SHURI**
> Mother ... Where are we?

PANEL 5

Zoom out to reveal SHURI with a GHOSTLY RAMONDA seated next to her.

> **GHOSTLY RAMONDA**
> Where else, Daughter?

PAGE 22

PANEL 1

Huge, broad portrait of Djalia. Appears to be ancient Wakanda. Maybe have ancient Wakandans building things. Up to imagination. But SHURI and GHOSTLY RAMONDA are looking out on the country.

> **GHOSTLY RAMONDA**
> Home.

WORLD OF WAKANDA (2016) BY ROXANE GAY

AN INTRODUCTION BY **ANGÉLIQUE ROCHÉ** IN CONVERSATION WITH **ANDREW SUMNER**

It's interesting looking at how Roxane Gay approaches her scripts—one of the things I asked her was, "you've written prose, you've done journalism. Are there certain types of story or narrative structure that work better for comics versus prose?" For Roxane, she familiarized herself with the structure of comics and with the genre, but she believes that the general rules of storytelling apply no matter what. Roxane's coming from a short-story-writing and essay-editing background. She really came to these scripts saying that you always want to leave the reader wanting more. With Roxane's scripts you get longer lines of dialogue, but you don't get a lot of dialogue. There is a lot of subtext, and these scripts have elements that you haven't seen in Wakanda stories before—the politics of human attraction, and the internal conflict that happens within women when they are defining who they are, defining what they will do, and what they will sacrifice in order to be the best.

The coolest thing about Roxane Gay is that she loves literature. She also loves pop culture. And Roxane Gay is a teacher. A lot of people forget that she taught at Purdue University—and a lot of people also forget that she really understands the anatomy of fiction. She has spent a lifetime loving and analyzing pop culture and stories. One of the coolest things about Roxane is that she can look at a script and say, "this is the strength, and this is the weakness. This is what I want to see more of."

When Roxane approached *World of Wakanda*, her thought was, "I knew I wanted women to be in love, and I wanted to tell a romance story. I wanted them to be strong, I wanted them to be whole people, and I didn't want a man to have to save them." Prior to writing *World of Wakanda*, Roxane had never read a contemporary super hero comic book. She was a huge *Archie* fan as a kid, she knows about the movies, and she absolutely loves

YA novels like *Sweet Valley High*. That's where she was when Ta-Nehisi Coates sent her an email, reached out and said, "Hey, man, you want to write for Marvel?"

Roxane attacked the assignment in the way she knew how—she immediately said to herself, "I know how our story is supposed to be told. I know the good and bad elements of a story. Let me try to do this in the way I know how." So what we're seeing in these scripts is Roxane bringing in the point of view that she's brought to her essay work, to her pop culture journalism, and to the prose work she's created with novels like *An Untamed State*. She's able to really bring that in—and you can see straight off the page that her two scripts are very different. Roxane is far more used to non-super hero comic books. Whether for good or for bad, that is very reflective in her *World of Wakanda* writing.

And that's why you see these very strong statements being made throughout these scripts, and not a lot of exposition. There's hardly any exposition in there at all, in my personal opinion. There's an understanding that there's no need for Roxane to have to explain things, there should be an inherent truth within the story. Both of these scripts are quite declamatory in tone, quite emphatically written with an academic style, almost as if a historian from Wakanda is telling you the story, a historian with the privilege of being the person that is creating a first-hand document that is going to be the primary source that, one day, a future historian will create their lectures from.

What I see in these scripts is Roxane creating a history that did not exist before this, but with a tone as if it has always existed. History is a science, and Roxane is able to chronicle this story in a way that is very much like a science. I also believe that her position is that the truths in this narrative can stand alone, that this world of Wakanda does exist. And that's the beauty of storytelling in such an authentic way, and the beauty of bringing the troops in to ground the story. Because I do feel like this

Roxane Gay story is very grounded.

It's very grounded in the reality of young women who want to be the best of the best, it's very grounded in a love that you're not always ready for. You can't choose when love is going to happen; you don't get to say, "I'm going to fall in love with this person on this day." But these scripts also make these characters real. They give them the ability to love and be loved, without the necessity for excuses or the necessity to hide.

From the very beginning there's an intent in both Roxane's dialogue and in Alitha E. Martinez's wonderful accompanying art to imbue the Dora Milaje with real strength. It was also Roxane's intent with these scripts to fully develop them as whole people with whole lives and different personalities, who are also a group of warriors. That was a fresh development because we would previously see separate members of the Dora Milaje in different Marvel stories. I love the fact that Roxane Gay is writing these fleshed-out characters, and that she also considers 'What is the definition of strength? How does that work?' because in her narrative, these young women ultimately become their own heroes and their own saviors.

And that is a patently Roxane Gay narrative that complements Ta-Nehisi's work really well, because Ta-Nehisi really is illustrating an over-arching country mood, and Roxane applies a more granular treatment, defining a strength that is very different, that isn't as physical as that presented by her male *Black Panther* colleagues. The fleshed-out elements of these scripts invest the reader in character-driven aspects of Wakanda that we haven't previously been given an opportunity to discover. That's something I really love about Roxane Gay's writing: she treats every character as if they have a purpose.

BLACK PANTHER

BLACK PANTHER:
WORLD OF WAKANDA
ISSUE #1
2016

"Dawn of the Midnight Angels -- Part One"

By Roxane Gay

Art by Alitha E. Martinez
and Rachelle Rosenberg

SPLASH PAGE

TEXT:

Originally assembled to keep peace among Wakanda's 18 rival tribes, the Dora Milaje served as personal bodyguards and potential wives for Black Panther and the royal family. Every organization, though, must evolve and that time has come for the Dora Milaje.

IMAGE:

In the center of the page, various members of the royal family across generations and posed around them, members of the Dora Milaje looking fierce. It would be great to draw the women with body diversity, all staring outward with determination and heads held high.

PAGE 1

PANEL 1

An image of Upanga, the Dora Milaje headquarters, a modern, imposing building with huge front doors. In front of the doors stands ZOLA, a woman in her early '50s, thick, solid, strong, very tall, salt and pepper hair, shaved on the sides, long on top. (Check out Panel 3 for a description of a big scar she has.) Standing next to her, ANEKA. At the foot of the stairs, 18 new recruits standing in three rows of six, one from each of Wakanda's tribes. Among them, AYO and FOLAMI. (We'll eventually learn that Folami is the daughter of the chieftain who Aneka is on trial for killing in BLACK PANTHER #1.)

> **CAPTION**
> A new generation of Dora Milaje stand
> ready to serve.

PANEL 2

Inside Upanga, the new recruits sit inside a small amphitheater with smooth stone benches. At each woman's feet, a pair of Wakandan fighting sticks, a blanket roll with necessities, and the Dora Milaje initiate uniform.

> **ZOLA**
> Welcome to your training as women and
> warriors of the Dora Milaje. You are
> the best of our people, but you are not
> yet good enough. Here, we will make you
> better. In your service to Black Panther,
> you will become the best.

PANEL 3

Zola points to a long, jagged scar on the left side of her face that runs down the length of her face, her neck, and her chest.

ZOLA
Your service will require sacrifice. Your service will take from you more than you think you can give, and yet give you will, beyond all imagining.

PANEL 4

Zola turns to Aneka, who stands tall, looking imposing and impervious.

ZOLA
I leave them in your capable hands. Put them through their paces. Make them better.

PAGE 2

PANEL 1

Aneka points her fingers at the recruits, seated, backs erect, staring back. There can be different expressions on their faces--pride, defiance, nervousness, awe.

ANEKA
You are here to learn to serve, to fight, to be fierce, to be fearless. From this day forward, excellence is your only option. Let us begin. Rise and follow me.

PANEL 2

The initiates standing in three rows of six, in a different room in Upanga--a large room with different training areas. In the center of the room, a fighting ring. In one corner, a series of targets against a wall. In another corner, a jagged climbing wall. In the third corner, climbing ropes dangling from the ceiling. In the fourth corner, a series of strategy games on small tables.

> **ANEKA**
> This is where you begin to learn what it really means to be a part of the Dora Milaje.

PANEL 3

Ayo, standing in the first row, with a smirk on her face.

> **AYO**
> I must say, this does not look like much. I will not learn to be fierce and fearless in such a silly room.

PANEL 4

Aneka standing right in front of Ayo, staring her down.

> **ANEKA**
> You are nothing more than a beautiful village girl and you presume to think this space, that has forged hundreds of Dora Milaje, doesn't look like much?

PAGE 3

PANEL 1

Ayo, staring defiantly back at Aneka

> **AYO**
> All I see are games for children, trifles really.

> **AYO (thought bubble)**
> Beautiful???

> **ANEKA (thought bubble)**
> Beautiful???

PANEL 2

Aneka striding to the fighting ring as the initiates make way for her.

PANEL 3

Aneka, motioning with one hand for Ayo to join her, a small smile on her face.

PANEL 4

The other initiates lined up around the ring. Above, in an observation gallery, we see Zola, looking down, a frown on her face, her arms across her chest.

PANEL 5

Aneka and Ayo standing in the center of the ring, staring at each other.

> **ANEKA**
> If games are what you see, a game we shall play.

> **AYO**
> As you wish. I can spare a few moments for a good game.

PAGE 4

PANEL 1

Ayo crouches in a fighting stance. Aneka stands tall and still.

> **AYO**
> You should know, my father raised me the way he raised my brothers--to fight without mercy. No matter how this ends, I will hurt you.

PANEL 2

Ayo has moved closer to Aneka, her fingers now curled into fists. Aneka smiles.

PANEL 3

Ayo swings at Aneka who calmly arches her back to the right, missing the blow.

PANEL 4

Ayo swings at Aneka, again, frustration lining her face. Aneka dodges the blow again.

> **ANEKA**
> I hope your brothers are not as hopeless as you.

PAGE 5

PANEL 1

Ayo lunges at Aneka. Aneka strikes Ayo in the throat.

PANEL 2

Ayo falls to her knees, clutching her throat, gasping for breath.

PANEL 3

Ayo, still on her knees, looking up at Aneka, rage in her eyes. The other initiates stare at Aneka, awestruck.

> **ANEKA**
> Now, let the training begin.

PANEL 4

The initiates dispersed to the corners of the room, engaging with the various training stations. Aneka is staring up at the observation gallery, where she sees Zola staring down, disapproving.

> **ANEKA (thought bubble)**
> I did what I had to do. The defiant among these girls must be broken before they can be built into what Wakanda needs them to be.

PAGE 6

PANEL 1

The initiate barracks at Upanga, a large room with nine sets of bunk beds. Toward the middle of the room, Ayo is on a lower bunk. In the bunk next to her, Folami.

CAPTION
Later that evening.

FOLAMI
How is your throat?

AYO
Fine. Just fine. That woman won't get the
better of me ever again, captain or not.

PANEL 2

Same scene, only now Folami is sitting up, on the edge of her bed.

FOLAMI
Have you learned nothing from being
humbled so?

AYO
Oh, I was not humbled. I misjudged Aneka,
but I was not humbled.

PANEL 3

In the Dora Milaje living quarters, a small seating area. Aneka and
Zola sit across from each other in comfortable chairs, holding mugs
of tea.

ZOLA
Your behavior today was out of character.
It is not my place to chastise you, but
did you need to humiliate that young woman?

ANEKA
The mere sight of her gets under my skin.
She was insolent, insulting.

PANEL 4

Same scene.

ZOLA
Was she? Or was she simply new, nervous,
full of bravado and trying to impress?
Was she, perhaps, a bit like you when you
first came to Upanga?

ANEKA
I was nothing like that. Nothing at all.

ZOLA
Your memory, my dear, fails you.

PAGE 7

PANEL 1

The animosity between Ayo and Aneka has only grown, but most of the initiates have come along nicely in their training.

In the training room, in the fighting ring, Ayo and Aneka face off, each holding a pair of Wakandan fighting sticks, about four feet in length, slender cylinders coming to sharp points on both ends.

CAPTION
Weeks later.

ANEKA
I hope you are prepared to be humbled once more.

AYO
You could never humble me. Know that.

PANELS 2-?? (THE REST OF THE PAGE)

In a series of images across the page, show Ayo and Aneka sparring with the fighting sticks. Up to you how to stage it, Alitha!

PAGE 8

PANEL 1

Ayo jabs Aneka in the breastbone and Aneka falters, holding her fighting sticks across her chest defensively.

PANEL 2

Ayo throws one of her fighting sticks into the air and kicks at Aneka's calves.

PANEL 3

Aneka falls to the ground. Ayo catches the fighting stick she threw into the air.

PANEL 4

Ayo holds the point of one of her fighting sticks at Aneka's throat.

> **AYO**
> It looks like it is you who is humbled,
> after all.

> **ANEKA**
> You have learned nothing from your
> training. You are still so tender,
> so green.

PANEL 5

Aneka grabs Ayo's fighting stick and pulls Ayo to the ground.

PANEL 6

Aneka straddles Ayo, smiling, holding her initiate's fighting stick
against her throat. In the corner of the training room, we see
Folami watching intently.

> **ANEKA**
> I believe today's lesson has been learned.

PAGE 9

PANEL 1

In her observatory looking over the training space, Zola stands, looking at a data projection of stats for the initiates projected from her Kimoyo/Tech Bracelet.

PANEL 2

Zola speaks into her Kimoyo/Tech Bracelet.

> **ZOLA**
> Folami, please come see me on the observation deck. Immediately.

PANEL 3

Folami stands at attention before Zola who still has the data projection of initiate stats up on the screen.

> **FOLAMI**
> You wanted to see me?

> **ZOLA**
> You are not progressing as well as your fellow initiates. Your fighting skills are awkward. You don't put the necessary effort into your strength training. I do not know that you have what it takes to be part of the Dora Milaje.

PANEL 4

Folami puts her hands on her hips, eyes narrowed.

> **FOLAMI**
> I may not be the best fighter or the strongest woman here, but I know things. And I know I belong here.

PANEL 5

Zola closes the distance between her and Folami, looking right into the initiate's eyes.

> **ZOLA**
> What is it you know?

> **FOLAMI**
> I know Nailah adds a powder from her village to everything she eats and drinks and that's why she is the strongest among us. I know Lulu sneaks into the training center after lights out to practice the strategy puzzles so she can do them faster during the day. Everyone here does something to get ahead.

PAGE 10

PANEL 1

Same scene.

> **ZOLA**
> It appears that you know quite a bit more than I would have guessed.

> **FOLAMI**
> I also know our captain always has her eyes on only one of us, that there is a weakness in her.

PANEL 2

Zola presses a finger against Folami's lips.

> **ZOLA**
> You know a great deal, Folami, and there may be use for you here after all. But you do not yet know what should be shared and what you should keep to yourself. Do I make myself clear?

> **FOLAMI**
> You have made yourself as clear as I hope I have made myself.

PANEL 3

Zola has stepped a few feet back, an eyebrow arched. Folami stands with her arms loosely at her sides.

ZOLA

From now on, you will train directly with me. And stop skulking around spying on women who have been trained to kill. That course of action will not end well for you.

PANEL 4

Folami holds a hand over her heart.

FOLAMI

As you command, Mistress Zola, so it shall be.

PANEL 5

In the elevator, descending from the observation deck, Folami leans against the wall, looking smug.

FOLAMI (thought bubble)

By the time I'm done, I will know everything about these women. They may be trained to kill, but I will be trained to do much more.

PAGE 11

PANEL 1

A hallway in Upanga. Ayo and Aneka approaching each other from opposite directions.

PANEL 2

Ayo and Aneka, only inches apart.

<div align="center">

ANEKA

You have nothing better to do than roam the halls?

AYO

I could ask the same of you.

</div>

PANEL 3

Ayo tries to walk away and when she is just past Aneka, Aneka grabs Ayo's wrist.

<div align="center">

ANEKA

Don't walk away when I am speaking to you.

</div>

PANEL 4

Ayo has turned around now, and is pressing Aneka against the wall.

<div align="center">

AYO

Why do you care if I walk away?

ANEKA (thought bubble)

Because even if it is mere moments, that will be too long before I see you again.

ANEKA

I don't. I care that you respect my authority.

</div>

PAGE 12

PANEL 1

Outside of the shot, the sound of others coming. I'm not sure how to show this but I hope you know how. Ayo still pinning Aneka against the wall.

PANEL 2

Aneka cupping Ayo's chin with her hand. The sound of others, still outside the shot, but getting louder.

> **ANEKA**
> You are maddening. Your disrespect drives me to distraction.

> **AYO**
> You just can't stand that I am better than you ever were.

PANEL 3

Ayo turns her face so that her lips are pressed against the inside of Aneka's wrist. She rests a hand on Aneka's waist.

PANEL 4

Before Aneka can respond, they realize they will only be alone for seconds longer. Ayo and Aneka running in opposite directions, each thinking, in thought bubbles, "What just happened?"

PAGE 13

PANEL 1

I am visualizing something like a split screen.

Ayo in her bunk, staring up. Aneka in her quarters, staring out the window, toward the initiate barracks.

> **CAPTION**
> Later that evening.

PANEL 2

Ayo sneaking out of the initiate barracks.

> **AYO (thought bubble)**
> What in all the heavens' names am I doing?

PANEL 3

Aneka standing at her door, her hand on the doorknob.

PANEL 4

Aneka sitting down, her back against the door.

ANEKA

I am a captain of the Dora Milaje. I will
not be broken by an initiate still wet
behind the ears. She is nothing to me.
The softness of her skin is nothing to
me. Her eyes are nothing to me.

PANEL 5

Ayo knocking on Aneka's door, but there is no answer. Sadness on
both women's faces.

PAGE 14

PANEL 1

Aneka leads a unit of six Dora Milaje, including Ayo and Folami, on
a mission for T'Challa.

The unit, standing silently outside of a building where they
suspect an Atlantean spy sent to Wakanda by Namor is holed up,
Aneka in first position, Ayo right behind her, Folami at the rear.

CAPTION

Three months later.

ANEKA

We were supposed to be on a training
mission, but T'Challa needs us to find
Namor's spy before he makes trouble for
our people. I hope it was not a mistake
bringing you initiates.

AYO

We are as up to this mission as you,
Captain.

PANEL 2

The unit inside the building where the spy is hiding out, having
located him. Folami, kneeling, using tools to pick the lock of the
door between the unit and the spy. The rest of the women, alert,
weapons at the ready.

PANEL 3

The unit, with the spy's hands shackled together, running out of the
building, where they are met by two mercenaries, firing at them. A
bullet grazes Aneka on her right arm. There is blood and a small wound.

ANEKA
I knew this was going too well.

AYO
Are you intimidated by a challenge?

ANEKA
Absolutely not. But I am responsible
for your lives and bringing this man to
T'Challa. I take that seriously and so
should you.

PANEL 4

The women seek cover behind the wall enclosing the courtyard (maybe
five feet in height) they are in. Ayo grabs the captive and holds a
knife between his legs, against his inner thigh.

AYO
How many men in total are we facing?

PANEL 5

The spy is silent, so Ayo moves her blade closer to his crotch.

AYO
You do not want to test me. You are far
more attached to what's between your legs
than I. How many men are we facing?

PAGE 15

PANEL 1

The captive smiles, revealing dirty teeth.

> **SPY**
> You poor lambs have been led to the slaughter. There is so, so much you don't know. King Namor is about to change your world in ways you cannot imagine. I am here with two other men but many more are coming. Many, many more...

> **ANEKA**
> Namor will find nothing but regret if he interferes, in any way, with Wakanda. You underestimate the royal family, the Wakandan people, and the woman holding her blade to your body.

PANEL 2

Ayo, looking at Aneka as bullets fly past the six women huddled defensively, but alert, behind the courtyard wall, maybe five feet tall.

> **AYO**
> If he says there are two other men with him, then there are at least twice as many.

> **ANEKA**
> Mmmm. It's good to see you thinking soundly in such unsound circumstances.

PANEL 3

Ayo peers over the wall and nods to Folami.

> **AYO**
> I count four of these ragged mercenaries.

> **FOLAMI**
> Five. There is a man behind that truck too stupid to realize we can see his feet.

PANEL 4

Everyone looks at Folami with newfound respect and they prepare to act.

PAGE 16

PANEL 1

Two of the initiates hold their vibranium shields in front of them as they run from behind the wall to draw fire.

PANEL 2

Folami and another initiate flank the captive while Ayo runs toward the truck behind which one of the mercenaries is hiding. Aneka holds a spear high over her head, aimed at the four men firing at the group.

PANEL 3

Aneka launches her spear and it divides into four separate spears.

PANEL 4

Each of Aneka's spears lands in one of the mercenaries.

PANEL 5

With her Wakandan fighting sticks out, Ayo quickly dispatches the man behind the truck.

PANEL 6

Ayo is standing in the truck bed, holding her sticks high above her head, looking victorious.

> **AYO**
> T'Challa, Queen Shuri, we will bring
> Namor's spy to you and we will break him!

PAGE 17

PANEL 1

Aneka surveys the scene and motions for Folami and Nailah to come out with the spy.

> **SPY**
> This is a petty victory. There are so
> many more of me throughout your beloved
> country and we will find where T'Challa
> and the Avengers are hiding. We will end
> them and all of you.

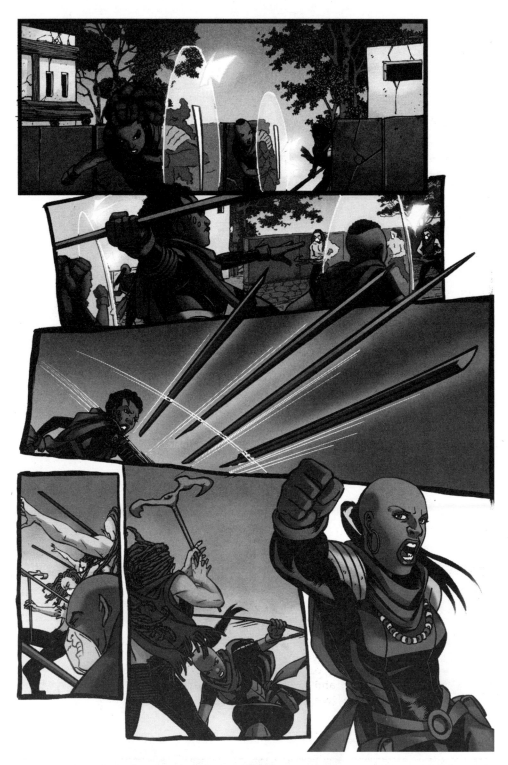

ANEKA
We should be on our way before any more of
his incompetent friends show up. We will
deal with whatever is going on at Upanga.

PANEL 2

Aneka falters, and slumps to the ground.

PANEL 3 & 4

Ayo jumps out of the truck bed and kneels at Aneka's side.

PANEL 5

Ayo applies a bandage to Aneka's wound, looking concerned, tender.

AYO
You should take better care of yourself.
We can ill afford to lose our captain.

ANEKA
I didn't know you cared.

PANEL 6

Ayo helps Aneka to her feet and holds the captain gently as the
unit heads back to Upanga.

AYO
There is a lot you do not yet know
about me.

ANEKA
Yet?

PAGE 18

PANEL 1

It is the Dora Milaje initiation ceremony in an ornate ceremonial chamber, deep below Upanga. The eighteen initiates kneel in a circle. Zola stands in the center of the circle, on a small stone platform. She is wearing a ceremonial robe and holding a pair of Wakandan fighting sticks in her hands, crossed over her chest. On an even higher platform, Queen Shuri sits in a stone throne.

> **ZOLA**
> When we first met, I said you were not yet good enough. Now, standing in this circle, you have been made better, through our training, through your strength of will. May both be with you as you serve Wakanda and the royal family.

PANEL 2

Zola points the fighting sticks toward the ground.

> **ZOLA**
> Though it may not always feel that way, the journey upon which you now embark will be the greatest honor of your life. There is only one thing left for me to say: Rise to the occasion.

PANEL 3

The initiates stand in line to receive their facial tattoos. Shuri stands, holding her arms open wide, her palms facing the ceiling.

> **SHURI**
> Now you will be marked, forever, as women warriors of the Dora Milaje. You honor your country, your people, with your service. You are marked so that all you encounter, for the rest of your lives, will know of your honor.

PANEL 4

We see Ayo receiving her tattoo, her face and limbs relaxed. Aneka watches, intently, her eyes watering slightly.

PANEL 5

On their Tech Bracelets, the initiates receive their new

assignments. Ayo will be joining T'Challa's personal guard. Folami will be joining Ramonda's personal guard in the Golden City.

PAGE 19

PANEL 1

A celebration in the Upanga courtyard--festive, lights strong across the space, wine, fruits, roasted meats, members of the Dora Milaje old and new milling about.

PANEL 2

Aneka stands and raises a glass.

> **ANEKA**
> A toast. From this moment forward, we
> fight together, we work together, we
> learn together...

PANEL 3

Aneka shifts her gaze, looking directly at Ayo.

> **ANEKA**
> And we love together.

PANEL 4

Everyone raises their glasses. Ayo looks back at Aneka.

> **ALL ASSEMBLED**
> Together!

PANEL 5

Folami, as usual, standing apart, watching as the women around her celebrate. There is an inscrutable expression on her face. A smirk? A frown?

PAGE 20

PANEL 1

Water begins to flood the courtyard and the rest of Wakanda as Namor tries to destroy The Golden City. [Make sure we can see Namor in this panel.]

PANEL 2

Aneka and Ayo rush toward one another, instinctively.

> **ANEKA**
> We must move, quickly!

PANEL 3

> **ZOLA**
> Warriors of Wakanda, stay calm. Climb to the
> roofs of these buildings around us. Climb!

PANEL 4

The Dora Milaje climbing to safety on the roofs of the barracks and living quarters. Ayo and Aneka helping Zola.

PANEL 5

The Dora Milaje, staring out at the destruction around them, hands curled into tight fists, still defiant. Ayo and Aneka standing next to each other, looking at each other, their fingers almost touching. Folami, watching Ayo and Aneka. Zola, watching them all.

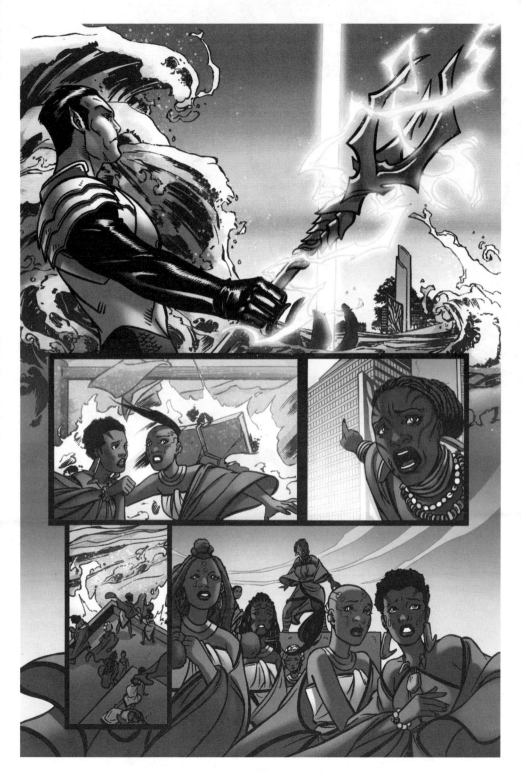

BLACK PANTHER

BLACK PANTHER: WORLD OF WAKANDA

ISSUE #2
2016

"Dawn of the Midnight Angels -- Part Two"

By Roxane Gay

Art by Alitha E. Martinez,
Roberto Poggi and Rachelle Rosenberg

SPLASH PAGE

TEXT:

Originally assembled to keep peace among Wakanda's 18 rival tribes, the Dora Milaje served as personal bodyguards and potential wives for Black Panther and the royal family. Every organization, though, must evolve and that time has come for the Dora Milaje.

IMAGE:

In the center of the page, various members of the royal family across generations and posed around them, members of the Dora Milaje looking fierce. It would be great to draw the women with body diversity, all staring outward with determination and heads held high.

PAGE 1

PANEL 1

ESTABLISHING SHOT OF THE POST-DISASTER WAKANDAN CITYSCAPE

PANEL 2

<div align="center">

Caption:
In the aftermath of Namor's destruction,
the Dora Milaje help to rebuild the
Golden City.

</div>

Ayo and Aneka and several other members of the Dora Milaje, including Folami, work on a small residential alley in the Golden City, cleaning debris and searching for bodies in the aftermath of Namor's flood.

PANEL 3

Ayo kneels over the fallen bodies of a woman and her young child.

<div align="center">

AYO
We cannot let this stand.

</div>

PANEL 4

Aneka stands behind the kneeling Ayo, her hand on Ayo's shoulder.

<div align="center">

ANEKA
I assure you, we will not.

</div>

PANEL 5

Ayo stands, facing Aneka.

> **AYO**
> We should be doing more than this. We
> should be hunting Namor down. What he has
> done to this city cannot go unanswered.
> We cannot show our enemies weakness.

> **ANEKA**
> We are doing important work in all our
> service to Wakanda and her royal family.
> You must be patient, my young, fiery
> friend. Our country is strong and the
> world knows it, even now.

PAGE 2

PANEL 1

Ayo backs away from Aneka, eyes blazing.

> **AYO**
> I am not young and I would not presume to
> be your friend. Leave me alone. Go. Go do
> more of your good work and let me do mine.

PANEL 2

Aneka stares at Ayo, hurt.

PANEL 3

Aneka walks away while Ayo stares after her.

> **AYO (thinking)**
> Why do I always say the exact opposite
> of what I mean to when I am around that
> woman?

PANEL 4

The Dora Milaje continue working their way down the street.
Survivors of the flood mill around, thanking the women for their
work and pitching in where they can.

PAGE 3

PANEL 1

ESTABLISHING SHOT OF UPANGA

PANEL 2

Caption:
Later that evening, at Upanga, Aneka
meets with Zola in her quarters.

ANEKA
There is much work to still be done,
but at least the rotten stench of the
dead will soon leave this city, if not
my memory.

ZOLA
I know it was not easy to do the work
of clearing the dead, but it was good,
necessary work nonetheless.

PANEL 3

Aneka frowns.

ANEKA
Ayo continues to resist authority.
Everything I say makes her snap at me.
I swear, the woman has fangs and those
fangs are forever exposed.

ZOLA
Is it authority she resists? Or
something else?

PANEL 4

Aneka takes a sip of tea.

ANEKA
I have no idea what you mean.

PANEL 5

Zola looks at Aneka, an eyebrow raised.

ZOLA
You can continue to look past the truth if you must, but eventually you will have to face it. In the meantime, I am assigning the two of you to Shuri. I am assigning Folami and Dalia to Ramonda.

ANEKA
Interesting choice for Folami.

ZOLA
Folami is talented but troubled and troubling. I hope that through service to the queen's mother, she might learn to temper the quiet rage that cloaks and will someday choke her.

PAGE 4

PANEL 1

Aneka standing, staring out of a window, fidgeting with the hem of her blouse.

ANEKA
I thought Ayo and I were supposed to serve T'Challa. That is what we prepared for.

ZOLA
It is not like you to question me.

PANEL 2

Aneka, sitting back down.

ANEKA
I am not questioning you. I just ... I am restless.

ZOLA
It would seem Ayo has gotten under your skin, in more ways than one.

PANEL 3

Aneka, sitting straighter, a harder look in her eyes.

ANEKA

Nothing of the sort. I was just surprised at the change. It is an honor to serve Queen Shuri and we will be excellent in our work.

ZOLA

I know this to be true, my dear. I do.

PANEL 4

Aneka, standing outside of Zola's quarters.

ANEKA (thinking)

This change in our assignment is not what it seems. Something is ... amiss. What is T'Challa up to?

PAGE 5

PANEL 1

Shuri (in her Black Panther outfit, minus the hood) is presiding over a dedication ceremony for the newly rebuilt Hall of Letters.

Ayo and Aneka stand only inches behind Shuri on the right and left, watching over the queen. Gathered before her are hundreds of Wakandans, cheering.

PANEL 2

Shuri raises one arm, the palm of her hand facing the crowd. She is smiling but her eyes are dark.

> **SHURI**
> It has been two months since the Golden City was devastated by Namor's floods.

PANEL 3

> **SHURI**
> Outsiders thought they could destroy this golden city in this proud country. They thought that with water, they could wash away our people, our history, our pride. Today, as the Hall of Letters opens its doors once again, we show the world that Wakanda is unbroken, and unbowed.

PANEL 4

The crowd cheers and people start coming forward to greet Shuri. Ayo and Aneka stand, alert.

PANEL 5

A Wakandan protester forces his way through the crowd, holding a worn picture of a woman, an intense look in his eyes.

PAGE 6

PANEL 1

Ayo notices the protester, who now has his hand reaching into his overcoat.

PANEL 2

Ayo and Aneka look at each other, nodding in unspoken agreement.

> **ANEKA**
> Yes, I see him too. Keep an eye out
> for others.

PANEL 3

Ayo and Aneka each place a hand on Shuri's shoulder, pulling the queen back just as the protester lunges toward the queen with a dagger in his hand.

PANEL 4

Ayo and Aneka step in front of Shuri, pulling their fighting sticks from holsters on their backs. Shuri remains calm and smiling as Wakandans come up to her to greet her and pay their respects.

PAGE 7

PANEL 1

Ayo and Aneka each grab the protester. Ayo twists the protester's arm until the dagger falls from his hand

PANELS 2 & 3

Aneka twists her right wrist and a blade emerges from the tip. Ayo slips behind the protester.

PANEL 4

Aneka holds the blade to the protester's throat. His eyes widen in surprise.

> **ANEKA**
> Where do you think you're going, brother
> of Wakanda?

> **PROTESTER**
> I must speak with the queen! There are
> things she should know, needs to know
> about her kingdom, her brother.

PANEL 5

Ayo twists the protester's arms behind his back, holding him steady. The protester is still holding the worn photo tightly in his hand.

AYO

And why, pray tell, have you brought a dagger to the conversation? Is your mind not sharp enough?

PROTESTER (shouting)

Look at all we have lost! Namor's flood was brought here by Wakanda's very hand!

PANEL 6

ANEKA

We will deal with this elsewhere.

Ayo and Aneka slip away from the crowd with the protester in custody, the protester shouting incoherently.

PANEL 7

Two more members of the Dora Milaje appear behind Shuri, who remains regal, calm, greeting her people.

PAGE 8

PANEL 1

Below Upanga, the protester sits in a stark interrogation room while Ayo, Aneka, and Zola stand in the next room, watching him through two-way glass. Behind them, three floor-to-ceiling data screens. On one screen, the image of the protester. On another, images of known terrorists and mercenaries with eyes on Wakanda [Chris and Wil will get you names and reference for the terrorists and mercenaries]. On the third, red dots marking the locations of all active Dora Milaje [use the map of Wakanda for this].

PANEL 2

Same scene, but with the three women now looking at the data screens.

> **AYO**
> Our enemies sense weakness in Wakanda.
> Now, even our own people sense weakness.
> I told you this months ago and here we
> are!

> **ANEKA**
> Wakanda is a great nation. By our very
> nature, and the resources we have, we
> will always have enemies. Right now,
> people are unsettled but the more time we
> put between ourselves and the flood, the
> better things will be.

> **AYO**
> I do not share such confidence, my
> captain.

PANEL 3

In the interrogation room, the protester is agitated, trying to stand but his feet are chained to the floor.

PANEL 4

The protester looks toward the two-way glass.

> **PROTESTER**
> You have no right to hold me here. I am a
> citizen of Wakanda!

PAGE 9

PANEL 1

Zola points to the protester.

> **ZOLA**
> Ayo, you must remain calm, especially
> now. I want the two of you to go in
> there and learn what you can. Clearly,
> something troubles this man, and I want
> to know what that is.

PANEL 2

In the interrogation room, Aneka sits on the table before the
protester, one leg crossed over the other while Ayo stands on the
other side, snarling.

> **ANEKA**
> You know who we are. You know what we
> are capable of. You know that in this
> country, and in this room especially, you
> demand nothing.

PANEL 3

The protester opens his hand and the worn photo falls to the table.

PANEL 4

The protester carefully smooths out the edges of the photo, holding
the corner with his thumb.

> **PROTESTER**
> This is my wife ... I held onto her as
> long as I could and then my body failed
> me and she slipped away and without this
> picture all I would remember is the look
> on her face as she was swept away by
> Namor's flood.

PAGE 10

PANEL 1

Aneka looks down at the photo and covers the protester's hand with
her own.

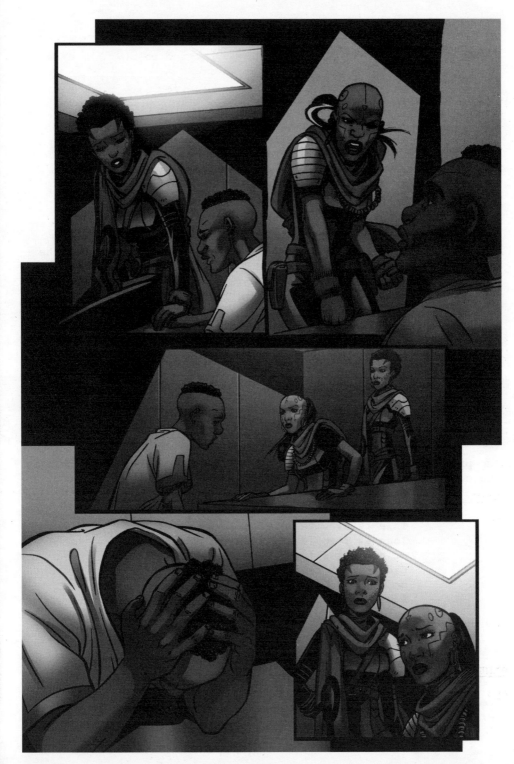

ANEKA

I am sorry for your loss. I am so sorry for your loss. Far too many beloved ones were lost in those waters.

PANEL 2

Ayo slams her hand down on the table.

AYO

I am not the sentimental one. I will not insult your grief but I do insist on knowing why in one hand you held a picture of your wife and in another, a blade you were not afraid to bare before our queen.

ANEKA

Forgive my colleague's demeanor but do know you will need to answer her question.

PANEL 3

Ayo sits across from the prisoner and Aneka stands behind her.

PROTESTER

This is all T'Challa's fault. I was not trying to harm Queen Shuri. I was trying to get her attention. She should know that her brother will ruin us all. He has already ruined me.

PANEL 4

The protester leans on the table, his head in his hands

PROTESTER

Instead of preparing to become king, T'Challa is preoccupied with the Avengers. He has allowed them into our country and so he has allowed their enemies into our country. What Namor wrought upon us is just the beginning.

PANEL 5

Ayo and Aneka look at each other, worried.

PAGE 11

PANEL 1

Back in Zola's office, Ayo, Aneka and Zola stand, looking at the protester through the two-way mirror.

ZOLA
This man is no danger to anyone but himself. He is blinded by grief and he is not without good reason.

AYO
But there is truth to what he says. The Avengers are not doing Wakanda any favors and T'Challa should be here, helping to rebuild the golden city!

PANEL 2

Aneka places a firm hand on Ayo's shoulder.

ANEKA
We serve the royal family. We serve T'Challa. Wherever he is, is where he needs to be. We must trust in that.

PANEL 3

Ayo brushes Aneka's hand away.

AYO
Are we to trust blindly? Are we to pretend it is mere coincidence that Namor tried to destroy our country only after the Avengers built a presence here?

PANEL 4

Aneka leans into Ayo, a hard look on her face.

ANEKA
You forget your place, dear Ayo.

PANEL 5

Ayo stands, arms crossed over her chest as Aneka and Zola stare at her.

ZOLA
Before the two of you say things you will
later regret, let me put an end to this. I
will let this protester go with a warning.
Ayo, you will remember that you have much
yet to learn. Aneka, you will remember
that you must lead with firm patience.

PAGE 12

PANEL 1

In a courtyard outside of Upanga, Ayo and Aneka stare at each other
angrily.

AYO
How dare you call me dear when you try
to undermine me in front of Zola? I grow
weary of your games.

ANEKA
Undermine you? Games? I was protecting
you from yourself, you foolish woman. We
are here to serve. We are women T'Challa
could marry when he becomes king. We do
not question his decisions.

PANEL 2

Ayo closes the distance between her and Aneka, their noses
practically touching.

AYO
I am many things but I am not foolish.
And I will serve, Captain, but I will
never marry the king. What antiquated
nonsense. And ... frankly, I am surprised
you would consider such a thing.

PANEL 3

Ayo rubs her thumb across Aneka's lower lip.

PANEL 4

Ayo and Aneka kiss, passionately.

PANEL 5

Aneka pulls away while Ayo clasps her wrist.

ANEKA
Ayo, you are a beautiful kind of trouble.
If I don't walk away now I am likely to
surrender to you completely and that
terrifies me.

AYO
You drive me mad, but what makes you
think I would let you walk away now that
I have had a taste of you?

PAGE 13

PANEL 1

Caption
The next morning

In Ayo's quarters, Ayo lies in bed, covered by a sheet. Aneka
stands by the window, staring outside.

ANEKA
To love you would be to turn my back on
the service I have given my life to.

PANEL 2

Ayo sits up in bed, holding the sheet against her chest.

 AYO
 Would that be a bad thing? Am I ... a bad
 thing?

PANEL 3

Aneka is still standing by the window, but now she is looking at Ayo.

 ANEKA
 You are a very good thing, the best thing.
 But we are supposed to offer ourselves in
 service to the king in all ways. I don't
 know if I can make you understand.

 AYO
 I don't want to understand. I want you.

PANEL 4

Aneka stands over Ayo and kisses her forehead.

 ANEKA
 Right now I hate myself for it, but I
 want you too. I ... I have to go.

PANEL 5

Ayo stares after Aneka, one tear running down her face.

PAGE 14

PANEL 1

Ayo is doing push ups on her floor when her Tech Bracelet pings.

PANEL 2

Aneka, sitting alone on a bench in a hallway within Upanga, also gets a ping on her Tech Bracelet.

PANEL 3

Ayo and Aneka meet in the hallway just outside of Zola's office.

 ANEKA
 Zola needs to see us and no doubt there
 will be work to do. But we must be
 professional around others. I am your
 captain. I have no business getting ...
 intimate with you.

PANEL 4

Ayo backs away from Aneka, her eyes flashing angrily.

> AYO
> Are you ashamed of loving me?

> ANEKA
> Did you not hear the things I said to you
> last night? Did you not feel how my hands
> met your skin? There are expectations of
> me, of us, as Dora Milaje and for now,
> we must keep this beautiful new thing
> between us until I figure out how we can
> serve Wakanda well and love each other
> well. I just need to ... figure this out.

PANEL 5

Ayo shakes her head.

> AYO
> I will heed your judgment in this, but
> let us be clear: what is between us is
> not new. What is between us is not wrong.
> And I am not a patient woman.

PAGE 15

PANEL 1

In a conference room in Upanga, four Dora Milaje are seated around a long oval table, including Ayo and Aneka. Zola sits at the head of the table.

> ZOLA
> The four of you are to go to Necropolis,
> where you will serve and protect
> T'Challa, effective immediately. You are
> to leave in two hours. Serve him well.

PANEL 2

The four Dora Milaje nod. Ayo and Aneka lean in to one another.

> **AYO**
> I hope, finally, we will do something
> useful, though I do not understand why
> we are going to Necropolis. That place is
> a wasteland.

> **ANEKA**
> Everything we do is useful, Ayo.

PANELS 3 & 4

Ayo and Aneka in their separate quarters packing for their new mission.

> **AYO (thinking)**
> I would not admit this to her, but I hope
> I will always serve by Aneka's side

> **ANEKA (thinking)**
> I will not tell her and I should not feel
> this way but I am grateful Ayo will be my
> side, through whatever comes next.

PANEL 5

At the entrance to Upanga, with their fighting sticks and a small
bag each, Ayo and Aneka look out into the distance.

> **AYO**
> I very much want to hold your hand but
> because I cannot, in this moment, know
> that the want is there, burning inside me.

> **ANEKA**
> We will serve T'Challa. That is what must
> burn inside us, for now.

MARVEL'S BLACK PANTHER—SCRIPT TO PAGE

PAGE 16

PANEL 1

Caption
In Necropolis...

T'Challa stands outside of a building in Necropolis, his arms across his chest. Ayo, Aneka and two other Dora Milaje stand before him.

T'CHALLA
Greetings, Adored Ones. I thank you for coming all this way.

ANEKA
You already know me and I am joined by three of our best--Ayo, Nailah, and Onyeka. How may we be of service, your highness?

PANEL 2

T'Challa points toward the building they are standing near.

T'CHALLA
My work here is complicated, delicate, treacherous. I need you to stand by my side because I cannot do this work alone. There is no one I trust more than you.

AYO
What is this work? I see the Avengers' fingers on whatever is going on here.

ANEKA
Ayo...

PANEL 3

T'Challa throws his head back and laughs. He holds his hands open.

T'CHALLA
You are as keen as a freshly sharpened blade. You must trust that my work here is for a greater good, not only for Wakanda but for the world.

PANEL 4

Ayo looks skeptical while Aneka frowns. Nailah and Onyeka stand quietly.

> **T'CHALLA**
>
> Just past these doors, Namor waits for me. I need two of you to join me inside and two of you to stand guard here.

PAGE 17

PANEL 1

The Dora Milaje stare at T'Challa with a range of expressions on their faces--shock, anger, worry. Ayo gets in T'Challa's face even though he is taller.

> **AYO**
>
> Surely you have misspoken, T'Challa. Namor has no business being alive in Wakanda. Give me the word, and he will breathe no longer.

> **ANEKA**
>
> It is not our place to question you, T'Challa, but ... what is the meaning of this? How is this possible?

PANEL 2

T'Challa waves a hand and rests a firm hand on Ayo's shoulder.

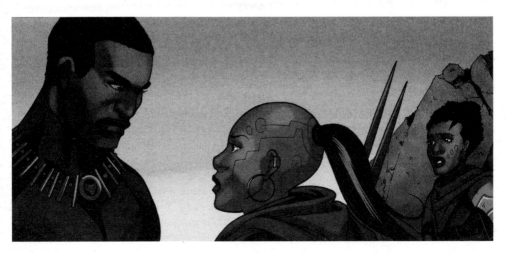

T'CHALLA

There are matters at work here, greater than Wakanda, greater than all of us. I take no pleasure in having Namor within the borders of our country but for now, there is no other choice. There are times when our enemies must become allies.

PANEL 3

Aneka now standing next to Ayo, pulling her away from T'Challa.

ANEKA

We do trust you, T'Challa. Ayo speaks impulsively at times, but she is the best of the Dora Milaje.

T'CHALLA

I know this to be true. You are all the best of the Dora Milaje. Now I must speak with Namor and you must do as I have asked. I leave my life in your hands.

PANEL 4

T'Challa enters the building, followed by Nailah and Onyeka-- Namor is visible in the background, drinking wine [see New Avengers #2 reference].

PANEL 5

Ayo looking angrily at Aneka as they flank the door, standing guard.

AYO

I am not impulsive. I am right, that this is wrong. This is what you torment yourself for? This is why you won't love me freely?

ANEKA

You cannot take issue with my words. I was trying to help you. And now is not the time to talk.

AYO

I do not need your help if that means following you blindly following T'Challa. I do not need anything from you.

PAGE 18

PANEL 1

Thanos and his crew attacking the Golden City as Wakandans try to escape the devastation.

PANEL 2

The Golden City, in the aftermath of Thanos's attack--smoking buildings, destruction everywhere, dead Wakandans in the streets.

PANEL 3

Ayo and Aneka, and other Dora Milaje, again working to clean up the Golden City. They are tired, dirty, determined.

> **AYO**
> How many times must we close the eyes
> of dead Wakandans before we stand up to
> T'Challa? First Namor, and then we did
> nothing when T'Challa colluded with him.
> Now Thanos has tried to ruin our country.
> T'Challa is so busy saving the world he
> has forgotten that it is Wakanda in need
> of saving.

> **ANEKA**
> I do not know. I am so tired. I fear I
> know nothing anymore.

PANEL 4

Ayo takes Aneka's hand and kisses the inside of her wrist.

> **AYO**
> Lean on me. Stop fighting me. Stop
> fighting what you feel for me out of a
> misguided devotion to a man who is not
> worthy of you, of me, of any of us.

PAGE 19

PANEL 1

Shuri confronts T'Challa about what he has been up to in Necropolis.

> **Caption**
> In Necropolis...

SHURI
What have you been doing in this place?

T'CHALLA
Necropolis does not concern you, sister.
What happens here is of no matter to
the kingdom.

PANEL 2

Four Dora Milaje surround T'Challa and Shuri--Ayo, Aneka, Nailah
and Onyeka. Ayo stands in a line followed by Aneka, Nailah and
Onyeka as T'Challa and Shuri speak.

AYO
Lies! He lies, Queen Shuri!

T'CHALLA
How dare you?

PANEL 3

Aneka steps forward and breaks her spear over her knee.

ANEKA
We loved you more than our lives, my
king ... but no more. You have lost your
way. You have lost your soul. You have
forgotten what it is to be a son of
Wakanda.

PANEL 4

Ayo, Nailah, and Onyeka break their spears, too.

PANEL 5

The Dora Milaje make a semi-circle around T'Challa, holding their
broken spears in their hands.

ANEKA
I am loyal to Wakanda, T'Challa. I have
trusted you, but I too see that we can
trust you no longer. You were not there
as we cleaned the dead bodies from the
street not once, but twice. You do not
live with the rotten stench of senseless
death consuming you.

PANELS 6 & 7

The four Dora Milaje say nothing further, instead turning their
backs on T'Challa. As the Dora Milaje walk away, following Shuri,
T'Challa stares after them, helpless.

<div align="center">

AYO
We are leaving. We are done with you.

</div>

PAGE 20

PANEL 1

Ayo and Aneka are sitting on a couch, drinking wine.

Caption
At Upanga, in Aneka's quarters.

ANEKA
I have given the royal family my whole
life. I have trusted T'Challa, Shuri,
Ramonda, those who came before them. Who
am I if I am not Dora Milaje?

AYO
You are more than your service. You are
so much more than your service.

PANEL 2

Aneka rests her head on Ayo's shoulder. Aneka looks defeated, the
weight of T'Challa's betrayal clearly affecting her.

ANEKA
I am your captain, and yet it is you
offering me strength, guidance.

AYO
You are my captain, always. Soon, we will
meet with Zola and we will continue to
serve, but from this day forth, our eyes
will be open. We will serve, but we will
also think and act for ourselves, and
what we think best.

ANEKA

You warned me and I ignored you. I
thought I knew best.

PANEL 3

Ayo stands and holds her hand out to Aneka.

AYO

Sometimes you know best. Sometimes I know
best. Between the two of us, one of us
will always know something. Now stand up
and hold your head high.

PANEL 4

Aneka takes Ayo's hand and stands.

PANEL 5

The women face each other, still holding hands.

ANEKA

So much of what lies before us is unknown.

AYO

I do not know what the future holds, but
I do know things will be different. WE
will be different...

KILLMONGER (2018) BY BRYAN HILL

AN INTRODUCTION BY **ANGÉLIQUE ROCHÉ**
IN CONVERSATION WITH **ANDREW SUMNER**

Every comic book writer is different—and when you look at Bryan Edward Hill's script, what you're seeing is his focus on the movement of the plot. He does give direction as to where you are, he does sometimes give camera direction, but his true focus is on "How do I move the character so that we can get him away from where he began and transform him into this determined protagonist who becomes filled with hate by the end of my story?" You can see all of that in the priorities of his directions to the artist, through the specificity of the things that exist in the world he is creating, and in his focus on continuing to move the narrative along. Instead of these scripts focusing on Erik's emotions and his feelings, they are about who he is. Who he is becoming and where he is going. And how he comes to be.

Killmonger by Bryan Edward Hill is actually the first comic book I read after starting at Marvel that was just its own mini-series. It wasn't jumping off from anywhere. It wasn't picking up from anywhere. And it jumps back into what I think is a very comic-book-driven story. So let me take a step back.

At this point in this book you've seen scripts by a movie director, by a man who is glorious with prose but also has a very poetic feeling to his writing, and by Roxane Gay, who (as I've actually told her in person) paints with words: when she writes, she illustrates her tales with emotions and what she wants you to feel—but she also paints what she's feeling on the page. And then you get to these very interesting scripts by Bryan Edward Hill—the origin story of Killmonger. Hill has worked a lot in TV on things like *Ash vs Evil Dead*, but you can tell from these scripts that his writing is totally rooted in his love of comics.

Killmonger: By Any Means is filling in what happened to Erik and illustrates how we get Killmonger. But also, Bryan writes an interesting take on a far more movie-based Killmonger, rather than a classic comic-book Killmonger. This is where we see that turn from cinema back into

comics. These are very much a pair of classic comic book scripts, without anywhere near as much camera direction as, say, the scripts by Reginald Hudlin. But Bryan's scripts really are moving at a comic book pace—they are bringing the reader along, and then setting them up for where we meet our protagonist in the story. And the thing that I love about Bryan Edward Hill is that he uses captions more than the other *Black Panther* scriptwriters we're seeing in this book because he has a lot more temporal space to fill into the narrative; we're not dealing with T'Challa, who's enjoyed decades of published comics, who is already the Black Panther. And you're not dealing with the Dora Milaje, who you know are in a group, a militia. You're dealing with a guy who starts out far away, with this hybrid background, trying to explain how he gets back to Wakanda. Hill is also weaving a history with a partially supernatural basis because he's dealing with Erik Killmonger and his demons. And dealing with what, exactly, is motivating Erik.

One of the things that Bryan has to establish in these scripts is that no good villain becomes a good villain if he does not fully believe in his mission, his cause and his reasoning for doing the things he does. The only difference between a hero and a villain is perspective. The villain believes they are doing the right thing because they believe what they are doing is justified. And, in this story, you have to establish this brilliant young man, and bring him to a point where he is willing to commit mass atrocities (and somehow retain his internal justification) without jumping into the realm of absurdity. And Bryan Edward Hill does exactly this. And it's wild. But it is very much a comic book narrative, and these two scripts are classic, lean, and efficient comic book storytelling.

Bryan deals a lot more in plot and in how we reconcile the contemporary Erik Killmonger with Killmonger's established canon because Erik Killmonger has technically been around (but rarely seen) since the 1970s. I love the fact that Hill brings in the deities here, which I think brings us back beyond the ancestral plane. So far in these contemporary Wakandan comics, we haven't really explored beyond the ancestral plane and the heart-shaped room, the other supernatural deities, the other beliefs, the other traditions of Wakanda.

Of all of the scripts presented in this book, Bryan's are the least focused on anything apart from "This is where we have to go. This is what

I'm here to accomplish in this story, and this is where I have to move the character to by the end of this story." Bryan is essentially being charged with cataloging the canon of Killmonger, focusing it, and putting it into one cohesive place, that can also easily sit side by side with the movie interpretation of Erik. Killmonger is a character you first meet in *Jungle Action* #6 in 1973, he's the first villain to be introduced when T'Challa returns to Wakanda; in Erik's first appearance, Don McGregor has T'Challa literally get beaten and thrown over a waterfall by this huge Wakandan, who has started fomenting a revolution in this country afflicted with a leaderless power vacuum. Whether or not inspiring a revolution is good or bad, he has sparked the flames of change. And in his mind, he's justified because he believed T'Challa's leadership was not enough.

Where does that come from? How do you reconcile someone who seems to be literally barbaric? When you first meet him, he's so violent and full of rage—the first arc of McGregor's run is literally called *Black Panther's Rage*, and it's about both men: Killmonger is raging and T'Challa is raging.

And then the 2018 movie introduces a Killmonger who is strategic and smart and analytical. And he moves with purpose. And with these scripts, Bryan Edward Hill had to work on showing how we get him to this place from where he started in the comics. To evolve that type of conflict, this specific type of opponent. Again, I don't want to call him a villain because Erik believes he's justified in what he's doing, believes he has been wronged. He believes he's the true leader of Wakanda—and to be very honest, who are we to say he's not? So being able to reconcile that and being able to also get Killmonger to a point where he is the cold person that you meet onscreen, something had to happen to get Erik there. And that's really what I loved about this story, because when you do meet Eric Killmonger in the story he has not yet determined what he wants—but there's a point in Bryan's story where he does cross over the precipice. In these first two fast-moving issues, Bryan Edward Hill is getting you to the peak of that precipice, to that point of no return for the creation of the Marvel Universe Killmonger we know today.

BLACK PANTHER

PAGE ONE

Nine-panel grid

NOTE: This page is Erik and T'Challa fighting at the waterfall, but we're doing a GRID OF EXTREME CLOSE-UPS OF VIOLENCE. We don't need to know who is hitting who, that's the point of the grid. It's brother-on-brother violence, brown hands and feet doing damage to brown skin. It's not action. It's VIOLENCE. This is a shotgun blast of moments from a PRISON FIGHT--it's just happening on top of a waterfall ... but we can't see the waterfall yet.

[See email for note about Killmonger's look. Take some liberties with how Black Panther's costume looks (like, whether his mask is on or off or torn, etc.)]

Panel One

Close-up on Erik's ANGRY EYE.

Panel Two

Erik's FIST smashes into T'Challa's face.

Panel Three

T'Challa's hand SPLASHES into the water. It's CUT and SCRAPED, the BLOOD from those wounds spreading into the water, making the crown-splash pink.

Panel Four

CLOSE on BLOOD running from T'Challa's nostril.

Panel Five

T'Challa throws a punch and we're CLOSE UP on Erik BLOCK-SLAPPING that punch out of the way.

Panel Six

On a BLACK PANTHER, SNEERING at us, its HUNTER'S EYES narrowed into hunting-slits. It HATES us.

Panel Seven

Erik's HAND GRIPS T'Challa's throat, and we're CLOSE UP under T'Challa's chin. Erik's hand has BRUISED and SCRAPED KNUCKLES.

Panel Eight

CLOSE on Erik's mouth SNEERING in GRIM SATISFACTION.

Panel Nine

CLOSE on an actual BLACK PANTHER ROARING, we're RIGHT IN FRONT OF ITS MOUTH, seeing the FANGS and the GLISTEN of the drool falling from the fangs.

PAGE TWO-THREE

DPS of Killmonger throwing T'Challa off the waterfall, the citizens of Wakanda watching in horror. Height. Terror. Beauty. The BEST IMAGE OF THIS MOMENT IN THE HISTORY OF BOTH COMICS AND FILM. Do your thing.

NOTE: Please put the TRIBAL SCARS on Erik's body. He won't have them in most of the series, but he has them now. They're visual signifiers of his transformation. The rest of the series is about getting Erik to this point.

PAGE FOUR

Panel One

Establishing of MIT CAMPUS. DAY.

CAPTION: Massachusetts Institute of Technology.

CAPTION: YEARS AGO.

We hear the voice of the CAREER COUNSELOR, JESSICA WEEKS, in a caption over the panel.

> **JESSICA (Caption):** NEW YORK CITY makes no sense for you, Erik.

Panel Two

What's happening: Erik is sitting across from Jessica in her office at MIT.

We're seeing this from Erik's POV, Jessica sitting across from him, at her desk. Brilliant. Polished. Intense. There's a sexiness about her, mainly due to her confidence and competence. She's not playing into it. It's just there.

> **JESSICA:** I have job offers lined up between here and Silicon Valley. You're the graduate everyone wants.

Panel Three

On Erik. This isn't what we expect. He's CLEAN CUT. Handsome. Fit, but pleasant. No more threatening than any fit young man his age (21-ish). He's wearing GLASSES. Thin frames that compliment his face. The only giveaway is the tight V-neck T-shirt that makes it clear Erik doesn't eat many carbs.

> **ERIK:** I appreciate the opportunity MIT has given me, but I need some time to think about the future.

Panel Four

Closer on Jessica. She's analyzing. Maybe even FLIRTING a little bit. Is she INTERESTED in Erik? We're not sure.

> **JESSICA:** Erik. The other graduates are begging me to have what you're throwing away.

> (linked)

> **JESSICA:** I've got military. Private. Humanitarian. You can take your pick. They'll pay you just to think for them.

> (linked)

> **JESSICA:** I'm your guidance counselor and I'm guiding you to reconsider.

Panel Five

On Jessica's wall. There's a FRAMED PHOTO next to her credentials. It's of HER GRADUATING from Princeton, in a cap and gown, standing with her MOTHER and FATHER. Everyone looks VERY PROUD. This is years ago, but we should know it's her from the voluminous red hair.

> **ERIK (Caption):** That you and your parents in the photo?

> **JESSICA (Caption):** That? Oh. Yeah. I keep it hanging so when my dad visits I don't have to hear him ask where it is.

> **ERIK (Caption):** My father died when I was a kid, Ms. Weeks.

> **JESSICA (Caption):** JESSICA. Please. I've
> known you for four years.
>
> **JESSICA (Caption):** And I'm sorry about
> your father.
>
> **ERIK (Caption):** Don't be--

PAGE FIVE

Panel One

On Erik.

> **ERIK:** You didn't kill him.
>
> (linked)
>
> **ERIK:** It was an accident.

Panel Two

FLASHBACK. We're in Wakanda, close on Young Erik (*N'Jadaka--I'm
just going to use Erik to make this easier on both of us. When I
need specific address for N'Jadaka, it'll be in dialogue*) kneels
next to his father's and mother's body, crying. There's SMOKE and
FIRE all around him. His family is dead.

> **ERIK (Caption):** Industrial.
>
> **ERIK (Caption):** Sometimes science
> goes wrong.

Panel Three

FLASHBACK. Young Erik is being pulled away from his father's body by M'Demwe. Erik's SCREAMING in horror and grief. It looks like a refugee tragedy, the price of war traumatizing this child.

> **ERIK (Caption):** I was lucky.

> **ERIK (Caption):** I had people who could look after me. A lot of kids don't.

Panel Four

FLASHBACK. We're seeing KLAUE from Young Erik's point of view. He's INTIMIDATING. M'Demwe stands next to Klaue, it's clear from their positioning that the men are in league with each other. NOTE: This is MERCENARY KLAUE. He's not in the "villain outfit" yet. He's still got both hands.

> **M'DEMWE:** His name is N'Jadaka. He's smart, Klaue. And now he's **ALONE**. Both his parents are **DEAD**.

> **ERIK (Caption):** It means something when people see the value in you.

Panel Five

FLASHBACK. Close on Young Erik as KLAUE'S HUMAN HAND touches his face, gently.

> **KLAUE (off panel):** Ag, shame when the bad things happen in business.

> (linked)

> **KLAUE (off panel):** Load him up. I could always use a Wakandan brain.

> **ERIK (Caption):** You don't forget moments like that.

PAGE SIX

Panel One

BACK IN JESSICA'S OFFICE. On Erik.

> **ERIK:** You telling me my mind has value? I appreciate that.

Panel Two

On Jessica. Listening.

> **ERIK (off panel):** But I already knew that.
>
> (linked)
>
> **ERIK (off panel):** Jessica.

Panel Three

On Erik.

> **ERIK:** I'm sure a lot of places want to **OWN** me. I'm a fresh graduate. Just got my **FREEDOM.** The price is low.
>
> (linked)
>
> **ERIK:** Tell your marketing department, thanks for the diploma, but they'll need to find another success story.
>
> (linked)
>
> **ERIK:** I'm going my own way.

Panel Four

On Jessica. She realizes she's not changing his mind.

> **JESSICA:** You could have told me no
> by email.
>
> (linked)
>
> **JESSICA:** Why are you looking at me
> like that?

Panel Five

CLOSE on Erik. Intense. Magnetic.

> **ERIK:** You know why I'm looking at you
> like this.

Panel Six

CLOSE on Erik.

> **ERIK:** We've known each other four years.

PAGE SEVEN

Panel One

NIGHT. We're in Jessica's apartment, seeing her in bed, naked under
the sheets. She's sleeping. If we can see it, there's a BOTTLE
OF WINE and TWO GLASSES on her nightstand. Moonlight drifts in.
She looks beautiful. We're seeing her OVER ERIK'S SHOULDER. He's
bare-chested, but we can't see much of him. He's in the frame for
spatial context.

Panel Two

CLOSE on Erik. Thinking. Unreadable. M'DEMWE'S VOICE is speaking to him from memory.

> **M'DEMWE (Caption):** I'm still your uncle, N'Jadaka. I'm the one you can **TRUST**.

Panel Three

FLASHBACK. N'Jadaka sits with M'Demwe, handing him a PISTOL. They're at an African airfield, built into the plains. Far from Wakanda. A propeller plane in the distance. This is the EXFIL point, the last stop before they leave Africa. They can be silhouettes, but if they are then make sure in the SHAPES it's clear that this is a GROWN MAN indoctrinating a YOUNG BOY. A big, male shape, speaking to a SMALL boy's shape.

> **M'DEMWE:** The **OUTSIDE WORLD** isn't Wakanda. **WE** are **NOT VALUED** there.

> (linked)

> **M'DEMWE:** Remember your anger, N'Jadaka. It's your SHIELD. Give your grief to it. Give your fear to it. That anger will keep you alive.

> (linked)

> **M'DEMWE:** EVERY outsider is your enemy. When your anger tells you that, you **LISTEN** boy.

Panel Four

WIDER ANGLE OF THE BEDROOM. Erik is bare-chested (no scars yet), holding his JACKET in one hand, letting it dangle to the floor. He's looking down at Jessica. A COLD EMOTION on his face. He says one word, mainly to himself, she's asleep and she can't hear him.

> **ERIK:** Colonizer.

PAGE EIGHT

Panel One

Erik's in the living room, opening the front door of the apartment. He's got his jacket on. He's leaving.

> **JESSICA (off panel):** Erik--

Panel Two

Jessica's standing in her bedroom doorway, wrapped in the sheet. She's just as cold as he is.

> **JESSICA:** Good luck in New York City.
>
> (linked)
>
> **JESSICA:** Hope you find what you're looking for.

Panel Three

Erik leaves the apartment.

> **ERIK:** Sure you do, Ms. Weeks.

Panel Four

Jessica stands alone in her apartment. She's a little angry, a little embarrassed, and a touch confused.

> **JESSICA:** COLONIZER.
>
> (linked)
>
> **JESSICA:** The #@$% does that mean?

PAGE NINE

FLASHBACK PAGE

Panel One

NIGHT. M'DEMWE is on his hands and knees, ON A BRIDGE, SOMEWHERE METROPOLITAN—but not a TOURIST SPOT. It's just a BRIDGE in the lonely place of the city, over black water. We don't have to see much of it here, but that's the setting. CONTRASTING against the feeling of Africa, this is a world of CONCRETE and STEEL. Harsh STREET-LIGHTS casting light on him from above. He's been beaten. He's bleeding from a broken nose, trying to stop what's about to happen to him.

> **M'DEMWE:** N'jadaka. **WAIT.** I'm not the one you should blame.
>
> (linked)

> M'DEMWE: **ULYSSES KLAUE** killed your
> father. I helped you. I **HELPED** you!

Panel Two

A SIXTEEN-YEAR-OLD ERIK holds a SPAS-12 shotgun on M'Demwe.

> ERIK: You had me steal for you. You **USED** me.

> (linked)

> ERIK: But I was **LEARNING** you, M'Demwe.

Panel Three

Erik SLAMS the BUTT of the shotgun between M'Demwe's shoulder blades.

> ERIK: How you **LIE**! How easy it is to make
> **NOTHING** matter to you but what you want.

Panel Four

On M'Demwe, now plainly begging for his life.

> M'DEMWE: N'Jadaka, **PLEASE**!

> (linked)

> M'DEMWE: You're **NOT** a killer.

Panel Five

On Erik, holding the SPAS-12.

> ERIK: I wasn't.

> (linked)

> ERIK: Until you showed me how I could be.

Panel Six

LONG SHOT OF THE BRIDGE. Erik FIRES the shotgun. Can the SFX be a design element in the panel, incorporated into the pencils?

This is the moment Erik makes a choice that will dominate the rest of his life. That's why we're on a bridge. He's in-between destinies, and the murder of M'Demwe sets him on the path that will lead to his downfall.

> SFX: BLAM.

PAGE TEN

(NOTE: Just a suggestion, but we could do the first three panels Warren Ellis style, in a small row at the top of the page. Then the final two panels are larger underneath it).

Panel One

Establishing panel of HARLEM. We're out of the flashback. This is a week after Erik left Jessica. We see a MOTEL at the end of the block, little more than a flophouse.

CAPTION: HARLEM. NEW YORK CITY

> **ERIK (Caption):** *Towards thee, I roll.*

Panel Two

INSIDE the apartment. A ROACH skitters across the old, wooden floor.

> **ERIK (off panel):** *Thou all-destroying but conquering whale.*

Panel Three

Erik's BARE FOOT SQUASHES the roach.

> **ERIK (off panel):** *To the last, I grapple with thee.*

> **SFX:** SPLUCK!

Panel Four

Erik's bare-chested, standing in front of a WALL in the motel room. ON THE WALL are pictures of KLAW (NOTE: This is the ICONIC KLAW. Time has passed since the Wakandan attack and KLAW HAS EVOLVED AS WELL. Time has affected him too. From now on, this KLAW is the villain complete with his aesthetics. There's a MAP OF EUROPE. AMERICA. WAKANDA (but that one is hand-drawn). NEWSPAPER CLIPPINGS. It's a collage of personal obsession.

> **ERIK:** *From Hell's heart I stab at thee.*

> (linked)

> **ERIK:** For **HATE'S** sake--

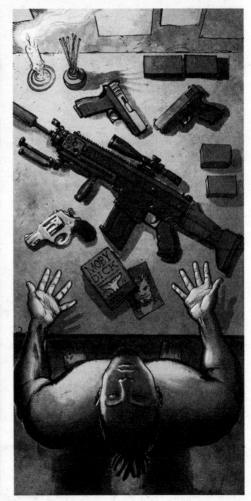

Panel Five

The only table in the motel room has TWO 9MM GLOCK PISTOLS.
MAGAZINES next to them. BULLET BOXES. There's a .38 SNUB NOSE on
the table. Those are the appetizers.

The MAIN COURSE on the table is a SCAR-H rifle that's been HOMEBREW-
MODIFIED into a SNIPER RIFLE with a TELESCOPIC SIGHT, EXTENDED
STOCK, EXTENDED MAGAZINES and a PISTOL GRIP MOUNT on the front of
it. It's an UNHOLY MONSTER of a self-modified weapon. Even the most
loyal FOX NEWS viewer would pause at this thing being on the street.

There's INCENSE burning on the table next to a candle. A bit of
Wakanda that Erik carries with him. In the candlelight, we can see
an OLD HARDCOVER of MOBY-DICK, and a FADED PHOTOGRAPH OF THE OLD
KLAUE, pre-villain outfit. The past is still here.

> **ERIK (off panel):**--*I spit my **LAST BREATH**
> at thee.*

PAGE ELEVEN

Panel One (largest panel on the page)

SAME NIGHT. LATER. We're in a LARGE, VACANT PARKING LOT somewhere
in Industrial Brooklyn. KLAW (wearing a trench coat over his
"villain outfit" so we keep our semi-grounded tone) stands next
to a HIRED GUN. The HIRED GUN is a little afraid, a little too
young and green to be doing what he's doing. He's in this image
for CONTRAST. Klaw is an ICE-COLD KILLER, commanding the image.
The Hired Gun, and his frailty, contrasts against that, so Klaw's
presence is felt by the reader. He's got the KLAW HAND and the
other one is holding a MAC-10.

Klaw is looking into the distance. A hunter's gaze. The Hired Gun
is looking at his watch.

> **KLAW:** Time.

> **HIRED GUN:** We just hit midnight, Klaw.

Panel Two

A wider angle of the parking lot. A BLACK VAN approaches Klaw and
the man.

> **KLAW:** Look alive. Watch the perimeter.

> (linked)

> **KLAW:** I do the talking, Bru. These New
> York deals can get tricky.

Panel Three

THROUGH A TELESCOPIC LENS--we see the van in front of Klaw. Klaw opening it. We can't see what's inside. Klaw is a little BLOCKED by his lookout kid. It's not a kill shot. Not YET.

Panel Four

On Erik, crouched on a rooftop, wearing dark clothes, watching the scene below through his SNIPER RIFLE. He's just waiting for that kill shot to come.

PAGE TWELVE

Panel One

ON THE GROUND with Klaw. He's opening the van and we can see it's got CHILDREN, mostly YOUNG GIRLS. They're blindfolded, tied at the wrists, and TERRIFIED.

> **KLAW:** Yeah. I can move them. But tell him
> that normally I traffic tech. Weapons.

> (linked)

> **KLAW:** Cattle costs extra.

Panel Two

On Erik's finger curling around the TRIGGER. He's about to fire.

NOTE: The next panels on the page are happening FAST.

Panel Three

KNIGHT'S FOOT KICKS the rifle up and out of Erik's hands and his SHOT BUCKS WILD into the air. We can't see her yet.

> **SFX:** BLAM!

Panel Four

CLOSE on Klaw, TURNING FAST. He HEARD that shot. He's NOT SCARED. He's already making his choice, throwing a command over his shoulder.

> **KLAW:** We're **MADE**.

> (linked)

 KLAW: Take the van.

Panel Five

Knight's foot KICKS Erik across the face.

Panel Six

Knight's hand SNAP-CATCHES Erik's rifle before it falls to the rooftop before it can make a sound.

PAGE THIRTEEN

Panel One (biggest panel on the page)

She hit the HELL out of Erik (because she's got a little super strength) so Erik's on the rooftop recovering and Knight is standing over him, holding the gun. Looking AWESOME. Erik's been a badass up until this point, but just based on the last page and this panel, we can tell he's outclassed by Knight ... at least NOW he is.

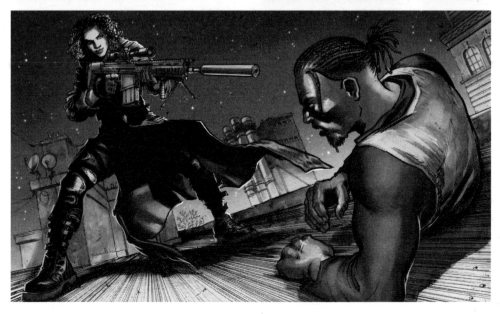

> KNIGHT: Okay, Lee Harvey Oswald.
>
> (linked)
>
> KNIGHT: Who **HIRED** you?

Panel Two

Erik is on his hands and knees, bleeding from his mouth because Knight hit the SHIT out of him. The only reason he's not unconscious is he's too angry to pass out.

> ERIK: ...no one ... hired...
>
> (linked)
>
> ERIK: al-alone...

Panel Three

On Erik, looking at something that RIPS something important out of his spirit.

> ERIK: ...no ... **NO**...

Panel Four

Erik's POV. He's seeing the van drive away, red lights fading in the distance. Presumably Klaw is driving it, and just like that his window of vengeance is gone.

> KNIGHT (off panel): For what it's worth--

PAGE FOURTEEN

Panel One

Knight is holding her OWN PISTOL (a Heckler and Koch 9mm) against the back of Erik's head.

> KNIGHT:--I believe you.
>
> VOICE (off panel): **KNIGHT**. Stand down.

Panel Two

Close on Knight, looking off panel to someone we can't see.

> KNIGHT: Seriously?

Panel Three

On Erik, starting to fade. That punch is catching up with him.

> **VOICE (off panel): SERIOUSLY.**
>
> (linked)
>
> **VOICE (off panel):** We'll take him into **THE EMPLOYER.** If HE wants us to kill him, then I'll get us **PAID** to do it.

Panel Four

On Knight.

> **KNIGHT:** Lucky you, Oswald.
>
> (linked)
>
> **KNIGHT:** You get to live another day.

Panel Five

Erik's POV. He sees KNIGHT'S HAND HOLDING the GUN about to SLAM into his face (into our face).

Panel Six

A BLACK PANEL. Just the BIG, GRAPHIC SFX--

> **SFX:** WHUMPP!

PAGE FIFTEEN

Panel One

A BLACK PANEL. Captions.

> **KING (Caption):** We spotted you as soon as you hit the roof, kid.
>
> **KNIGHT (Caption):** I don't think he's listening. I hit him pretty hard, King.
>
> **KING (Caption):** A man like Klaw does business with our EMPLOYER, and our employer has us as **INSURANCE** against someone like you.

> KING (Caption): **BUSINESS**, kid. You got in
> the way of it.

> KING (Caption): He's listening. We can
> lose the cloth.

Panel Two

We're in a DIMLY LIT OFFICE. POLISHED WOOD. IT'S BIG. LIKE THE BACK
OF A PRIVATE CLUB.

On Erik. A FEMALE HAND slides a black hood off his face. He's
seated in a chair, hands tied behind his back, feet tied to the
chair. We don't have to see all of that now, but that's how he's
seated. He's got a little DRIED BLOOD on his face, but he doesn't
look too bad.

> And he's SIMMERING with anger.

Panel Three

We're behind Erik, or this is Erik's POV. We see KNIGHT, ROOK and
KING. In their composition, King is clearly the one in charge. He's
DRINKING from a cup of coffee, absolutely calm.

> KING: I'm **KING**.

> KNIGHT: **KNIGHT**.

> ROOK: **ROOK**.

> KING: So who are **YOU**?

Panel Four

On Erik.

> ERIK: You should have let me kill him.

> (linked)

> ERIK: Because now I have to kill you too.

PAGE SIXTEEN

Panel One

CLOSE on King. He's amused by this. Maybe he's been in a chair like
that before, spitting tough words at a tough guy--for some reason,
King likes Erik a little more now.

> **KING:** Yeah.
>
> (linked)
>
> **KING:** Okay, kid.
>
> (linked)
>
> **KING:** You stepped on my job with whatever baggage you're carrying. Knight should have killed you. And she could have, because--

Panel Two

On Knight. Confident. WINKING.

> **KING (off panel):** She's gone toe to toe with Spider-Man.
>
> **KNIGHT:** And I got away.

Panel Three

On Erik. Silent. Angry. Listening.

> **KING (off panel):** But I made the call to save your life.
>
> (linked)
>
> **KING (off panel):** I'm not the bad guy in the room--

Panel Four

On King.

> **KING:** The bad guy is behind you.
>
> **VOICE (off panel):** Turn him around please, Mr. King.

PAGE SEVENTEEN

Panel One

We're behind Erik. Now he's facing the opposite side of the room and WILSON FISK sits behind a LARGE, MAHOGANY DESK--JUDGING US.

[Have fun with how you draw Kingpin, Juan. Feel free to go full-on Sienkiewicz with him!]

> FISK: **ULYSSES KLAUE** is unsavory.
>
> (linked)
>
> FISK: But profitable. I will make the **ASSUMPTION** that he **HARMED** you in some way. I imagine you seek **REVENGE**. More than likely you **DESERVE** it.
>
> (linked)
>
> FISK: Had it not been for Mr. King, your actions would have interrupted my **TRANSACTION**, and left the appearance--
>
> (linked)
>
> FISK: That events can happen in this city that aren't MY will.
>
> (linked)
>
> FISK: So I am acutely aware of your **COST**. It would behoove you to tell me what **BENEFIT** I would have in keeping you alive.

Panel Two

On Erik. Fearless.

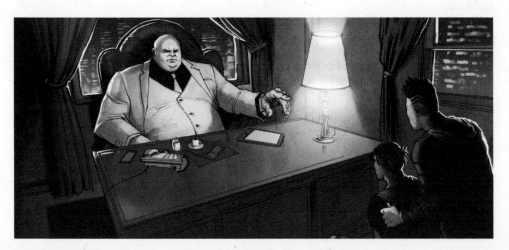

ERIK: I'm the smartest man in this room.

(linked)

ERIK: And I don't have to prove it to you.

Panel Three

Erik's looking down. Resigning.

ERIK: Do whatever you @#$&@%$ want, fat man.

PAGE EIGHTEEN

Panel One

(Largest panel on the page. The FISK panels, like FISK, should be BIG.) On Wilson Fisk.

FISK: Mr. King. Dispose of him, please.

Panel Two

On Erik's hands STRUGGLING against his bonds.

ERIK: Let me out of this chair.

Panel Three

On Erik SCREAMING.

ERIK: LET ME OUT!!!

Panel Four

The BLACK HOOD is PULLED over Erik's face, TIGHT.

PAGE NINETEEN

Panel One

NIGHT. We're by the harbor. Erik is getting DUMPED out of the back seat of a BMW 7 SERIES, BLACK. There's no hood on his head. His hands and feet are still tied.

Panel Two

King stands over Erik, pulling a KNIFE from his pocket.

> **KING:** New York City doesn't exist for you anymore.

> (linked)

> **KING:** You're going to get whatever matters to you and then you're going to leave. By sunrise, be gone.

Panel Three

King drops the knife by Erik's head.

> **KING:** Whatever you're holding onto, let it go. I know you think that hurt is worth it.

> (linked)

> **KING:** But it's not. Trust me.

> (linked)

> **KING: CHRISTMAS** came early for you kid. Have a nice life. **SOMEWHERE ELSE.**

Panel Four

The car drives away from Erik. He's on the ground, reaching for the knife.

Panel Five

Erik cuts through the bonds on his wrists. He's got NO INTENTION of leaving.

> **ERIK:** I'm not a **CHRISTIAN.**

PAGE TWENTY

Panel One

It's HOURS LATER. THE EDGE OF DAWN. Erik's entering the motel room. TIRED. SORE. FRUSTRATED.

Panel Two

Erik picks up his NOW EMPTY table. He must have brought all the guns with him and lost them in the field.

Panel Three

Erik throws the table into the WALL OF KLAW INFORMATION, shattering it.

Panel Four

Erik turns his head because he HEARD SOMETHING behind him.

Panel Five

A SHOTGUN BLAST comes through the MOTEL ROOM window, SHATTERING it as Erik DIVES for cover.

PAGE TWENTY-ONE

Panel One

A **SKI-MASKED GUNMAN** armed with a MOSSBERG SHOTGUN enters the motel room through the window.

Panel Two

Erik charges Ski-Mask, pushing away his shotgun as it BLASTS across the apartment.

Panel Three

Erik JAMS HIS THUMB into the EXPOSED EYE of Ski-Mask

Panel Four

Ski-Mask is BENT over, holding his face. Blood drips from Ski-Mask's face. Erik PUNCTURED something.

Panel Five

Erik GRABS Ski-Mask's HEAD from behind.

PAGE TWENTY-TWO

Panel One

Erik SMASHES Ski-Mask's FACE
into his knee.

Panel Two

Erik DRAGS Ski-Mask towards the
motel room window.

Panel Three

Erik SLAMS Ski-Mask's face
into the jagged edge of the
broken window, killing him.
(I know this is violent, but
the intention is making the
violence count. Every life Erik
takes strips him of conscience.
He's chipping away at his soul,
action by action.)

Panel Four

Erik COLLAPSES in the motel
room, EXHAUSTED. If we can see
the motel room, Ski-Mask's
body is dead, still hanging in
the window.

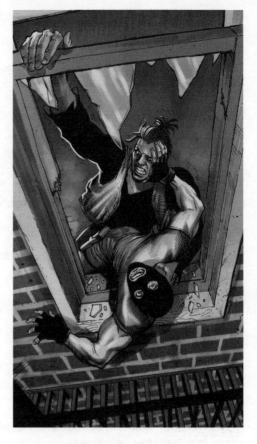

> ERIK: Mother ... Bast ... mother...

Panel Five

On Erik, the adrenaline, fear and anger running out of him. He's
holding his head, sitting on the floor.

> ERIK: Mother Bast...

> VOICE (off panel): I forgot to ask you,
> kid.

PAGE TWENTY-THREE

Panel One

King has walked through the front door of Erik's apartment. He
stands comfortably in the motel room. The Wakanda map and intel
from before is still in the room, if we can see it.

> **KING:** What's your name?

Panel Two

Erik's standing up. It HURTS. King's facing him. Erik REALIZES--

> **ERIK:** You weren't letting me go. You
> wanted to follow me here.

> **KING:** The big guy? His name is **WILSON
> FISK.** He wanted to know where you came
> from. So we needed you to lead us here.

> (linked)

> **KING:** AFRICA. You from there, or just
> planning to retire in the jungle?

Panel Three

On Erik.

> **ERIK:** You tracked me, and watched while I
> killed one of yours.

> (linked)

> **ERIK:** That what you call **LOYALTY**?

Panel Four

King stands over the body of Ski Mask, looking down at it.

> **KING:** He's not one of mine. He was
> a **TRYOUT**.

> (linked)

> **KING:** If he was the one left alive, I'd
> be making the offer to him.

Panel Five

King's looking at Erik (at us).

> **KING:** But you're the one alive. So I'm
> making the offer to YOU.

> (linked)

> **KING:** We need another piece. Work with us.

PAGE TWENTY-FOUR

Panel One

On Erik.

> ERIK: Why would I **WANT** to do that?

Panel Two

On King and Erik.

> KING: Because Klaw is **GONE**. You spooked him underground and that is where he will **STAY**. Your trail is **COLD**.

> (linked)

> KING: But Fisk can put you next to him.

> ERIK: Fisk is **PROTECTING** him.

Panel Three

On King.

> KING: Today. How long do you think that will last?

> (linked)

> KING: Fisk is your way to Klaw. And my team is your way to Fisk.

Panel Four

On Erik, picking up a PISTOL from the floor. We can be close on his hand while he's picking up the pistol. Strange that King would LET him do this, but he is.

> ERIK (off panel?): Why would you help me?

Panel Five

On King.

> KING: Because I've BEEN you, son. Talented and stupid.

> (linked)

KING: Fisk wants us to have a **FOURTH**. He
calls it **SYMMETRY**. He's particular about
his ... employees.

PAGE TWENTY-FIVE

Panel One

Erik aims the pistol at King.

Panel Two

The PISTOL GLOWS with energy--the way that MUTANT TELEKINESIS READS
in comics.

> **KING (off panel):** Son...

Panel Three

King WILLS the pistol into his open palm--his palm is glowing too--
he's the one moving the gun.

> **KING:** You need to stop underestimating
> the world around you.

Panel Four

Erik starts to GLOW with TELEKINESIS energy, lifting off the
ground.

Panel Five

CLOSE on King. Calm.

> **KING:** This is going to hurt a little.

> (linked)

> **KING:** But you had it coming.

PAGE TWENTY-SIX

Panel One

Erik is TELEKINETICALLY thrown through the broken window.

Panel Two

ON THE STREET, Erik lands in a PILE OF GARBAGE BAGS and GARBAGE CANS.

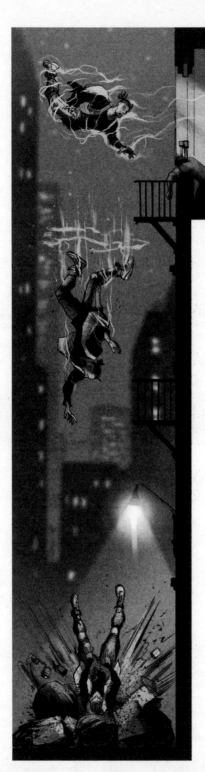

Panel Three

Knight's feet standing next to Erik in the garbage. She's standing over him, holding a GLOCK 90 on him, but we might not be able to see it in this panel.

> **KNIGHT (off panel):** He broke your fall. That means he LIKES you, Oswald.
>
> (linked)
>
> **KNIGHT (off panel):** I **DON'T** like you, but King made the call.

Panel Four

On Knight, from Erik's point of view. Looking very cool, standing over him. We can definitely see her holding the Glock on him here.

> **KNIGHT:** You smell like Harlem. Time to get you cleaned up.

PAGE TWENTY-SEVEN

Panel One

There's a DECENT, but not too FLASHY BEACH house. Modern. Build in right angles, plenty of windows. It's sitting alone on the shoreline. Gray

sand leading to the bluish water. We hear King speaking with Knight and Bishop.

> **CAPTION:** LONG ISLAND
>
> **KNIGHT (Caption):** You're **WRONG** about him, King. We should have left him in the trash.
>
> **KING (Caption):** You're holding a grudge, Knight. Think pragmatically.
>
> **KING (Caption):** You want the **BIG JOB**?

Panel Two

Inside the beach house. This is the LIVING ROOM/BAR area. A wall of windows that look out onto the beach. It's not really furnished, this place. They might STAY here, but they don't LIVE here.

King leads the conversation. Bishop and Knight watching him.

> **KING:** Then we need a bigger crew.
>
> (linked)
>
> **KING:** I'm tired of **RENTING** my life. Fisk can open up the whole world to us. We just need to show him what we can do.

Panel Three

On Knight, not buying it.

> **KNIGHT:** You have a **LOT** of faith in Wilson Fisk.
>
> (linked)
>
> **KNIGHT:** And you have **TOO MUCH** faith in a man with a white-hot chip on his shoulder.

Panel Four

On Rook.

> **ROOK:** She's right, King. He's a **HEAD-CASE**.

Panel Five

On Knight.

KNIGHT: I **KNOW** I'm Goddamned right.

> (linked)

KNIGHT: When you look someone in the eye
you need to see the **LINE**. The line they
will not cross. The thing they will not do.

> (linked)

KNIGHT: I look at him, and that line
ISN'T there.

PAGE TWENTY-EIGHT

Panel One

We're behind Erik. He's bare-chested. Standing at the edge of the
beach. Looking into the horizon. We see the whole world stretched
out past the water.

> KNIGHT (Caption, Cont.): Someone **RIPPED**
> it out of him.

Panel Two

The reverse angle on Erik. He's looking out at the water, looking
for some kind of sign, some sense that he's on a path that can lead
him to peace.

> ERIK (Caption): My father called it
> **D'YSHALAH**.

> ERIK (Caption): The great shoreline of
> the universe.

> ERIK (Caption): The place where the
> **WRONGED DEAD** wait for justice in the
> world of the living.

Panel Three

The same angle as Panel One, but now we're seeing this INSIDE ERIK'S
MIND. HIS IMAGINATION. He's standing in front of WATER GLOWING with
a luminescent color. STARS like DIAMONDS in the black sky. TWIN
MOONS floating in the sky like eyes looking down at the world.

> ERIK (Caption): I have to imagine it.
> Because I don't have my father's faith.

> **ERIK (Caption):** I call out for him. I hear his **VOICE** in the breath of **MOTHER BAST**.
>
> **VOICE OF BAST (off panel, from Behind Erik--EPIC LETTERING):** TURN AROUND.

Panel Four

Erik has turned and he's FACING A GIGANTIC, FEMALE BLACK PANTHER staring at him with INTENSE, GREEN EYES. He's standing before THE GODDESS BAST.

> **BAST:** N'JADAKA. Son of N'JOBU. Put down your war.
>
> (linked)
>
> **BAST:** RETURN HOME.

PAGE TWENTY-NINE

Panel One

On Erik, bowing his head in brooding shame.

> **ERIK:** I have no home, Mother.

Panel Two

WIDE SHOT of the shoreline. The NORMAL shoreline. Erik's vision has faded. This is a profile image of Erik standing on the shoreline and KNIGHT is standing ten feet behind him. They're both small in this panel. The horizon behind them, the vastness of everything.

> **KNIGHT:** Oswald.
>
> (linked)
>
> **KNIGHT:** You were talking to yourself. Just how **CRAZY** are you?
>
> **ERIK:** I'm not crazy.

Panel Three

Erik turns around to face Knight.

>>>> **ERIK:** And my name is Erik.

>>>>>> (linked)

>>>> **ERIK:** Erik Killmonger.

Panel Four

On Knight. She's not trying to look alluring, but she can't help it. She's too confident. Too certain of herself. It's got a gravitational pull.

>>>> **KNIGHT:** There's a **BIG SCORE** coming our way from Fisk. Enough to retire. King sees **VALUE** in you joining up. I don't. Become a problem and I'll put you down myself.

>>>>>> (linked)

>>>> **KNIGHT:** Why are you looking at me like that?

Panel Five

On Erik, keeping his thoughts to himself. He looks just as HANDSOME as Knight is beautiful.

>>>> **ERIK:** I'll tell you--

PAGE THIRTY

SPLASH

We're behind Erik, but we're seeing the scene from his point of view. We're still in the MYSTICAL KINGDOM OF D'YSHALAH, seeing the glowing water, the diamond stars in the sky, the TWIN MOONS in all of their beauty.

Knight is standing in front of Erik, oblivious to what's in Erik's imagination. Behind Knight--

BAST is hulking thirty feet over her, ROARING up into the mystical sky, like a WARNING. Its GREEN EYES GLOWING, ITS MASSIVE FANGS BARE and GLISTENING.

>>>> **ERIK:**--when we know each other better.

BLACK PANTHER

KILLMONGER
ISSUE #2
2018

"By Any Means -- Part Two"

By Bryan Hill

Art by Juan Ferreyra with Eduardo Ferreyra

PAGE ONE

FOUR PANELS of equal size, like 35mm film panels running down the page.

Panel One

We're in a MANHATTAN DANCE CLUB. The most vibrant spot in the city tonight.

KNIGHT dances in the center of the twisting bodies on the floor. She's got on her LITTLE BLACK DRESS, blowing off some steam, not dancing with anyone in particular, just moving to the music. FREE. Music video perfect. She's the most alluring woman in the whole club right now, maybe the whole city. We're a little far away from her. Not quite a LONG SHOT, but knees to above her head. A full body shot. A panel that could sell that dress in a VOGUE magazine.

> **KING (Caption):** Fisk has **FOUR TARGETS**. We have to hit them all.

The SFX of the MUSIC is a design element in the panel.

> **SFX:** BOOM-CLAP BOOM-CLAP BOOM-CLAP BOOM-CLAP BOOM-CLAP BOOM-CLAP

Panel Two

We're a little closer on Knight, paying a little less attention to the people dancing around her. The LIGHT is on Knight, and so are our eyes.

> **KING (Caption):** They're in town from overseas. Some kind of international meeting of the criminal minds. Short window.

> **KING (Caption):** Don't ask me why Fisk wants them gone. I don't know.

> **KING (Caption):** And I suggest that we don't care.

> **SFX:** BOOM-CLAP BOOM-CLAP BOOM-CLAP BOOM-CLAP BOOM-CLAP BOOM-CLAP

Panel Three

Closer on Knight. She's running her hand through her hair, wiping sweat from her forehead with her palm. She's the only woman in the world now. She's NOT looking at us. She's not giving us that much.

KING (Caption): They have security
details. All of them. The problem is **TIME**.

KING (Caption): If we hit one, then
we'll scare the others. They'll run.
We'll fail. Fisk brings it back on **US**.

KING (Caption): We do this right and
Fisk bumps us up to the **BIG TIME**. This
is **THE** job.

SFX: BOOM-CLAP BOOM-CLAP BOOM-CLAP BOOM-
CLAP BOOM-CLAP BOOM-CLAP

Panel Four

NOW Knight is looking at us. We're close to her. Her eyes catching
the light, moving to the music. Like a pop star's album cover on
a billboard you'd see on Sunset Boulevard. If she asked you for
something, you'd give it to her, and if you didn't have it, you
would take it from someone that does.

KING (Caption): So we have to split up.
Hit them separately. **SIMULTANEOUSLY.** It's
a $#%& plan and you will have **NO BACKUP**.

KING (Caption): We need to look at the
recon. We'll pick our targets. Erik--

KING (Caption): Erik, you **LISTENING**?

KING (Caption): Earth to Erik.

SFX: BOOM-CLAP BOOM-CLAP BOOM-CLAP BOOM-
CLAP BOOM-CLAP BOOM-CLAP

PAGE TWO

Panel One (Largest on the page)

King and Rook sitting at a table in the VIP section. Erik is already standing, walking away from the table. They're all dressed to the nines. Blazers and slacks. No ties. Shirts unbuttoned.

> **KING:** Erik--
>
> **ERIK:** I heard you, King. Four on the floor.
>
> (linked)
>
> **ERIK:** We need another round. I'm buying.

Panel Two

On Rook and King.

> **ROOK:** What's his deal?
>
> **KING:** He's a problem child that made bad choices.
>
> (linked)
>
> **KING:** Just like you and me.

Panel Three

On Rook.

> **ROOK:** You trust him?

Panel Four

On King.

> **KING:** I trust his anger.
>
> **(linked)**
>
> **KING:** I have a backup plan for the rest.

PAGE THREE

Panel One

Erik standing at the bar. The bartender, a BLONDE WOMAN, pours some drinks in front of him. Knight has nudged up to the bar next to Erik.

> **KNIGHT:** We're here to have fun. You boys keep talking business.

> **ERIK:** You don't think business is fun, Knight?

Panel Two

CLOSE on Knight. Flirting. Not serious about it. Having fun on a Friday night.

> **KNIGHT:** You keep watching me dance and I might get the wrong idea.

Panel Three

On Erik, about to take a drink from his cocktail.

> **ERIK:** I'm not watching you, Knight. I'm making myself immune.

Panel Four

On Knight.

> **KNIGHT:** Immune? To what?

Panel Five

Erik walks away from Knight, carrying two drinks.

>**ERIK:** Everything you're selling.

>>(linked)

>**ERIK:** Nice dress.

PAGE FOUR

Nine-panel grid

Panel One

Erik's hand sets a drink in front of King.

>**ERIK (off panel):** Can I talk now, or are you still going?

Panel Two

Erik sits at the table.

>**KING (off panel):** You have the floor, Erik.

Panel Three

On Erik.

>**ERIK:** We're just **KILLING** people.

>>(linked)

>**ERIK:** Don't make it complex.

Panel Four

On Erik.

>**ERIK:** I don't know Fisk, but I'm pretty sure the fat man likes opera.

>>(linked)

>**ERIK:** You want to impress him, make it a show.

Panel Five

On King. Intrigued.

 KING: Go on.

Panel Six

On Erik.

 ERIK: Find a nice place. Secluded, but upper class. Tell them Fisk wants to meet up. **LIE.** They'll wonder, but they'll come.

 (linked)

 ERIK: We hit them all at the same time. **BANG.**

Panel Seven

On Rook, not wanting to do this AT ALL.

 ROOK: King, this guy's **SUICIDAL.** We should have done him when Fisk wanted us to.

Panel Eight

On Erik, cool but TIGHT.

 ERIK: You can still try, Rook. I'm right here--

 KING (off panel): ERIK. Shut up.

Panel Nine

On King. TIRED of all this bravado.

 KING: Rook. Talk it over with Knight. We need her mind on this. New blood and I are going to talk **OUTSIDE.** Now.

PAGE FIVE

Panel One

Erik and King outside of the club, near the valet. SPORTS CARS and SUVs handled by valets. They're having a low-volume argument, voices measured, words hard.

KING: Rook's got a **HEALING FACTOR.** A good one. Only way you're beating him is cutting off his head.

ERIK: That a pro-tip?

KING: No. This is.

Panel Two

On King.

> **KING:** I don't know what hurt you, kid. But you're letting your rage convince you that you're indestructible. You're not.

> (linked)

> **KING:** Anger is like an old gun. When it works, you're deadly. When it doesn't it will blow up in your face.

Panel Three

On Erik, listening.

> **KING (off panel):** And it doesn't warn you which will happen.

> **ERIK:** You said Fisk can get me to Klaw. It's all I want, King.

Panel Four

On King.

> **KING:** This I know.

> (linked)

> **KING:** What I don't know is if you can
> **RUN** your little badass plan. **SMALL** space.
> Armed killers. **NO** options. That's not a
> hit. That's a **WAR**.

Panel Five

Erik walks away from King. Headed somewhere.

> **ERIK:** Good thing I'm a warrior.

> (linked)

> **ERIK:** Finish your party. I'll meet you
> back at the house. Whatever plan you
> choose, I'm in.

PAGE SIX

Panel One

FLASHBACK.

We're on YOUNG ERIK. Weeks after he was taken from Wakanda. We're
outside, in a POOR but BUSTLING South American city. Erik's just a
boy, wearing a T-shirt, standing and speaking to someone we can't
see. He's still a little SHELL-SHOCKED. Coming to terms with his
new life.

> **YOUNG ERIK:** You wanted to see me,
> Mr. Klaue?

CAPTION: South America.

CAPTION: Years ago.

Panel Two

On KLAW, wearing casual clothes. Cargo pants and a linen shirt
for the heat. His STUMP is wrapped in a DIRTY BANDAGE. He's got a
bottle of beer in front of him, but the cap is on. If we can see

behind him, there are BARE-CHESTED KIDS playing SOCCER/FOOTBALL in the dirt. Kids passing the time in poverty.

We're seeing this over Young Erik's shoulder.

> **KLAW:** Ya, I did.

> (linked)

> **KLAW:** M'Demwe says you've got royal blood. Noble Wakandan warriors **CHUCKING** magic spears and all that, ya?

Panel Three

On Young Erik.

> **YOUNG ERIK:** My father was a nobleman.

> **KLAW (off panel):** And now he's **DEAD**.

Panel Four

On Klaw, wiping the sweat from his face with a handkerchief. Using his good hand.

> **KLAW:** Let **WAKANDA** die with him, boy. Killing isn't **RITUAL**. It's **BUSINESS**. Don't make it complex.

> (linked)

KLAW: You're an **OUTLAW** now. A creature of escalation. Know what that means?

Panel Five

On Young Erik.

YOUNG ERIK: No.

KLAW (off panel): No, **SIR.**

Panel Six

Profile of Klaw and Young Erik. Klaw can be in shadow. Daylight hits Erik. It's like darkness itself speaking to him.

KLAW: It means I will teach you how to **KILL EVERYTHING.** Man or woman. Beast or child. Your gods are **DEAD.** I am your nation. Serve me, and I will provide.

(linked)

KLAW: No more **JUNGLE NAMES.** Gonna call you ... **ERIK** now.

(linked)

KLAW: Ya. My little Erik.

PAGE SEVEN

Panel One

Exterior, establishing panel of SOCIAL CLUB in Manhattan, the nice part of town, a pretty VACANT block. Only people who belong here walk down it. A LINE OF EXPENSIVE SEDANS PARKED OUTSIDE. All of them have a SUITED BODYGUARD standing next to it.

VOICE CAPTION: We're all here.

Panel Two

We're inside the SOCIAL CLUB. It's table-clothed dining areas and dim light. The kind of place business deals open and close. The place where you bribe U.S. Senators. The business behind business.

More PLAIN-CLOTHED (suited) bodyguards in the room. In the back, we're focused on the ONLY TABLE WITH PEOPLE. Four people seated there, all of them well-dressed. Underneath each of them is a CAPTION.

A WOMAN (40's), holding a martini.

CAPTION: *The money launderer.*

A BLACK MAN (30's).

CAPTION: *The International Lawyer.*

A WHITE MAN (40's).

CAPTION: *The Narcotics Trafficker.*

A SKINNY, BALD WHITE MAN (40's).

CAPTION: *The Accountant.*

The Bald Man is speaking.

> **BALD MAN:** So where's Fisk?

Panel Three

We're back outside of the social club. ALL OF THE BODYGUARDS by the cars are DEAD and BLEEDING. They've been shot quickly and quietly.

> **VOICE CAPTION:** Maybe he's late.

> **VOICE CAPTION:** Fat guys travel slow.

PAGE EIGHT

Splash

THE DOORS to the meeting hall have BLOWN open. King, Rook, Knight and Erik march into the room wearing FULL GEAR (KEVLAR CHEST ARMOR) and BALLISTIC FACE MASKS. Erik's face mask is BLACK, and he's the only one wearing a black one (to distinguish him).

They come in FIRING. Hard and LOUD. Using SUPPRESSED, AUTOMATIC WEAPONS.

Bodyguards are ALREADY being shot down.

> **SFX:** SPAKK! SPAKK! SPAKK! SPAKK! SPAKK!
> SPAKK! SPAKK! SPAKK! SPAKK!

NOTE: The following action sequence should feel CHAOTIC and LOUD. It's more about the EMOTION of the VIOLENCE and less about getting clear beats of violence. EMOTION. EMOTION. EMOTION.

PAGE NINE

Panel One

King uses his TELEKINESIS, SMASHING a table into a PAIR of BODYGUARDS.

 SFX: KRASSSSSSH

Panel Two

Rook takes a BULLET to his RIGHT HAND--the HAND getting BLOWN OFF at the wrist.

 SFX: SPLITCH

 ROOK: AGH!

Panel Three

Knight shoots The Accountant in the head.

 SFX: SPAKK!

Panel Four

Erik shoots the Lawyer in the chest.

>**LAWYER:** NGGH

>**SFX:** SPAKK!

Rook, with the ONE HAND he's still got, FIRES wildly from his weapon.

>**SFX:** SPAKK! SPAKK! SPAKK! SPAKK!

PAGE TEN

Panel One

Now there's GUNSMOKE filling the room. CHAOS. A bodyguard aims his 9MM at Erik. Erik can't see it. He's marching through the room and FIRING.

>**SFX:** SPAKK! SPAKK!

Panel Two

Rook CRASHES into the bodyguard, STABBING him in the neck with a KNIFE (in his good hand).

>**ROOK:** Erik! Watch it!

Panel Three

Rook STUMBLES to Erik.

>**ROOK:** I'm the **SHIELD**. Use me. **BODY ARMOR**
>will take most of it.

Panel Four

Erik GRABS Rook, holding him in front of him as a human shield. He's already aiming his gun into the room.

PAGE ELEVEN

Panel One

Erik's using Rook as a human shield. Rook's taking a CHEST HIT into his armor from somewhere, his SHATTERED HAND bleeding. Erik's FIRING.

>**SFX:** SPAKK!

Panel Two

The International Lawyer gets BLOWN AWAY by Erik's shot, flying over a table.

Panel Three

CLOSE on Erik, his eyes WILD behind his mask. He's firing a VOLLEY of shots.

> **SFX:** SPAKK! SPAKK! SPAKK! SPAKK!

Panel Four

The THREE REMAINING bodyguards are CUT DOWN by Erik's gunfire.

PAGE TWELVE

Panel One

Smoke and haze in the room. Rook's in a lot of pain. Erik helps Rook sit in a chair. Knight and King are standing.

The Money Launderer is on her knees, pleading for her life.

> **MONEY:** Please ... I can pay you. You don't have to kill me.

Panel Two

Erik leans over Rook. Rook's sitting in the chair, holding his SHATTERED hand close to his chest.

> **ROOK:** I'm ... fine. It'll grow back.

> **MONEY (off panel):** I can set you all up with accounts. **OFF SHORE.** Just gimme my phone...

Panel Three

Erik aims his weapon at The Money Launderer. She's TERRIFIED. Crying. PLEADING. Her hands in the air in front of her.

> **MONEY:** Please don't. Don't. Don't.

Panel Four

Erik's holding his weapon on The Money Launderer, but he's hesitating.

> **MONEY (off panel):** Please...

Panel Five

Just the SFX here. BLACK PANEL.

> **SFX:** SPAKKK!

PAGE THIRTEEN

Panel One

Knight stands next to Erik. HER gun is smoking. She took the shot.

> **KNIGHT:** We need to move.

Panel Two

King leads Erik out of the room. Knight's helping Rook to his feet, arm over her shoulder.

> **ROOK:** Agh. **EASY.**

Panel Three

Erik has stopped walking and he's looking over his shoulder. We can see his EYES behind the mask and they're a little wide. Taking something in that's affecting him.

Panel Four (the largest panel on the page)

ERIK'S POV

We see the bodies in the room. The smoke. The aftermath of a war that Erik wanted. A war he won.

>**KING (off panel):** Looks like anger won tonight, kid.

PAGE FOURTEEN

Panel One

We're back at the BEACH HOUSE. Night. CLOSE on Erik's hand, holding and SHAKING, whiskey spilling out of the glass.

>**KING (off panel):** Adrenaline makes the hands shake. Don't judge yourself for it.

>(linked)

>**KING (off panel):** It'll pass.

Panel Two

King sits with Erik on the BACK PORCH of the beach house, overlooking the water. They're out of their gear now. King's drinking from a glass. There's a bottle of Jack Daniel's on the table between them.

King's talking to Erik like a big brother. Calming him down with the conversation.

>**KING:** I have a little farm. Not in America. It's far from everything.

>(linked)

>**KING:** At night the sky is pure black. You can see all the stars blinking at you.

Panel Three

CLOSE on King.

>**KING:** When I get my money right, I'm going there. Working the land. I will pretend to be **NOBODY**.

Panel Four

On Erik.

> **ERIK:** Why you telling me this?

Panel Five

On King.

> **KING:** Because you need more than revenge, Erik. Think about the world that comes after. Have something to **LOSE.** You know why people in pain love Jesus?

Panel Six

On Erik.

> **ERIK:** No.

Panel Seven

On King.

> **KING:** Because you can endure **ANYTHING** if you believe heaven is on the way.

PAGE FIFTEEN

Panel One

Rook is ASLEEP, laying on the COUCH of the beach house. Knight touches his forehead gently. Like a mother or a sister.

> **ERIK (off panel):** He going to be all right?

Panel Two

On Knight and Erik.

> **KNIGHT:** He's healing. It's ugly, but he's survived worse. Wait until you see it grow back. Hope you have a strong stomach.

> **ERIK:** I **WAS** going to kill her.

Panel Three

On Knight.

> KNIGHT: Have mercy, Erik. Are you **STILL** trying to prove something?

> (linked)

> KNIGHT: The reason I'm **ON** this squad is you cowboys don't like killing women. If she was in that room, I promise you she deserved it.

Panel Four

On Erik.

> ERIK: So what happens now?

Panel Five

On Erik and Knight.

> KNIGHT: We tell Fisk it's done. Get the promotion. The GOOD WORK. Maybe he sends us after **DAREDEVIL**. That'd be something.

> ERIK: Daredevil? I don't know who that is.

> KNIGHT: Just another mask.

> (linked)

> KNIGHT: Don't look so lost, Erik.

Panel Six

Knight walks away from Erik, leaving the room.

> KNIGHT: You're getting what you wanted.

PAGE SIXTEEN

Panel One

We're inside the rear of a LUXURY SUV, BIG BODIED, PLUSH LEATHER SEATS. It needs to be big because WILSON FISK is sitting across from someone we can't see, taking up nearly all of the space of his seat. The SUV isn't moving, but we probably can't see out of the DARK TINTED WINDOWS.

FISK: If the nature of my work intimidates you, Mr. King, perhaps we should end our relationship with last night's **ACCOMPLISHMENT**.

Panel Two

King sits across from Fisk in the car. Alone.

KING: I'm not intimidated, Mr. Fisk. I'm confused.

(linked)

KING: Doesn't he work **FOR** you?

Panel Three

On Fisk.

FISK: I have no need for multiple contractors. I have a need for the **BEST**. I will know who that is when there is a **SURVIVOR**.

(linked)

FISK: Your compensation will be **GENEROUS**. If you succeed.

Panel Four

On King.

KING: We'll get it done, Mr. Fisk.

FISK (off panel): You were right about that young man.

Panel Five

On Fisk.

> **FISK:** Perhaps he **IS** of value.

PAGE SEVENTEEN

Panel One

Night. The ROOF of a PARKING GARAGE. King walks to Erik, Rook and Knight. The SUV drives away. We see the MAJESTIC SKYLINE of New York City.

> **KNIGHT:** What'd he say?

Panel Two

King walks PAST Knight, Erik and Rook. He's FRUSTRATED. Controlled anger.

> **KNIGHT:** King?

> **KING:** We're being set up. He's trying to get us killed.

Panel Three

King has stopped. He's turning over his shoulder. Saying something GRIM.

> **KING:** He's sending us after **BULLSEYE.**

> (linked)

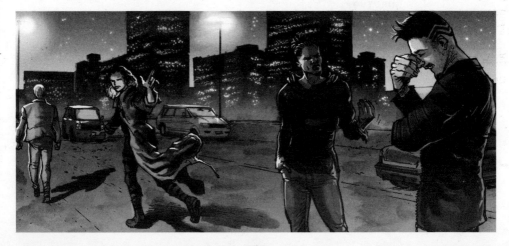

KING: That's a Goddamn **DEATH SENTENCE**.

Panel Four

King walks away from the group. Knight's walking to catch up with him. Erik stands with Rook.

KING: Make travel plans. We're **BURNT** in New York.

KNIGHT: Hold on. I'll talk to him.

ERIK: Who's **BULLSEYE**? You said Devil-Man.

ROOK: **DAREDEVIL**.

PAGE EIGHTEEN

Nine-panel grid

Panel One

King walking away. Knight calling to him off panel.

KNIGHT (off panel): King! Talk to me.

Panel Two

King turns sharply.

KING: We **CAN'T** beat Bullseye. **NO ONE** has.

Panel Three

A DARK GLOVED HAND drops a BOLA-STYLE WEAPON (three strings with small spheres at the end) like a yo-yo. We're too close to the hand to know where we are, but the lighting matches. THIS IS NEAR.

Panel Four

On Knight.

KNIGHT: This is the **EXIT STRATEGY,** King. You don't want to work for Fisk forever. You want to **RETIRE**. Tell Fisk we want **TRIPLE**.

(linked)

KNIGHT: We get it done and it's happily ever after.

Panel Five

On the GLOVED HAND SPINNING the bola.

> **SFX:** WHIMMMMMM

Panel Six

On King. Losing his temper.

> **KING:** It's a **TRAP**, Knight! Fisk **DOESN'T WANT** us.

> (linked)

> **KING:** Maybe it's leaving Erik alive. Maybe **"THE KINGPIN"** just changed his mind. Doesn't matter. We **LEAVE**. We survive. **THAT** is the call.

Panel Seven

On Erik. Looking down. He's got a little shame on him.

> **ERIK:** Rook. You saved my life.

> (linked)

> **ERIK:** I owe you.

Panel Eight

The BLACK GLOVED HAND THROWS the spinning bola.

Panel Nine

On Rook.

> **ROOK:** We're good.

> (linked)

> **ROOK:** Whatever problem we had--

PAGE NINETEEN

Panel One

The bola WRAPS AROUND Rook's neck. Erik LEAPS backwards, caught off guard.

> **ROOK:** Eck!

Panel Two

The bola EXPLODES around Rook's neck, an EXPLOSION where Rook's head should be.

> **SFX:** KOOOOOOOOOOOOOOOOOOOOOOOM

PAGE TWENTY

Splash

In the foreground, Erik has pulled a 9MM PISTOL, on his knees, recovering from the explosion. Rook's body has fallen close next to him.

In the background, the centerpiece of the panel, is BULLSEYE. Confident. Walking forward.

> **BULLSEYE:** So I hear you want to take **MY** job.
>
> (linked)
>
> **BULLSEYE:** I **LIKE** my job.

END SECOND ISSUE

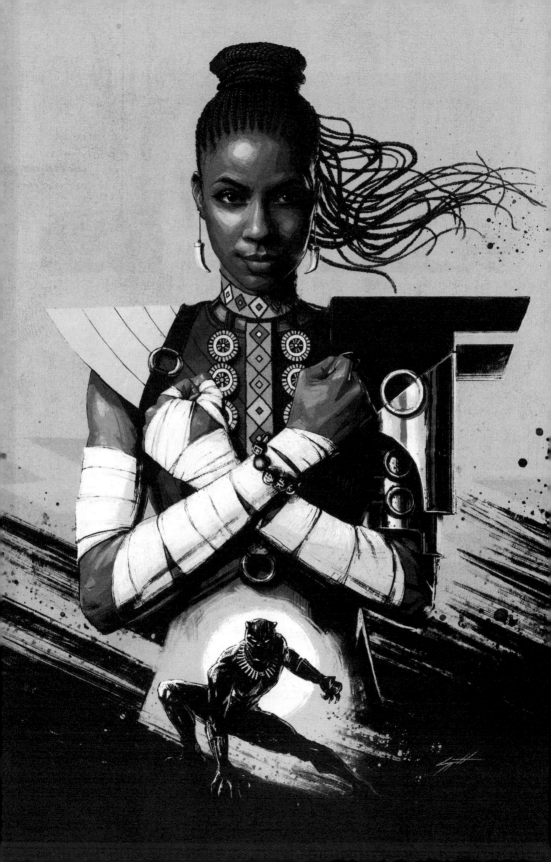

SHURI (2018) BY NNEDI OKORAFOR

AN INTRODUCTION BY **ANGÉLIQUE ROCHÉ**
IN CONVERSATION WITH **ANDREW SUMNER**

As with Bryan Edward Hill's Killmonger, this Shuri mini-series was created alongside the establishment of the movie iteration of Shuri. These Nnedi Okorafor scripts represent the first time we get a modern comics series that is focused directly on this amazing technology-focused leader, who has now come back to the world of the living. Nnedi's ability to lean on the character to tell her own story (and to lean on African influences and cultural influences) sets up the tone, and sets up the structure of this story in a uniquely scientific, almost mathematical way. Nnedi's heavily reference-based *Shuri* scripts are written and paced in a very, very succinct manner, with extremely direct, clear reference materials attached into the script, delineating Nnedi's required aesthetic. These references provide a very clear playbook for the elements Okorafor considers to be necessary for her scripts to establish Shuri's position within the Marvel Comics Universe.

The dopest thing about Nnedi Okorafor is that she trained as an athlete—her brain thinks like a person who trains and trains and trains to be truly great at what she does. And Nnedi Okorafor once had a freak thing happen to her that paralyzed her for a certain amount of time. While she was paralyzed, her friends brought in books for her, including science fiction books, and she was like, "Where are all the black people?"

The three other things that you need to know about Nnedi before you read these two scripts are that 1) she basically wrote her first book by the time she was done with her first year of college; 2) she loves insects; 3) she is a very proud, first-generation American. Those things ring true in the imagination of the stories that she crafts because she questions: "Why can't magic and sci-fi and fantasy exist and be influenced by black people in African culture? Why can't they look like me? And what does that look like? How does that manifest? How does that type of magic,

that type of fantasy, manifest when it's rooted in the culture, traditions, lore, and fables that are from the African continent?"

That is what Nnedi Okorafor really brings to the essence of telling stories, but she also brings this tremendous technical skill, because Nnedi writes comics like she's writing a mathematical equation. She knows where she wants to bring her characters. She knows how she wants a character to evolve, and she can visualize where she wants the character to be at the end of her run. There's no doubt in my mind that when she wrote the first lines of this story, Nnedi knew exactly where she wanted Shuri to be when this story was done.

Before Ta-Nehisi's run, Shuri is really this faceless character who we think is dead (well, kind of dead, but also not really). And then we meet her, in this space in between. And then she's brought back. One of the things that I love that Nnedi addresses very clearly in her scripts (because at this point within Marvel comic continuity—for those who are not keeping up with the rest of the line—Black Panther is in space, he has run away) is that T'Challa is out of contact at this point. Queen Ramonda basically says to Shuri, "Here's the thing: we don't know if your brother's gonna come back. And you're technically next in line. I'm a little older, I don't really need to rule. I've already done this thing. You need to get prepared to take on this thing again." And what Nnedi addresses in these scripts and this storyline is: "If I have a person who has already taken on the mantle of Black Panther and that person loses their life, learns all of the knowledge of the whole universe—or at least of the whole Wakandan people—and they get dragged back into the world of the living, they are not going to be okay."

But Shuri is also reconciling what it means to be back in the land of the living and suddenly have this responsibility thrust back on her. She can't be just a teenager—we are really meeting a whole new Shuri, one who has gone to the underworld and back. That's an interesting angle, specifically for Nnedi Okorafor to take, because she has a unique perspective (as a black woman writer with her specific life experience) about Shuri dealing with the burdens, stresses and fears that come with responsibility—even if you are equipped and brilliant, and even if it is your legacy. And what does

it mean to have to deal with the burden of legacy? To deal with it alone because your brother T'Challa has now left you—twice? That's a beautiful and interesting concept that Nnedi is able to encapsulate in these scripts. Shuri's back among the living, but we've skipped her childhood; she's now in her early twenties.

The whole narrative of these scripts feels like a book outline, because that's where Nnedi comes from, and Nnedi does write these very direct, profound, concrete stories. She establishes very succinct, clear characters. If you read Nnedi's *Binti* trilogy, Binti is a very brilliant woman who undergoes a profound transformation and has to deal with a world where she doesn't fit in. And that's kind of where Shuri is: she's in between all of this change because Wakanda was her home, and then it wasn't her home. And now it's her home again, but she's not the same person anymore. She doesn't even have a chance to figure out what kind of person she is before her brother T'Challa disappears. I find that very interesting. I think that the connection between Binti and Shuri is a very resonant one.

Nnedi's scripts let the reader know that Wakanda is fictional, but (as it now exists in the Marvel Universe) it's also a varied amalgamation of different African cultures. Nnedi's technical approach to these scripts and the template she creates gives her the freedom to pull African traditions into the narrative, traditions that are dear to her, that can enhance her characters and enhance her portrayal of Wakanda. Nnedi is undoubtedly a technical writer, but what really stands out about these *Shuri* scripts is the high level of detailed, visually augmented reference that she includes. I think it's a truly powerful aspect of the way Nnedi writes, from this technical perspective. There is an intention to infuse a very specific type of culture into her scripts, and to establish a cultural narrative that is rooted in traditional African realities. That all goes to the question of "What does sci-fi and fantasy look like if it is not rooted in Western culture, if it is rooted in a culture that was birthed in Africa?" Nnedi's specificity is one of the key, unique elements of her work as an Afrofuturist writer and an essential part of her great contribution, with these fascinating scripts, to the world of Shuri, T'Challa and Wakanda.

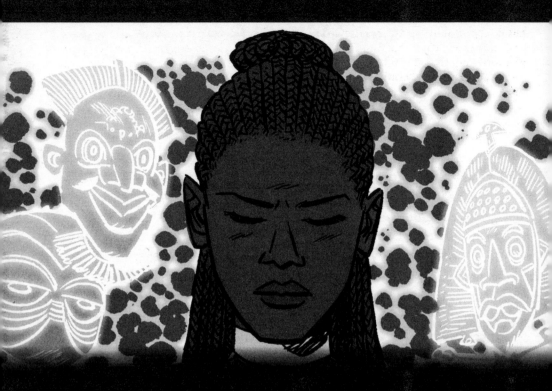

BLACK PANTHER

SHURI

ISSUE #1

2018

"Last Dance"

By Nnedi Okorafor

Art by Leonardo Romero
and Jordie Bellaire

Author's Note: Make sure Manifold looks closer to Shuri's age so his obvious love for her doesn't come off as creepy. Since we're straddling the lines with Shuri's age (she's younger and older and we're not specifying), Manifold should skew young. They should both look like they're in their early 20s.

PAGE ONE

PANEL 1 (Row 1)

Breaking Wakandan news showing the anchorperson (she wears an Ankara top). Beside the anchorperson is an image of T'Challa and Manifold's shuttle. It looks like a futuristic, sleek space shuttle. The simple design is like a long, slim, very shiny, short spear. Maybe the design of the Wakanda flag is worked onto the side of the ship in some way? The ship is on a small island in the middle of a lake.

> **DIALOGUE/ANCHORPERSON:** This launch will make Wakanda the first nation to send human beings beyond the moon. It will carry King T'Challa and Australian X-Men mutant Eden Fes, a.k.a. Manifold...

PANEL 2 (Row 2)

A town somewhere in Wakanda. The buildings are small, but modern, and the roads are dirt, but very neat and clean. This is not Birnin Zana (the capital city of Wakanda). There is a large screen in the middle of the town square, and people are standing in a small crowd looking at the newscast on the screen. We only see the launch site, and the image is closer to the ship.

> **DIALOGUE/ANCHORPERSON:** Built by Princess Shuri and her team, Princess Shuri boasts that this ship is lighter, faster and sturdier than anything yet built by humankind.

PANEL 3 (Row 3)

We're in the busy streets of Birnin Zana now, and people are walking as they look at projections of the launch from their kimoyo beads. Focus on a woman who stopped in the middle of the crowd to watch the same broadcast projected holographically from her beads.

> **DIALOGUE/ANCHORPERSON:** The shuttle launches in two hours at 9AM sharp...

PAGE TWO

PANEL 1 (Row 1)

At the launch site, Shuri, T'Challa (no mask) and Manifold are walking beside the ship. T'Challa and Manifold are all suited up for the journey (they should be wearing the same costumes that they wear in the Coates issues). Shuri is wearing the outfit from your new design. Beyond the ship we can see the lake, and in the distance the land. Shuri is talking to Manifold. She's smiling because she loves what she's saying. Manifold is looking at her. T'Challa is steps away, looking up at the ship

> **DIALOGUE/SHURI:** I covered the ship's exterior with a network of molecular wires that carry information to the central computer. So if something fails, needs attending to, basically if the ship 'feels badly', it'll alert you before disaster strikes! It's like a nervous system! I gave it skin!

PANEL 2 (Row 2)

Close on Shuri and Manifold as Shuri utterly grins at Manifold. Manifold might as well have hearts popping from his eyes, he looks so smitten.

PANEL 3 (Row 2)

T'Challa comes up behind Shuri and Manifold and interrupts the moment. The point of view is from in front of the three of them. Shuri is grinning at T'Challa's words.

> **DIALOGUE/T'CHALLA:** My sister is a genius.

> **DIALOGUE/MANIFOLD:** Trust me, I know.

PANEL 4 (Row 3)

T'Challa (his mask forming around his face--see Stelfreeze issues), Shuri and Manifold stand together talking.

> **DIALOGUE/SHURI:** Manifold, you'll take care of my brother out in space, right?

> **DIALOGUE/T'CHALLA:** I'm your older brother; I can take care of myself.

> **DIALOGUE/MANIFOLD:** We're going through a wormhole, T'Challa. You're taking me with you for a reason.

PAGE THREE

PANEL 1 (Row 1)

Shuri watches them walk away. The point of view is from beside her, so we see the side of her face watching them go toward the entrance of the ship.

> **CAPTION/SHURI:** T'Challa is so sure our missing gods are out there. I'm glad I convinced Manifold to go with him. He can bend time, that skill should come in handy after entering a wormhole.

PANEL 2 (Row 2)

Shuri is indoors now, but the point of view is close to the window, so we only see her and a full view of the ship taking off. There is no exhaust because this is a Wakandan ship and it's run using vibranium. There are only great blasts of air from the vibration.

> **CAPTION/SHURI:** While my brother is gone, I'm in charge.

PANEL 3 (Row 3)

Pull back to show that Shuri is standing in the Wakanda Mission Control Center. Beside her stand her mother Ramonda and N'lix, her scientific advisor. (He's a previously established character from Maberry's BLACK PANTHER run. N'Lix is a Wakandan inventor, he created the Desert Sands. I just think it would be cool if Shuri had a team, instead of just herself. It takes a team to invent stuff.) T'Challa's advisers Hodari and Akili are there too. Shuri's launch team (probably about ten people, at least half of them are female) sits, each looking at individual hologram screens.

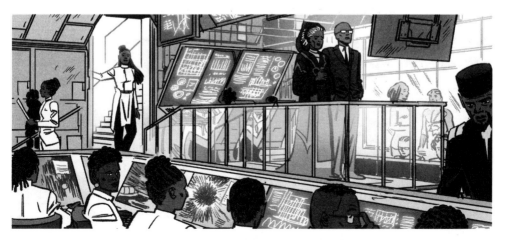

DIALOGUE/RAMONDA: *Ngikufisela inhlanhla*,
my son.

*"Good luck" in Zulu, the language of Ramonda's people.

(Base the Wakandan Mission Control Center on the Mission Control
Center at NASA, but far more futuristic. Team members have their
own curved individual screens and a HUGE screen that makes up the
ceiling; this screen is dome-like and shows outer space.)

PANEL 4

Zoom in on one of the hologram screens, now showing the ship
approaching a wormhole in space.

PAGE FOUR

PANEL 1 (Row 1)

Establishing shot of the Royal Palace.

PANEL 2 (Row 1)

It's nighttime and the point of view is from outside the very large
window of Shuri's lab, which is located near the top floor of the
palace. The lights are on and there is noise coming from inside.
We can't see anything inside due to the angle. We are looking up
at the window. There are two pigeons, who'd been sitting on the
windowsill, fleeing in fright.

SFX: Bzzzzzzzzz Shraaaaaaah!

CAPTION: Nearly two weeks later...

PANEL 3 (Row 2)

We are inside Shuri's lab now, and this is a detailed panel. Her lab is spacious (basically the one we see in the film). There is a humongous screen near the window with a chair in front of it. On this screen is an image of outer space and a spot in the center circled in purple. This is where the wormhole WAS but no longer is. At the top of the screen it says "1 Week: 6 Days: 23 Hours: 45 Minutes". This screen and the chair are not prominent in this panel, but they are there.

Shuri is wearing a tank top with an open back, and she wears a necklace with a tiny thimble on it. She's turned and is stumbling to the side, and we can see that there are wings on her back. The wings shine and shimmer brilliantly like they are made of silver thick foil. She has a happy, surprised look on her face.

Her wings are in the process of knocking things off the lab table beside her. Some things are in mid-fall.

>	**DIALOGUE/SHURI:** Whoa! Yes! They work!

PANEL 4 (Row 3)

She stands upright in her lab, flapping her wings. More things are getting knocked from and blown off the table, and there are papers blowing around her.

>	**DIALOGUE/SHURI:** My brother's going to
>	love this...

PAGE FIVE

PANEL 1 (Row 1)

Shuri pauses, looking at the window. Her wings are still, things are scattered on the floor--papers, pens, a tablet, bits of circuitry.

>	**DIALOGUE/SHURI:**	... when he gets home.

PANEL 2 (Row 2)

She's running toward her large open window, her wings pressed to her back.

>	**DIALOGUE/SHURI:** Let's just see how well
>	these work, shall we?

PANEL 3 (Row 3)

The point of view is from behind Shuri as she dashes toward the window. She's almost there. We see her wings from behind her. She looks like a strange angel. We get a glimpse of the large computer screen showing outer space and the circle around the place where T'Challa and Manifold vanished.

PAGE SIX

PANEL 1 (Row 1)

Shuri is leaping from her window, which is high up. We see her in the air, Birnin Zana spread out before and below her.

PANEL 2 (Row 1)

She plummets toward the palace buildings below. The point of view is from above her, looking down.

> **DIALOGUE/SHURI:** Ah! Come On! Fly!

PANEL 3 (Row 2)

She's caught herself. She's flying away from the palace, smiling.

> **DIALOGUE/SHURI:** There we go. My latest success! Nanotech wings. Emergency flight in a can. I am awesome.

PANEL 4 (Row 3)

She flies over the city in the night. She looks down. The sky is clear and it's a waxing gibbous moon. She looks solemn.

> **CAPTION/SHURI:** It's about to be exactly two weeks since we lost contact with my brother and Manifold when they entered that damned wormhole. Maybe in two minutes.

PAGE SEVEN

PANEL 1 (Row 1)

While over the city, she hovers for a moment, touching the thimble around her neck. The thimble glows purple where her fingertips touch it.

> **DIALOGUE/SHURI:** Retract.

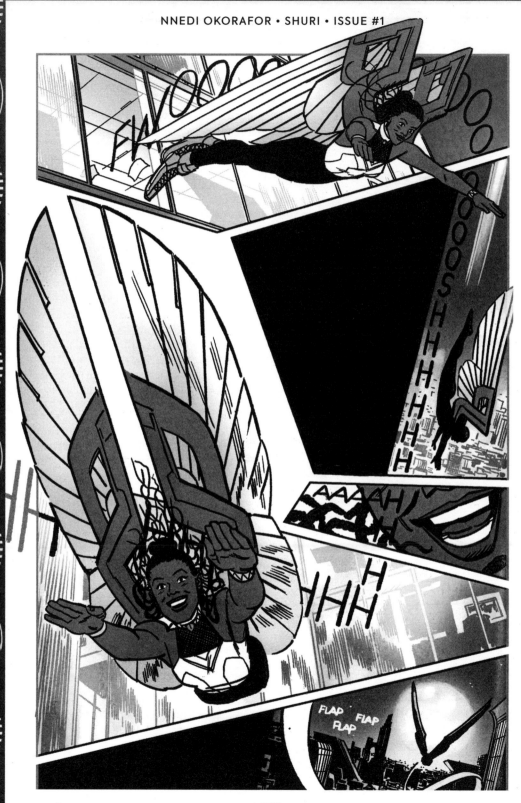

> **CAPTION/SHURI:** I'm not going to think about it. Just going to stay busy busy busy.

PANEL 2 (Row 2)

Still in midair, her wings are disintegrating into tiny shiny balls. Some are already going into the tiny thimble around her neck.

PANEL 3 (Row 3)

Shuri falls toward the city again. It looks like she's about to die, but she merely looks pensive and serene.

> **CAPTION/SHURI:** But now, two weeks. What to do?

PAGE EIGHT

PANEL 1 (Row 1)

Before she reaches the tops of the buildings below, she changes. Close on Shuri as she changes into a giant black bird (she did this once before in BLACK PANTHER #11--check out the "Ancient Future power" PDF).

PANEL 2 (Row 2)

As a giant black bird in the night, she flies up toward the palace. The thimble is around her neck.

> **CAPTION/SHURI:** While in my "living death," my soul traveled to the Djalia.* There, the Griot and my Ancestors taught and gifted me with so so much--flight, strength, shape-shifting, bringing back the dead. They even gave me ancient knowledge that I've woven into all these amazing new creations that work!... so *how* did I still lose my brother?

> **ED NOTE CAPTION:** *Djalia is Wakanda's collective memory.

PANEL 3 (Row 2)

As a black bird, she alights in her lab, her wings out.

> **CAPTION/SHURI:** And yes, people's Ancestors are always with them ... but mine never *left* me.

PANEL 4 (Row 2)

Shuri shifts back into her human form. She looks like a bird, tucking into itself with the head of a human.

PANEL 5 (Row 3)

Close on Shuri from the neck up, as she stands in her lab. Here we're going to show that when the Griots/Ancestors from the Djalia "visit the real world," they appear differently than how they did in the Djalia (in part because the main Griot looks just like Ramonda). So here in this panel we see three of the Griot/Ancestors floating around Shuri--one is a round mask, the second is a mask with wide bulging eyes, the third is a strange bronze creature thing.

> **DIALOGUE/SHURI:** Don't speak to me. I know. It's been two weeks. Just want to be alone right now.

> **DIALOGUE/ANCESTOR 3:** You're never alone, Ancient Future.

> **DIALOGUE/SHURI:** Ugh, don't call me that right now. Please.

PAGE NINE

PANEL 1 (Row 1)

Close on the computer screen with outer space (and the circle around where T'Challa and Manifold disappeared) on it. In the middle at the bottom there is something tiny that has appeared (it's a message icon). There should be little lines to show that there's a sound.

> **SFX:** Ping!

PANEL 2 (Row 1)

Shuri is tying a robe around herself as she walks to the screen and her chair. We can still see the three Ancestors hovering around her.

> **DIALOGUE/SHURI:** Oh, what now?

PANEL 3 (Row 2)

Close on the message on the huge screen. Shuri stands beside her chair, looking down at the message. Message in text form: "Muti: Today is the two week mark, isn't it?" This panel is smaller than the 4th panel.

PANEL 4 (Row 2)

Shuri plops down in the chair, a virtual keyboard appearing before her at the same time. Ancestor One and Ancestor Three hover around her.

> **DIALOGUE/SHURI:** Oooo, come on. It's late. Why is everyone up and reminding me?

> **DIALOGUE/ANCESTOR 3:** We don't sleep. Ancient Future, it's time to start looking harder for T'Challa.

> **DIALOGUE/SHURI:** I know, I know ... but ... please, just let me talk to Muti for a bit.

PANEL 5 (Row 3)

Shuri sits typing. The Ancestors have disappeared, so it's just her in her lab. She's wearing her robe. On the screen is an open box below the tiny one that opened on the huge screen.

> **CAPTION/SHURI:** Muti was my friend. One day, he hacked into my systems and we just started talking.

> **SFX:** Clackity clack clack!

PAGE TEN

PANEL 1 (Row 1)

Close on the screen. Muti's message says, "Muti: What are you going to do about him being missing now?" In the box, below Muti's first text, it now says, "So Sure: I don't know."

> **CAPTION/SHURI:** What I *did* know about Muti was that he was part of the Vibranium extraction academy, the son of farmers, and he lived in a Mute Zone, villages in Wakanda who'd hacked themselves off Wakandan networks.

PANEL 2 (Row 1)

Close on the texts. Below Shuri's text appears this: "Muti: I know it's late. Just checking on you."

> **CAPTION/SHURI:** Muti's the only person who doesn't call me "princess".

PANEL 3 (Row 2)

Shuri sits back in her seat and is shutting her eyes. The texting spot on the screen is still there. We prominently see the screen, "2 Weeks: 0 Days: 0 Hours: 15 Minutes".

> **DIALOGUE/SHURI:** Where are you, brother? And why? And what am I gonna do?

PANEL 4 (Row 3)

Shuri leans forward and is typing again.

> **SFX:** Clackity clack click...

PANEL 5 (Row 3)

Close on the texts. The new one says, "So Sure: When I was seven, I saved my brother from a snake..."

PAGE ELEVEN

PANEL 1 (Row 1)

This is a flashback, and this should be reflected in the colors. T'Challa (about 15 years old here, not wearing the Panther costume yet) and Zuri (T'Challa's old mentor/trainer) spar in a clearing where there is all grass and a baobab tree (this tree will be an

important location/setting at the end of this script), the forest continuing beyond the field.

> **CAPTION/SHURI [Note these captions are being written as a text message, so the font should reflect this]:** So Sure: When I was little, I used to sneak up on my brother when he was being trained.

PANEL 2 (Row 2)

Now shift to focus on Shuri, where here we reveal to readers that a seven-year-old Shuri is shimmying in the tall grasses, sneaking up on T'Challa, who is still sparring in the distance. Shuri has a slingshot strapped to her side.

> **CAPTION/SHURI:** Even then, I learned best by observation.

PANEL 3 (Row 2)

The point of view is from behind Shuri as she shimmies through the tall grass, like a snake in the grass. A grasshopper is leaping away. She's very close to T'Challa now as he spars with his teacher.

> **CAPTION/SHURI:** And I moved like a panther.

PANEL 4 (Row 3)

T'Challa is leaning and stepping back to dodge a blow from his teacher's fist. Shuri is directly at his feet, looking right at an actual snake that is mere inches from T'Challa's foot. Her eyes are wide with shock.

PAGE TWELVE

PANEL 1 (Row 1)

Close on Shuri in the grass on her belly. The point of view is from behind Shuri's head. The snake is in front of Shuri and it's facing T'Challa, ready to bite. Shuri is already grabbing a rock as she keeps an eye on the snake.

PANEL 2 (Row 2)

Close on Shuri. The point of view is right in front of Shuri as she aims the stone in her slingshot at us/the snake.

> **DIALOGUE/SHURI:** Brother...

PANEL 3 (Row 3)

The point of view is from behind Shuri as she lets the stone fly.
The slingshot's rubber band has already released the stone. It's
flying toward the snake. T'Challa's foot and leg are still in
biting distance. The snake is coiled, about to strike. T'Challa is
now looking down at Shuri and the snake.

> **DIALOGUE/SHURI:** ... watch out!

PAGE THIRTEEN

PANEL 1 (Row 1)

Close on the snake and the stone crashing into its head.

PANEL 2 (Row 2)

T'Challa is turned around to see Shuri still on her belly,
slingshot in hand. The dead snake lies at his feet.

> **DIALOGUE/T'CHALLA:** Great Bast!

PANEL 3 (Row 2)

The point of view is from behind T'Challa's teacher as he comes to
T'Challa and Shuri. Shuri is wildly kicking away the dead snake,
her slingshot still in her hand, a foot in the air, the snake
flying.

> **DIALOGUE/T'CHALLA:** What are you even dong
> here, Shuri?
>
> **DIALOGUE/SHURI:** Saving you.

PANEL 4 (Row 3)

Focus on the teacher.

> **DIALOGUE/TEACHER:** A twig snake in the
> grass. That's unusual. Shuri, you just
> saved the next King of Wakanda. Be proud.

PANEL 5 (Row 3)

Focus on the young Shuri standing there with her slingshot, looking
annoyed.

> **CAPTION/SHURI:** He didn't even say, "good
> shot".

PAGE FOURTEEN

PANEL 1 (Row 1)

Close on Shuri's lab screen on which Shuri has typed, " ... say,
'good shot'. It was always about my brother first. He was the right
sex, plus he was the oldest. Now he's flown off and I can't find
him ... and I built that ship ... what if it's my fault?"

PANEL 2 (Row 1)

Pull back a bit to show Shuri sitting and looking at the screen
where Muti has responded, "Muti: Maybe he's lost." The point of
view is from the side so we see the response and the annoyance
(similar to the look on her face when she was little). We see
Ancestor 3 (dimmer than usual) hovering beside her shoulder.

> **DIALOGUE/SHURI:** See? Always about my
> brother. I'm going to bed.
>
> **DIALOGUE/ANCESTOR 3 [the font should be
> small to reflect this is whispered to
> her ... and not heard]:** And you shouldn't
> be talking to strangers on a computer.

PANEL 3 (Row 1)

On the screen it shows the bottom half of "Muti: Maybe he's lost."
And then this right below it:

So Sure: I guess I should be looking for him instead of talking to you, right? TTYL.

MUTI: [Eyes rolling emoji]. Later.

Shuri is getting up from her chair.

PANEL 4 (Row 2)

Shuri is in the Birnin Zana Market. She's dressed in her costume but wearing a pretty periwinkle shawl over herself to hide her identity. It's daytime. She's standing beside a booth where many colorful textiles are being sold. She's holding a tiny glass ball and looking down at it in her hand.

CAPTION: The next day...

PANEL 5 (Row 3)

Shuri drops the small globe. People are passing by her and doing business at the textile shop, taking no notice of what she's doing.

PAGE FIFTEEN

PANEL 1 (Row 1)

Close on the ball rolling through the market, past the textile shop. The point of view is on the ground from in front of the rolling shiny glass ball, and we can see Shuri watching it roll away.

PANEL 2 (Row 2)

Shuri is looking at her kimoyo beads, from which a hologram is projecting the market around the ball.

> **DIALOGUE/SHURI:** Alright. It's working.
> First the Wings-in-a-Can, now Little
> Sauron. I'm on a *roll*.

PANEL 3 (Row 2)

Close on her kimoyo beads showing where the ball is rolling.

> **DIALOGUE/SHURI:** Find the meat market.
> That's always fun.

PANEL 4 (Row 3)

The point of view is behind the ball as it rolls into the meat market. There are sellers offering all kinds of meats. There are also refrigeration pillars beside the laid-out meat that send out cool air to keep the meat fresh and free of flies. It's the traditional blended with the modern.

PANEL 5 (Row 3)

Shuri is still standing in the same spot at the textiles, looking at the projection on her kimoyo beads.

> **DIALOGUE/SHURI:** Heehee, perfect sound,
> perfect HD image, and perfect scent! I
> can even *smell* the blood. I'm crushing
> the game of spy tools.

PAGE SIXTEEN

PANEL 1 (Row 1)

Close on the projection on her beads and the image of the meat market is interrupted with the words, "Incoming message".

> **DIALOGUE/KIMOYO BEADS:** Queen Ramonda

PANEL 2 (Row 1)

Shuri stands there, her mother projected on her kimoyo beads.

> **DIALOGUE/RAMONDA:** Where are you?

> **DIALOGUE/SHURI:** The market.

> **DIALOGUE/RAMONDA:** Without guards? You need to stop doing that.

> **DIALOGUE/SHURI:** Mother, I'm fine.

PANEL 3 (Row 2)

Close on the hologram of Ramonda.

> **DIALOGUE/RAMONDA:** I'm not arguing with you right now. Come to the baobab spot. We have an important meeting there in an hour. And don't fly there alone; have the guards drive you.

> **DIALOGUE/SHURI:** Aw, come on. I'm busy, and those meetings are boring. Nothing ever gets done.

PANEL 4 (Row 2)

Shuri is transforming into a flock of birds (the power we've shown her most frequently use, like on the BP #9 cover). Half human still, part flock of birds. Taking off to get to the meeting location.

> **DIALOGUE/SHURI:** Hung up on me, just like that. Really? This better be important.

PANEL 5 (Row 3)

Cut to Shuri now arriving, transitioning back to human from flock of birds, landing on a dirt path between the trees. The shawl is gone now, perhaps left in the market, dropped when she transformed. There is tech in the tree to her left (like one of those disguised

cell phone trees, but this tree is real, with the cellphone tech embedded in it).

> **DIALOGUE/SHURI:** Don't know why we'd have an "urgent" meeting all the way out here.

PANEL 6 (Row 3)

The point of view is from behind Shuri as she approaches some bushes and starts to part them.

PAGE SEVENTEEN

Splash page.

This is the baobab tree clearing where she once saved T'Challa from the snake. All the women (except Okoye) are seated in front of the tree, facing Ramonda. Okoye sits with her back against the baobab tree. Her spear is in her lap. Shuri is just stepping into the clearing.

Sitting in the group in the grass before the baobab tree are:

Bube, a single mother of two from a Mute Zone and a seamstress, 34 yrs old. She wears a grand pink dress.

Zuwena, an older woman who is director at the extraction academy, 75 yrs old.

Mansa, a teenage girl from Nakia's village, 18 yrs old.

Tiwa, an older woman who is the mother of ten, 73 yrs old.

> **DIALOGUE/ZUWENA:** Now we're all here.

> **DIALOGUE/RAMONDA:** You're late.

> **DIALOGUE/SHURI:** Do I have to sit? Snakes like this place.

PAGE EIGHTEEN

PANEL 1 (Row 1)

Focus on Zuwena, who is sitting. Ramonda is standing behind her. The point of view is from Shuri's and we see the other women turned and looking at us/Shuri as Zuwena speaks.

DIALOGUE/ZUWENA: Historically, when Wakanda was in trouble, the women would meet ... in secret. Over the years, this tradition has fallen to the wayside.

PANEL 2 (Row 2)

Focus on Ramonda.

DIALOGUE/RAMONDA: It's called the Elephant's Trunk and I'm bringing it back, because right now it is needed. We will discuss, and then I will bring these words to the council.

PANEL 3 (Row 2)

Focus on Okoye.

DIALOGUE/OKOYE: We've a wide representation of Wakandan women for the little time I had to choose first members. Everyone here has been vetted and sworn to secrecy. Women, give your introductions. Princess Shuri, you know me, Okoye, Dora Milaje General.

PANEL 4 (Row 3)

Pull back to show all the women, but close enough where we can see their faces. Shuri is sitting furthest from Ramonda, near where she'd entered the clearing.

DIALOGUE/ZUWENA: I am Zuwena, director of the extraction academy.

DIALOGUE/MANSA: My name's Mansa, I'm from Q'Noma Valley. I ... just graduated from high school.

DIALOGUE/TIWA: I'm Tiwa, mother of four and professor of physics at Wakanda University.

DIALOGUE/BUBE: Bube, single mother of two, dress maker of many.

PAGE NINETEEN

PANEL 1 (Row 1)

Focus on Ramonda.

> **DIALOGUE/RAMONDA:** We'll get right to it.
> King T'Challa has been missing for two
> weeks and Wakanda needs a leader.

PANEL 2 (Row 1)

Focus on Okoye.

> **DIALOGUE/OKOYE:** Let's remember that the
> Black Panther is no longer the ruler of
> Wakanda, except in spirit.
>
> **DIALOGUE/TIWA:** But what's a nation
> without a spirit.
>
> **DIALOGUE/SHURI:** He's not dead, he's
> just ... out of reach.

PANEL 3 (Row 2)

Bube is looking angrily at Ramonda.

> **DIALOGUE/BUBE:** Why do you royals keep
> these kinds of secrets from the people of
> Wakanda? We're not children. This is why
> everything happened.*

> **DIALOGUE/RAMONDA:** What do you think will
> happen if the nation knew King T'Challa
> was missing?
>
> **DIALOGUE/BUBE:** We'll keep living our
> lives. Gods or no gods, Wakanda forever.
>
> **ED NOTE CAPTION:** *If you want to know
> what "everything" is, check out Ta-Nehisi
> Coates' 'Black Panther: A Nation Under
> Our Feet' and Roxane Gay's 'World of
> Wakanda'.

PANEL 4 (Row 3)

Close on Mansa (the teen) as she speaks.

> **DIALOGUE/MANSA:** Right now, fact: The
> world knows we sent our king into space.
> It's only a matter of time before it
> knows he's missing. We have to appear
> strong ... right?

PANEL 5 (Row 3)

All the women, including Shuri, look at the teen girl, surprised
by her wisdom.

PAGE TWENTY

PANEL 1 (Row 1)

Pull back to show all of them sitting in the group. The point of
view is from above. On the other side of the baobab tree there
actually is a snake slithering along its way, unconcerned with the
activities of humans. Shuri looks confused.

> **DIALOGUE/RAMONDA:** Right, Mansa. So we are
> all in agreement, then.
>
> **DIALOGUE/ALL THE WOMEN (except Ramonda
> and Shuri):** Yes.
>
> **DIALOGUE/SHURI:** Agreement to what?

PANEL 2 (Row 1)

The point of view is from just behind Ramonda. We see Shuri sitting
amongst the other women, all of them looking at us/Ramonda. Shuri's
eyes are wide with surprise.

DIALOGUE/RAMONDA: Shuri, stand up.

PANEL 3 (Row 2)

Ramonda is speaking to Shuri. The point of view is from the side, so we see some of the women's faces and the backs of the heads of others. Shuri is standing as Ramonda speaks to her. The teen is actually grinning with excitement, the other women look eager with bated breath.

DIALOGUE/RAMONDA: Shuri, you're a woman of many names because you are so many things. The Ancestors call you Ancient Future. Some of us call you the Griot. I call you my daughter. All of us here have agreed. You've already earned Bast's approval. And you've done it before.

PANEL 4 (Row 3)

Close on Shuri's face as she looks at us. Strong, contemplating, ready. We see a dim image of the Ancestors behind her.

DIALOGUE/RAMONDA (off): Will you step up and be the Black Panther?

... TO BE CONTINUED.

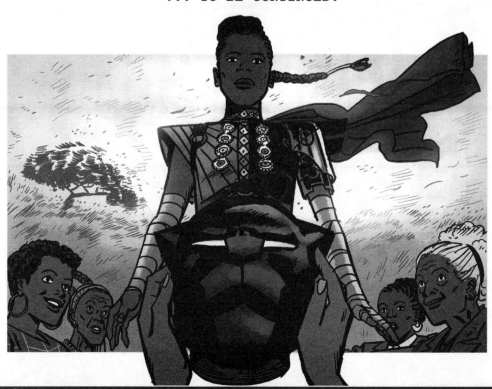

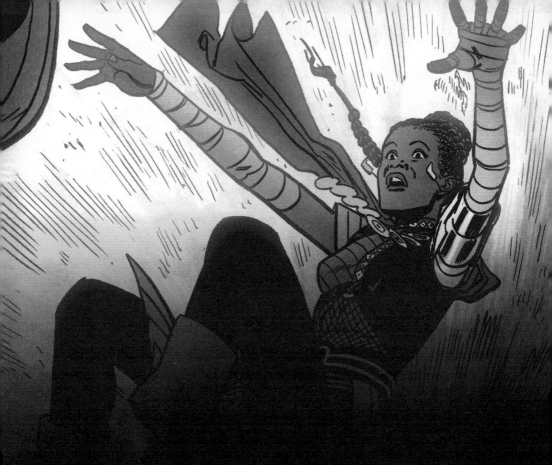

BLACK PANTHER

SHURI

ISSUE #2
2018

"The Baobab Tree"

By Nnedi Okorafor

Art by Leonardo Romero
and Jordie Bellaire

Author's Note: This continues right where Issue 1 left off, thus everyone is in the same outfits, etc.

Storm's hair is braided as it was in X-Men: Wakanda Forever. Also, a reminder: Storm's skin tone should be dark, like Shuri's, and her features African.

For easy reference, here are the descriptions of the Elephant's Trunk:

Bube, a single mother of two from a Mute Zone and a seamstress, 34 yrs old. She wears a grand pink dress.

Zuwena, an older woman who is director at the extraction academy, 75 yrs old.

Mansa, a teenage girl from Nakia's village, 18 yrs old.

Tiwa, an older woman who is the mother of ten, 73 yrs old.

PAGE ONE

PANEL 1 (Row 1)

Close on Shuri's face. She's looking right at us as she speaks.

> **DIALOGUE/SHURI:** No. I'm not going to take up the mantle of the Black Panther.

PANEL 2 (Row 2, 3)

This is a detailed sun-shiny panel. Pull back to show that she's standing amongst the women of the Elephant's Trunk. They are still at the baobab tree. All the women are sitting except for Shuri and Ramonda, and Okoye leans against the baobab tree carrying her spear.

Shuri and her mother are facing each other. All the women are sitting with their backs to the tree, facing Ramonda. The three ancestors hover around Shuri, their faces unreadable.

Ramonda looks surprised.

Mansa and Tiwa look annoyed (the youngest and oldest in the group). Tiwa is giving a side-eye, Mansa is rolling her eyes. Bube is smirking.

DIALOGUE/SHURI: ...I've done that before
and it wasn't a good fit. I DIED wearing
that suit, died trying to live up to that
legacy. And I really don't like who I
was back then. Wakanda wanted my brother,
I'll just end up walking in his shadow
for ... for however long he's gone. Let
this tradition end and let's begin a new
one. One where Wakanda stands on its own,
without needing symbols or a protector.
Maybe that's why the gods left. Let's
stand up and show the world who we really
are.

DIALOGUE/MANSA: Oh, come on.

DIALOGUE/TIWA: *Mscheeeew.*

PAGE TWO

PANEL 1 (Row 1)

Focus on Bube. She's still sitting, a smirk on her face.

DIALOGUE/BUBE: Smart woman. I'm tired of
the realm's prominence. We're already
halfway there. Modern African democracy
is our best future.

PANEL 2 (Row 1)

Pull back so we can see Okoye, who is leaning against the tree,
grasping her spear.

DIALOGUE/OKOYE: Bube, why are you so bitter?

DIALOGUE/BUBE: I'm not bitter. By the
way, General Okoye, kudos to you for
seeing past yourself enough to choose a
group that includes some of us who don't
worship King T'Challa.

PANEL 3 (Row 2)

The women continue to talk. Shuri and Ramonda are staring at each
other as the women talk around them, clearly having a silent
mother-daughter conversation.

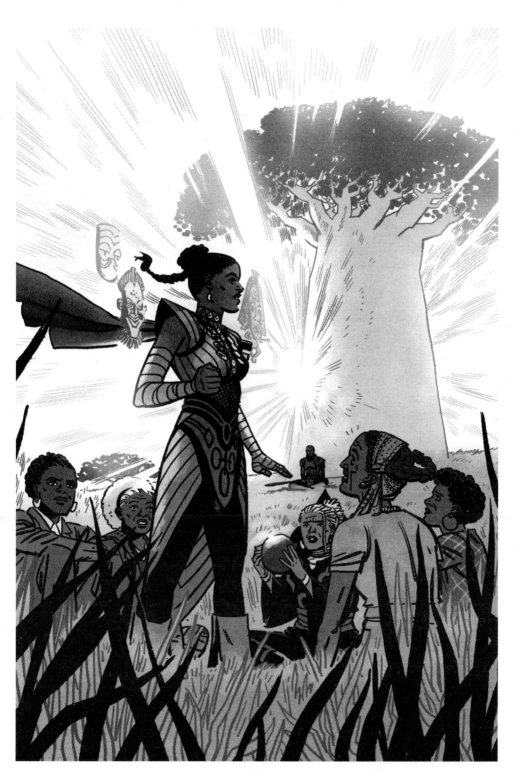

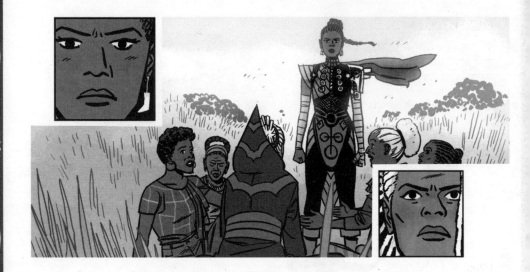

DIALOGUE/MANSA [to Tiwa]: Shuri would kick ass as Black Panther. Why won't she do it?! She's done it before.

DIALOGUE/TIWA: The days where duty is understood have long been over.

DIALOGUE/ZUWENA: Nothing is definite. We should table this for now.

PANEL 4 (Row 3)

Ramonda faces Shuri. The point of view is tight on them.

DIALOGUE/RAMONDA: Clearly we made a mistake asking you, daughter. No, you are not your brother.

PAGE THREE

PANEL 1 (Row 1)

Close on Shuri's shocked and dismayed face. This is an awful thing her mother has said to her.

PANEL 2 (Row 1)

Pull back to show Shuri stalking away from her mother, her mother stands looking at her go, angry looks on each of their faces. There are defiant tears in Shuri's eyes. There are no tears in Ramonda's eyes. This is a deep and old family tension.

PANEL 3 (Row 2)

Shuri walks up the path, behind her is the clearing where her mother stands and the other women sit (except Okoye, who is at the baobab tree) looking at her, in the distance. The point of view is in front of Shuri, so were can see her face clearly, along with everyone in the distance.

Lush trees flank the path. Shuri's face is wet with tears and she's clearly distraught. She's slapping a low hanging tree branch, sending leaves flying.

> **SFX:** Thwack!

> **DIALOGUE/SHURI:** I'm staying focused on what matters right now.

PANEL 4 (Row 3)

Shuri is changing into a flock of black birds and the birds are flying into the sky, above the trees. The point of view is behind her now, so we see up the path where it meets the road.

> **DIALOGUE/SHURI:** I'm gonna find my brother.

PAGE FOUR

PANEL 1 (Row 1)

It's still sunny. Shuri is a flock of birds, flying wildly in the air just above the treetops (make sure there are some palm trees mixed in with other trees). There is tech in some of the tree-tops. A cell phone tower tree.

There are two green parrots flying out of one of the treetops as Shuri flies by.

> **SFX:** Flap flap flap!

PANEL 2 (Row 2)

The birds are flying over Birnin Zana. The palace before them and it seems to be surrounded by its own small ... storm. Lightning is flashing from inside the clouds. Shuri/Flock of Birds is about a mile away from bursting into it. This is a detailed panel that gives us a good view of the innovation of the city. There are other birds on rooftops, including pigeons. There is a green rooftop and a hut on that green rooftop. A hawk is perched atop a lightning rod and it's eyeing the storm in the distance.

PANEL 3 (Row 3)

As a flock of birds, Shuri is slicing into the turbulent winds of the storm as she approaches the palace. The birds are getting violently buffeted around.

PANEL 4 (Row 3)

The turbulent storm is flinging all the birds wildly and wetly into Shuri's lab. Some birds are tumbling, skidding onto the floor. Other birds are in mid-air, flying into the room. It's chaos and each bird look like its in various stages of trouble. The point of view is from inside the lab and we are facing the window, so we see what's happening with each bird, we see the thunderstorm chaos of rain, lightning, and wind outside, the rain spattering inside.

PAGE FIVE

PANEL 1 (Row 1)

Shuri stands in front of the window, her clothes soaked. She's staring at Storm, who is sitting in her lab on a coach near the bookcase. Everything about her body language says sad, so so so sad. She's looking up at Shuri and Shuri is looking right at her. Storm's hair is braided, as it was in X-Men: Wakanda Forever Issue 2.

> **DIALOGUE/SHURI:** Oh!...all that's from you.

> **DIALOGUE/STORM:** My love is lost in space.

PANEL 2 (Row 2)

Shuri is looking back at the window. Papers are blowing around the room and rain is spattering in. Behind her, Storm still looks distraught.

> **DIALOGUE/STORM:** I'm sorry.

PANEL 3 (Row 2)

Shuri is sitting beside Storm on the couch and hugging her.

> **DIALOGUE/SHURI:** We'll find them, Storm. I built that ship. It's made to bring them home safely. But how did you know?

PANEL 4 (Row 3)

Shuri has stood back up and is flicking water from her wet arms.

> **DIALOGUE/STORM:** Your mother broke down yesterday and she finally told me. I came right away. Two weeks! Where are they?

PANEL 5 (Row 3)

The point of view is from behind Shuri as she stands turned toward the window again and we see that outside, the storm has retreated; the sun is peeking through the storm clouds. Water drips from the top of the window.

> **DIALOGUE/ SHURI:** I'm working on that. I need a little time.

PAGE SIX

PANEL 1 (Row 1)

Storm and Shuri both stand at the large window, looking out at Wakanda. The point of view is from behind them. Outside, the sun shines, drops of water and dripping from the top from the window.

> **DIALOGUE/ANCESTOR 1:** Shuri, tell Ororo that we welcome her back to Wakanda.

> **DIALOGUE/SHURI:** Storm, the Ancestors greet you and welcome you back to our fine country.

> **DIALOGUE/STORM:** Hello, Great Ones and thank you. Though I wish my coming was for better reasons. Shuri, you can still hear them?

> **DIALOGUE/SHURI:** Of course. Ugh.

> **DIALOGUE/ANCESTOR 2:** And a blessing we are.

PANEL 2 (Row 2)

Change the perspective, but they still stand looking out the window. The Ancestors are hovering around both Shuri and Storm.

> **DIALOGUE/STORM:** That's so fantastic.

> **DIALOGUE/SHURI:** Yeah ... except sometimes I really don't feel like having access to the entire history of Wakanda allllllll the time.

> **DIALOGUE/ANCESTOR 3:** Knowledge is power.

PANEL 3 (Row 3)

Storm is walking away from Shuri toward Shuri's giant screen. She's far enough for Shuri and the Ancestors to have their own private conversation. Shuri is looking at her go; she's still standing at the window.

> **DIALOGUE/STORM:** I want to see the exact place where their ship went into the wormhole and you lost contact. Come show me.

> **DIALOGUE/ANCESTOR 1:** If you don't know where you've been, you can never know where you are going. Ororo is an old soul.

DIALOGUE/ANCESTOR 2: The gravitational pull of a wormhole is nothing compared to pull of the heart.

DIALOGUE/SHURI: [quietly] Oh stop. The only way we're going to find them is through solid science.

PAGE SEVEN

PANEL 1 (Row 1)

Storm and Shuri are in Shuri's lab looking at the huge screen, the spot where T'Challa and Manifold's ship disappeared is circled as it was in Issue 1.

DIALOGUE/SHURI: It took them 30 hours to get to the wormhole. Then, the moment they went in ... nothing.

DIALOGUE/STORM: They're out there somewhere, I'm sure.

PANEL 2 (Row 1)

Focus on Storm.

> **DIALOGUE/STORM:** I think we should go see Chief Ikoko, T'Challa's scientist friend from one of the mute zones.

PANEL 3 (Row 2)

Focus on Shuri, smiling and winking. Small panel.

> **DIALOGUE/SHURI:** Ah, you mean his ex-*girl*friend. Nice how you left that detail out.

PANEL 4 (Row 2)

Shuri is walking toward the window and looking outside. Storm is behind her, staring at the screen.

> **DIALOGUE/STORM:** Be serious, Shuri. *She* contacted *me* first. She's the one who told me to talk to your mother about the ship being missing.

> **DIALOGUE/SHURI:** She knew?

> **DIALOGUE/STORM:** Suspected. And she was right.

> **DIALOGUE/SHURI:** ...well she's not a scientist, not a real scientist.

> **DIALOGUE/STORM:** Now who's mincing words? She's a scientist of the spiritual. She even has a PhD, so she's a doctor of it.

PANEL 5 (Row 3)

Storm is still staring at the screen. Shuri has turned from the window to look at her. Shuri's kimoyo beads are lighting up as she gets a call from Okoye.

> **DIALOGUE/SHURI:** If I can't find him, what makes you so sure *she* can?

DIALOGUE/STORM: Three days after they went missing, she contacted me. She too had been tracking them, just in a different way. I didn't believe her ... didn't want to. If she can do that, well, maybe she can do more.

PANEL 6 (Row 3)

Close on Shuri's beads as Shuri looks down at it. Okoye is projected as a hologram.

DIALOGUE/OKOYE: Shuri, I think your mother might be missing. Come meet me in her sitting room.

PAGE EIGHT

PANEL 1 (Row 1)

Storm and Shuri stand with Okoye in Ramonda's sitting room. It's elegant with a South African flair.

DIALOGUE/SHURI: So my mother didn't come back with you?

DIALOGUE/OKOYE: We flew out just after you left. But she insisted ... I mean *really* insisted we drop her at one of the markets far from the palace. Wouldn't let any guards go with her. We haven't heard from her since. Can't even track her beads, she must have switched them off.

PANEL 2 (Row 2)

A different angle showing them talking. Shuri is frowning, annoyed with what she sees as her mother's antics. Remember, in the previous issue she told Shuri not to travel about without guards.

DIALOGUE/SHURI: I think my mother's trying to make a point. To me. Please, Okoye, can you find her immediately and tell me as soon as you do?

DIALOGUE/OKOYE: Of course.

PANEL 3 (Row 2)

Close on Shuri. She's turned away from Okoye, as Okoye and Storm talk. She's typing into a virtual screen and we can see it.

> **So Sure:** *Muti, my mother ... can you locate her with whatever means you have?*

PANEL 4 (Row 2)

This is a very small panel that shows what Shuri typed and Muti's response of:

> **Muti:** *On it.*

PANEL 5 (Row 3)

Storm and Shuri rush down the hall. Shuri is looking at her kimoyo beads as they rush.

> **DIALOGUE/SHURI:** N'Lix, quick favor, put in a surveillance protocol to locate my mother. Let me know the minute you find her.

> **DIALOGUE/STORM:** I'm sure your mother is fine.

> **DIALOGUE/SHURI:** I know ... but I need to be sure. Ugh, mama has made her point. Now, follow me. We're traveling to the mute zone in style.

PAGE NINE

PANEL 1 (Row 1)

Storm and Shuri stand in an amazing garage. T'Challa's motorcycle sits in the back, there are four huge wheels made of metal mesh (those are made to roll on the moon), there's a sleek flat vehicle that looks like a hover car, but it's in near pieces, there is a block-like toy-like car whose front looks exactly like its back, and the walls are full of tools and equipment and computer screens. The shape of the room is dome-like. It's not enormous, but it's spacious for a garage full of tech in various phases of operation. There are decorative African masks on the upper parts of the walls ... so it looks like many ancestors are watching over whoever works here.

We see the ancestors floating around Shuri. Shuri is carrying a flat black heavy square.

> **DIALOGUE/SHURI:** We could fly there, but this will be much faster and way more fun.

PANEL 2 (Row 2)

Shuri is throwing the square to the ground. It's somewhat heavy, so she's straining a bit to throw it down.

> **DIALOGUE/SHURI:** ...you're supposed to enter mute zones on foot. This is heavy but we can just wedge this in a tree until we're ready to come back for it.

PANEL 3 (Row 2)

The square is wildly unfolding.

PANEL 4 (Row 3)

It's unfolding more, and beginning to look like what it is ... a very fast—looking two-person trike that uses air for wheels.

PANEL 5 (Row 3)

The trike looks amazing and sleek, albeit a bit flimsy (because it's foldable). Shuri is holding her hands out and Storm is smirking, her arms crossed over her chest.

> **DIALOGUE/SHURI:** Voilà! A foldable trike! Like *The Jetsons*!

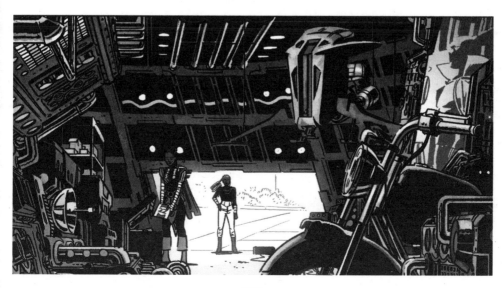

PAGE TEN

PANEL 1 (Row 1)

Storm stands there looking at the trike. Shuri is already
sitting inside.

> **DIALOGUE/STORM:** Looks cramped. I don't
> like cramped.

> **DIALOGUE/SHURI:** Just climb in.

PANEL 2 (Row 1)

They both sit inside the trike now. The windshield and top half
of the trike is fully transparent. Little lines show that the
windshield and top of the trike have just disappeared.

> **DIALOGUE/SHURI:** See? The roof can be
> opaque or transparent. Not so cramped
> now, huh? I made that part for people
> like you.

PANEL 3 (Row 2)

The point of view is from behind the trike as they zip down the
road, the city skyline in the background. They are driving down a
two-lane highway, lush forest on both sides.

> **DIALOGUE/SHURI:** Manifold once told me
> about the Australian aboriginal concept
> called Dreamtime. He said it helped him
> understand the line between body and mind,
> the scientific and the mystical. I guess
> if I look at it that way, it makes sense.

> **DIALOGUE/STORM:** Manifold. I think you two
> make a nice couple.

> **DIALOGUE/SHURI:** Manifold is in space,
> right now.

> **DIALOGUE/STORM:** So is my T'Challa.

PAGE ELEVEN

PANEL 1 (Row 1)

They have stopped the trike at the decorative archway over the road. It's covered with flowering foliage and at the center, the town symbol (from Long Live the King) is carved into the stone of the arch. A pangolin is quickly crossing the road, away from them.

> **DIALOGUE/SHURI:** You think we'll find her easily?

> **DIALOGUE/STORM:** Yes. The way T'Challa described her, she's hard to miss.

PANEL 2 (Row 2)

The trike collapses in on itself as Shuri stands over it. She's clearly just touched some mechanism to make it do this.

PANEL 3 (Row 2)

Shuri is picking up the black square. She used both hands because it's heavy.

PANEL 4 (Row 3)

Shuri is shoving the square into a crevice on the archway as she holds up the vines and pretty flowers that cover the crevice.

> **DIALOGUE/SHURI:** I hope nothing lives in this spot. Not about to carry this around. It's too heavy.

PANEL 5 (Row 3)

The point of view is from behind them as they walk up the empty road, the arch behind them, like in Long Live the King.

> **DIALOGUE/STORM:** It's kind of nice here. Quiet.

> **DIALOGUE/SHURI:** I guess. But it's nice everywhere in Wakanda, though. I don't see why they need to be so secretive.

PAGE TWELVE

PANEL 1 (Row 1)

The point of view is from behind Shuri and Storm as they walk into the town square.

The town square is active and vibrant. There is a marker in the distance (Ikoko is at the market looking at oranges) and small modern buildings at the perimeter of the town square (see Long live the King Issue 5 for reference to how this town square looks).

> **DIALOGUE/SHURI:** So where would one find the female chief of a town with no name?

PANEL 2 (Row 2)

Storm and Shuri watch as Ikoko walks toward them from the market.

Ikoko wears an akara dress.

> **DIALOGUE/SHURI:** Well, that was easy.

> **DIALOGUE/STORM:** I guess we aren't that easy to miss, either.

PANEL 3 (Row 2)

Storm and Ikoko (if you can, show that Ikoko is wearing a wedding ring) are standing before each other; they are both quite tall, about the same height. Storm on the left side of the panel, Ikoko on the right. Shuri is in the middle facing us (Shuri is shorter than both of them).

> **DIALOGUE/IKOKO:** Welcome, Ororo. I always thought I'd first meet you with T'Challa.

> **DIALOGUE/STORM:** Chief Ikoko. These are unpredictable times.

PANEL 4 (Row 3)

Close on Shuri, who is snickering.

> **DIALOGUE/SHURI:** Are you two done trying to see who is taller? Big women.

PANEL 5 (Row 3)

The three of them are walking into the town square, Ikoko leading the way. The point of view is from behind them.

> **DIALOGUE/STORM:** We need your help, Ikoko.

> **DIALOGUE/STORM:** I assumed. Come, let's talk where the entire town isn't listening.

PAGE THIRTEEN

PANEL 1 (Row 1)

They are in a nice but modest room with wicker chairs and a wicker table. There are teacups, a plate of sugar cubes and a bowl of plantain chips on the table. Shuri and Storm are seated and Ikoko is pouring them tea from a cabbage-shaped teapot.

The ancestors hover around Ikoko as she pours tea, and she's smiling. Storm is sipping her tea.

> **DIALOGUE/ANCESTOR 1:** Ah, yes, this one I know.

> **DIALOGUE/SHURI:** Ikoko, can you see the Ancestors?

> **DIALOGUE/IKOKO:** No. But I always know when they are close. Their presence feels warm, like sunshine.

PANEL 2 (Row 2)

Focus on Ikoko.

> **DIALOGUE/IKOKO:** So what brings you both here? T'Challa and Manifold's absence, I assume.

PANEL 3 (Row 2)

Focus on Shuri. Storm is dropping a sugar cube into her tea.

> **DIALOGUE/SHURI:** Have you told anyone besides Storm?

> **DIALOGUE/IKOKO:** No. But I thought you'd find him by now.

DIALOGUE/SHURI: Whatever. People think a lot of things.

DIALOGUE/STORM [to herself, quietly, so in a smaller font]: Mmm, this tea is terrific.

PANEL 4 (Row 3)

Focus on Storm. Shuri looks a bit stung.

DIALOGUE/STORM: Can you help us find him, Ikoko ... by other means? There can be limits to technology.

DIALOGUE/ANCESTOR 2: Or more like there are technologies beyond that of the physical realm.

DIALOGUE/SHURI [muttered, small font]: Humph. Give me enough time, I bet I could still find him my way.

PANEL 5 (Row 3)

Pull back to show the three of them. Ikoko looks pensive, she's clearly ignoring Shuri's immaturity. Shuri is looking at Ikoko, still a bit salty.

DIALOGUE/IKOKO: Ah. I see. Maybe I can help. Connections ... Shuri, what's a place that's close to the earth and connects you and T'Challa?

PAGE FOURTEEN

PANEL 1 (Row 1)

Shuri leads Storm and Ikoko into the clearing toward the baobab tree where the Elephant's Trunk meeting was held earlier in the day. Behind them, parked on the path, are the trike and Ikoko's large (but electric) yellow Hummer-type truck. It's late day, so the sunlight is rich with hues. It's a beautiful panel. On the other side of the baobab tree, out of their sight, Mansa sits holding her tablet (like a book). However, where she'd been reading moments ago, she's now looking back toward Shuri, Storm and Ikoko because she's just heard them arrive.

> **DIALOGUE/SHURI:** My brother was trained here a lot; I used to spy on him.

> **DIALOGUE/IKOKO:** Did you know this baobab tree is named Grootboom the 2nd? It's named after the original Grootboom in Namibia, the largest baobab in Africa. I used to hitch rides here to study. Baobabs keep everything away. So it's peaceful.

PANEL 2 (Row 2)

Focus on Mansa diving into the high grass on the other side of Grootboom 2.

PANEL 3 (Row 1)

Shuri, Storm and Ikoko stand on the other side of Grootboom 2. We can see just a peek of Mansa hiding on the other side in the tall grass, watching, listening.

> **DIALOGUE/SHURI:** You really think you can send me into space?

> **DIALOGUE/IKOKO:** Not your body, just your spirit. You guide your projection to T'Challa.

PANEL 4 (Row 3)

Storm is flying up, she's already halfway to the top of the baobab tree. Shuri is sitting cross-legged in front of the tree, facing its trunk.

> **DIALOGUE/IKOKO:** Just enough lightning to charge the air, not to kill us.

> **DIALOGUE/STORM:** I heard you the first time.

PAGE FIFTEEN

PANEL 1 (Row 1)

Focus on Shuri. She's facing the tree. Ikoko is standing behind her, a palm-sized sack in her hand.

> **DIALOGUE/IKOKO:** Relax. Stare at the tree.

PANEL 2 (Row 1)

Focus on Ikoko who is talking as she pours/draws white powder from the sack to the ground behind Shuri into the shape of Legba's veve.

> **DIALOGUE/SHURI:** Will I feel it happening?

> **DIALOGUE/IKOKO:** Shhh. Close your eyes.
> Visualize what's in front of you until
> it's like your eyes are open.

PANEL 3 (Row 2)

Focus on Storm who hovers above, near the top of the baobab tree. Her eyes are white and her braids are writhing as she sends gentle, almost lace-like lightning current around the tree. It's quite beautiful. We can see Mansa crouching in the grass, the gentle lightning extending to her, too. It's all around the tree. Shuri is cross-legged and facing the tree below. Ikoko is drawing the veve symbol in powdered chalk.

> **DIALOGUE/IKOKO:** Do you feel vibration yet?

> **DIALOGUE/SHURI:** Yes! Is ... is Storm causing that? Some kind of low-grade lightning? Air is a bad conductor of electricity, so it acts as a resistor.

> **DIALOGUE/IKOKO:** Focus, Shuri. You're about to go. Get ready.

PANEL 4 (Row 2)

Close on Shuri's kimoyo beads. A holograph of Okoye has appeared. We see Shuri glancing down.

> **DIALOGUE/OKOYE:** Shuri, your mother is ... Shuri? Are you there?

> **DIALOGUE/SHURI:** Okoye. I'm here. Yes. Where's my mother?

PANEL 5 (Row 3)

Focus on Shuri. Ikoko is standing behind her watching with wide excited eyes. The air around her is sparking because of Storm's lightning.

> **DIALOGUE/ANCESTOR 2:** You're both going.

> **DIALOGUE/SHURI:** Wait! I have to ... what? Both? Who's both?

PAGE SIXTEEN

PANEL 1 (Row 1)

Focus on Shuri as her body slumps, sparkles of Storm's lightning all around her.

PANEL 2 (Row 1)

Focus on Mansa as her body slumps in the grass, sparkles of Storm's lightning all around her.

PANEL 3 (Row 2)

Focus on Shuri as her spirits lifts from her slumped body. She (her spirit) is looking down at herself. Storm is still hovering and changing the air. Ikoko is standing there looking at Shuri's slumped body. The Ancestors stand around her body and as they look up to watch her leave, they look as they did in Djalia, like humans from ancient Wakanda. Two of them are women (one very old, one very young), one is a young man.

> **DIALOGUE/SHURI:** Whoa!

> **DIALOGUE/IKOKO:** It's working.

PANEL 4 (Row 2)

Shuri is above the tree now. Storm floats below her, white eyes and electrified. Below, Ikoko is speaking to the air, but she's not looking directly at Shuri's spirit (since she can't see her).

> **DIALOGUE/IKOKO:** Shuri, if you can hear me, it's going to take you any moment. Brace yourself.

> **DIALOGUE/ANCESTOR 3:** We cannot go with you. You're going to be on your own, Ancient Future.

> **DIALOGUE/SHURI:** What? You're not coming???

PANEL 5 (Row 3)

Shuri is falling upwards into the sky. Storm, Ikoko and Mansa (who is collapsed in the grass) are below. Shuri is falling toward us.

> **DIALOGUE/SHURI:** Eeeeeeeeeeeeee!

PAGE SEVENTEEN

PANEL 1 (Row 1)

Shuri is flying fast through the blackness of space, earth waaaaaay behind her. The moon is on the far left (we're not going toward it). Her eyes are bulging and she looks shocked.

> **DIALOGUE/SHURI:** I'm going into space!

PANEL 2 (Row 1)

Shuri flies through the star-salted blackness of space, earth out of sight. Now she's grinning, though she also looks a bit terrified.

> **DIALOGUE/SHURI:** I'm in space! Whoooooooo, Shuri the Space Girl!! Finally! WHOOOOOOOOOOOO!

PANEL 3 (Row 2)

This panel is big and takes up 2/3rds of the page. We are in the star-salted blackness of space and in the distance is T'Challa and Manifold's ship. Shuri is twisting and reaching toward the ship.

> **DIALOGUE/SHURI:** T'Challa! Manifold!

PAGE EIGHTEEN

PANEL 1 (Row 1)

Shuri is propelling away from the ship.

> **DIALOGUE/SHURI:** Wait! No! Stop! I can't stop! Stop me, Ikoko! That's their ship!

PANEL 2 (Row 2)

She's now moving so quickly that stars are streaking past her (so there are a lot of white lines. It's like she's jumping into hyper speed).

PANEL 3 (Row 3)

Close on Shuri's horrified face. She's looking right at us. There should be strange lights around her face. This moment should be reminiscent of the moment at the end of *Interstellar* or *2001: A Space Odyssey*.

PAGE NINETEEN

PANEL 1 (Row 1)

Shuri is falling backwards into what looks like a tunnel of wood. The wood should look real and detailed. There's no dialogue here and she's not screaming (though she looks like she should be), so there's plenty of allowance for heavy detail. Wood wood wood. She's facing us and her feet and arms stretched toward us as she flies backward. This panel is reminiscent of Alice in Wonderland, where Alice is falling down the rabbit hole.

PANEL 2 (Row 2)

The panel is all black.

PAGE TWENTY

PANEL 1 (Row 1)

This is a narrow panel. Close on Groot's confused face. Especially Groot's eyes.

PANEL 2 (Row 2)

This panel takes up most of the page. It's practically a splash page. Groot is standing there looking down at Rocket, a serious questioning look on his face. Groot is so totally confused. Rocket has a laser gun in hand and it's smoking. He's already tried shooting the Space Lubber.

There's a wind of electricity swirling and crackling around them and a giant wet-looking grasshopper monster with appendages that branch into circuitry wherever it touches behind them. It's sitting in a baobab tree looking down at their ship, which has a large dent in the side (from when the Space Lubber knocked them toward the small moon's atmosphere). The tree seems meshed with glowing networks of circuitry.

> **DIALOGUE/ROCKET:** Groot, buddy, why can't we ever have normal problems?
>
> **DIALOGUE/GROOT-SHURI:** I am Shuri?

... TO BE CONTINUED.

from *Black Panther* #2 (2005)